We all cast a shadow, and sometimes we look backwards. And I think that this was like the Obeah—they are part of our shadow. That part of me is gone, or killed. That me is over. . . . we look backward sometimes and find these things that are not in the light of reason.

1986

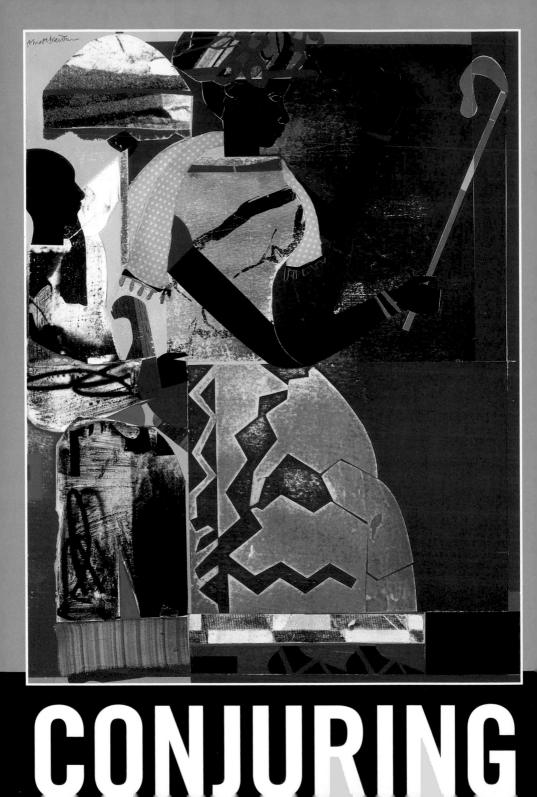

CONJURING

Richard J. Powell
Margaret Ellen Di Giulio
Alicia Garcia
Victoria Trout
Christine Wang

Nasher Museum of Art
at Duke University

BEARDEN

Published on the occasion of the exhibition *Conjuring Bearden*

March 4–July 16, 2006

Nasher Museum of Art at Duke University
2001 Campus Drive, Durham, NC 27705
(919) 684-5135
www.nasher.duke.edu

Conjuring Bearden is made possible by the Mary Duke Biddle Foundation, Duke University's Office of the President and The Duke Endowment, the Provost's Common Fund, the Duke Semans Fine Arts Foundation, the Women's Studies Program, the Department of Art and Art History, and the African and African American Studies Program. Additional funding was provided by Primus First Realty and Womble Carlyle Sandridge & Rice, PLLC. This project also received support from the North Carolina Arts Council, an agency funded by the State of North Carolina and the National Endowment for the Arts, which believes a great nation deserves great art.

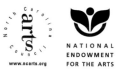

© 2006 Nasher Museum of Art at Duke University
All rights reserved.
All Bearden images are licensed by VAGA, New York, New York.

No part of this publication may be reproduced in any manner whatsoever without permission in writing from the Nasher Museum of Art at Duke University.

Cataloging-in-Publication data are available from the Library of Congress.
Library of Congress Control Number applied for
ISBN: 0-938989-27-8

Distributed by Duke University Press

Text by Richard J. Powell, John Spencer Bassett Professor of Art and Art History, Duke University, and Margaret Ellen Di Giulio, Alicia Garcia, Victoria Trout, Christine Wang
Designed by Molly Renda
Printed in the United States by Progress Printing

FRONT COVER: Romare Bearden, *The Conjur Woman*, ca. 1979. Collage with fabric, string, pins, and photomontage on board, 23 × 15 in. Lent by Evelyn Boulware and Russell Goings. Copyright Romare Bearden Foundation/Licensed by VAGA.

TITLE PAGE: Romare Bearden, *She-ba*, 1970. Collage on board, 48 × 37 ⅞ in. Wadsworth Atheneum Museum of Art, Hartford, Connecticut. The Ella Gallup Sumner and Mary Caitlin Sumner Collection Fund. Copyright Romare Bearden Foundation/ Licensed by VAGA.

BACK COVER AND PAGE 91: Frank Stewart, *Romare Bearden, New York*, 1979. Photograph, 36 ½ × 27 in. Copyright Frank Stewart/Black Light Productions.

Contents

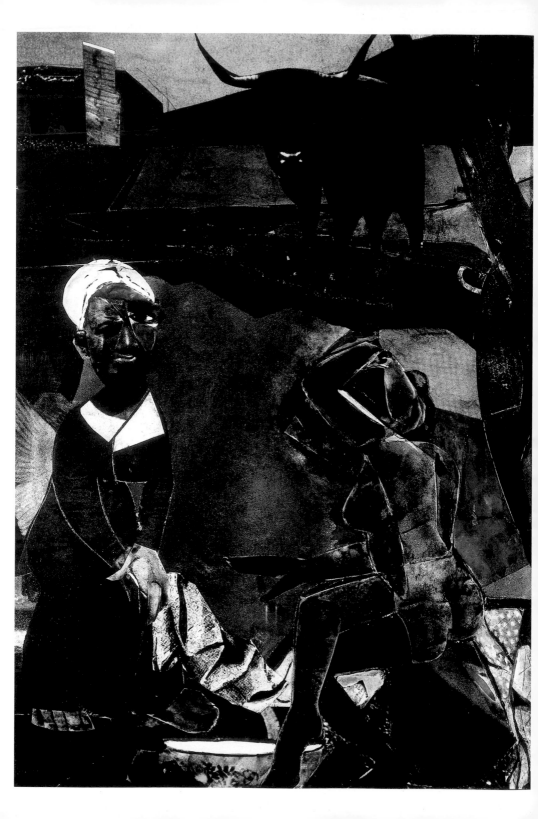

Foreword and Acknowledgments

The Nasher Museum of Art at Duke University is pleased to present *Conjuring Bearden*, the first exhibition to explore the theme of the "conjur woman" in the work of North Carolina–born artist Romare Bearden. Thanks to the recent Bearden retrospective organized by the National Gallery of Art in Washington, D.C., Bearden's work is much on our minds, but his fascination with the African American folk healer in the form of the conjur woman and the Caribbean "Obeah," while deeply resonant, is still little understood.

We are immensely grateful to Richard J. Powell, Duke's John Spencer Bassett Professor of Art and Art History, who conceived this project as a collaboration between the Nasher Museum and Duke's Department of Art and Art History that would engage students in the work of organizing an important exhibition under his careful direction. Rick Powell worked tirelessly on every aspect of the project, guiding his students through all stages of organizing an exhibition, fundraising, assisting with the catalogue, coordinating the accompanying "Romare Bearden/Conjuring Women" colloquium and curating the "Conjuring Bearden Through Film" series. He was always delightful, charming, and good-humored, while energizing us with his creativity and sensitive intellect. Under his tutelage and inspired by his example, his students Margaret Di Giulio, Alicia Garcia, Victoria Trout, and Christine Wang contributed to every aspect of the exhibition and wrote insightful essays for the catalogue. We heartily thank them all.

We are grateful to the lenders, whose tremendous generosity was essential in securing key works. They include the Romare Bearden

Conjur Woman as an Angel, 1964. Photomontage, 40 ½ × 28 ½ × 2 ¾ in. Courtesy of the Romare Bearden Foundation & Estate of Nanette Bearden. Copyright Romare Bearden Foundation/Licensed by VAGA.

Foundation, ACA Galleries, the Asheville Art Museum, John P. Axelrod, Evelyn Boulware and Russell Goings, the Mint Museum of Art, Susie Ruth Powell and Franklin Anderson, the Michael Rosenfeld Gallery, the Jerald Melberg Gallery, the Shaw Family Archives, Frank Stewart/Black Light Productions, the Studio Museum in Harlem, and the Wadsworth Atheneum.

We also thank those who helped with the logistics of the exhibition and in locating works, especially Sheila Rohan and Deidra Harris-Kelley of the Bearden Foundation, Mary and Jerald Melberg, Dorian Bergen, Susan Sillins and Frank Stewart, and Edith Shaw Marcus, Meta Shaw Stevens, and Larry Shaw. Ali Evans of the Studio Museum and Brooke Anderson of the American Folk Art Museum were generous with their time and insights to Professor Powell and his students during their research trip to New York.

We are especially grateful to the Mary Duke Biddle Foundation, whose financial support sustains many of the museum's artistic and educational programs, including this exhibition, and to our other funders, the Duke Semans Fine Arts Foundation, the North Carolina Arts Council, Primus First Realty, and Womble Carlyle Sandridge & Rice, PLLC. We also acknowledge the generous assistance of Duke University's Office of the President and The Duke Endowment, the Provost's Common Fund, the Women's Studies Program, the Department of Art and Art History, and the African and African American Studies Program.

It has been exciting to see how this exhibition has inspired campus-wide collaboration that will be a model at the Nasher Museum for years to come. We thank Duke's President, Richard Brodhead, Provost Peter Lange, and Cathy Davidson, Vice-Provost for Interdisciplinary Studies; Kathy Silbiger, Executive Director of Duke Performances; David Paletz, Director, Film/Video/Digital Program; and Patricia Leighten, Chair, Department of Art and Art History. We are also grateful to Tina Campt, Interim Director, Women's Studies Program, who co-organized the "Romare Bearden/Conjuring Women" colloquium with Rick Powell; Jane Gaines of the Program in Literature for co-curating the "Conjuring Bearden Through Film" series; Karen Glynn, Visual Materials Archivist in the Rare Books, Manuscripts, and Special Collections Library, for alerting us to the work of filmmaker H. Lee Waters, whose work documents life in North Carolina towns during the period of Bearden's youth; Tom Whiteside for his sensitive editing of the H. Lee Waters film included in the exhibition; Anthony Kelley of the Department of Music for his original jazz score accompanying the film; and Hank Okazaki of the Film/Video/Digital Program for overseeing the logistics of the "Conjuring Bearden through Film" series. We also thank Lee Sorensen, Art Librarian at

Lilly Library, for his untiring and cheerful assistance to the students in their research.

The exhibition would not have been possible without the Nasher Museum staff's hard work. We are most grateful to Associate Curator Anne Schroder, who worked closely with Professor Powell, his students, and our campus partners as the museum's coordinating curator for the exhibition. Sarah Schroth, Nancy Hanks Senior Curator, supported the exhibition and advised on many aspects. Registrar Jeffrey Bell and his assistant Myra Scott expertly handled loans and shipping, and Chief Preparator Brad Johnson made certain the works were handsomely presented. Rebecca Swartz, the museum's Director of Development and External Affairs, secured community support and sponsorships to sustain our education and public programs. Wendy Hower Livingston oversaw the publicity for the exhibition and secured copyright permissions. Curator of Education Juline Chevalier created a range of programs for the show, ensuring a wide and diverse audience. Staff members Martha Baker, Rita Barden, Michelle Brassard, Lisa Charde, Dorothy Clark, Carolina Cordova, Harvey Craig, Alan Dippy, Ken Dodson, Jamie Dupre, David Eck, Anna Lorenz, Douglas Vuncannon, and our student assistants also contributed to the process of organizing and presenting the exhibition. We are also grateful to the docents and Friends of the Nasher Museum of Art.

Kimerly Rorschach
Mary D.B.T. and James H. Semans Director

Introduction: Conjuring Bearden

I t is only in the last 30 years that the art of Romare Bearden (1911–1988) has received considerable museum attention. Starting with the Museum of Modern Art's exhibition *Romare Bearden: The Prevalence of Ritual* (1971), this artist's works have been key components in defining a particular stream of American modernism. The three other major museum surveys of Bearden's art—*Romare Bearden, 1970–1980* (1980); *Memory & Metaphor: The Art of Romare Bearden* (1991); and, most recently, *The Art of Romare Bearden* (2003)—each successfully employed the retrospective model in tracing this artist's experimentations with easel painting and the medium of collage, processes that, in Bearden's discerning hands, transformed conventional narrative painting and the collage's conceptual simultaneity into paramount visual discourses on African American identity and mythos. Among the many smaller Bearden exhibitions, one in particular—*Romare Bearden in Black and White: Photomontage Projections, 1964* (1997)—merits special recognition for its concentration on Bearden's pivotal work in the mid-1960s with collage, photoduplication, and enlargement technologies.

All of these endeavors have, in their individual ways, established Romare Bearden as an important visual delineator of a modern condition. From his prophetic paintings from the 1940s of heroic women and men engaged in enigmatic, unnamed rituals to his very last collages from the mid-1980s onward of a stark, often bleak rural existence, Bearden has grounded the twentieth century imagination in the cotton field fantasies and inner city dreams of black America.

One of the primary thematic currents throughout Bearden's career was a grassroots, African American, philosophical knowledge

Sam Shaw, *Romare Bearden with Model*, New York, ca. 1947. Photograph, 14 × 11 in. Courtesy of the Shaw Family Archives, Ltd. Copyright Sam Shaw.

base whose observable mechanisms (e.g., the "conjur woman," expressive folkways, herbalism, animal symbolism, and superstitions) emblematized a cultural position worthy of artistic consideration. The idea of the conjurer—someone who, through a combination of spiritual interventions, psychology, and herbalism, transforms the world—was a recurring theme in Bearden's art. It would not be an exaggeration to say that Romare Bearden was obsessed with the notion of vernacular, African American–based origins of knowledge, efficacy, and metaphysical dominion.

When Bearden and the Museum of Modern Art chose to entitle his first major museum solo venture *The Prevalence of Ritual*, this preoccupation with the black folk theme was clearly behind that decision. Yet, other than receiving a dutiful citation by the organizers of that show (and as a brief reference by curators and catalogue essayists from succeeding exhibitions), the idea of conjuring—as a topic, obsession, and creative act in Bearden's work—has surprisingly never been addressed, either curatorially or critically in depth.

The closest any scholar has come to examining this very important theme in Bearden's work is author Myron Schwartzman's transcribed and published interviews with Bearden on the subject of the conjur woman's Caribbean equivalent, the Obeah woman. Among the numerous observations that Bearden made about his understanding of black mysticism, one especially stands out: ". . . We all cast a shadow, and sometimes we look backwards. And I think that this was like the Obeah—they are part of our shadow. That part of me is gone, or killed. That me is over. . . . we look backward sometimes and find these things that are not in the light of reason."

Although Bearden is speaking in this passage about the Obeah woman, his references to an otherworldly afterimage—whose multiplicity belies our otherwise levelheaded sense of a rational, cerebral, and discrete self—figure time and time again in his post–1964 works. This acknowledgment of what literary critic Marina Warner has in so many of her writings described as a kind of cultural storytelling specter is especially present in those pictures whose conjur/Obeah/black-folklore themes are visually predicated (via Bearden's unique approach to the collage) on chromatic amplifications of nature, multiphased spatial dynamics, and composite anatomies.

Conjuring Bearden is a modest attempt at addressing Bearden's enthrallment with the powers and spiritual efficacy of the black vernacular. Through displaying selected works on the themes of the conjurer, the Obeah woman, symbolic flora and fauna, and the glanced-back-at "shadow" to which he referred—and juxtaposing these images with wall texts, photographs, film clips, and recorded music—we hope to fill the art historical lacunae on this essential yet under ana-

lyzed aspect of Bearden's career. We also hope in *Conjuring Bearden* to interrogate the artist *himself* by including a small selection of artworks that broach other related themes and stylistic strains: visual evidence of Bearden's self-identification with the transforming and restorative powers of conjuring in art. The accompanying exhibition catalogue, a film series, a national colloquium, and related public programming will build on the exhibition's principal thesis and hopefully inspire future, more concentrated and multidisciplinary studies of this artist's intellectual contributions.

Richard J. Powell
Margaret Ellen Di Giulio
Alicia Garcia
Victoria Trout
Christine Wang

Only the conjur woman, alone in the woods, seems unaffected by her solitude; therefore no train defaces her woods. A conjur woman, they say, can change reality, but for the rest of us, it is too late. The World is without her kind of mystery now.

1964

Conjur Woman #1, 1964. Photomontage, 38 $^{15}/_{16}$ × 30 $^{9}/_{16}$ × 2 $^{3}/_{4}$ in. Courtesy of the Romare Bearden Foundation & Estate of Nanette Bearden. Copyright Romare Bearden Foundation/Licensed by VAGA.

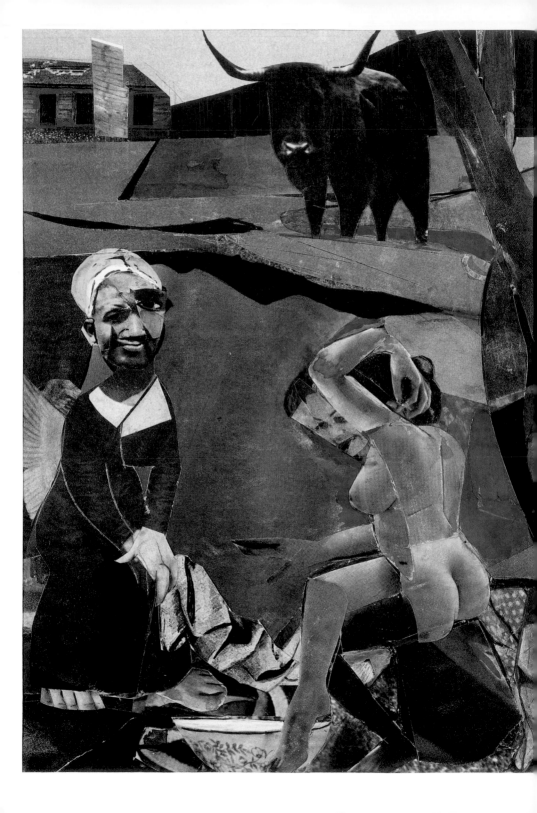

Richard J. Powell

Changing, Conjuring Reality

O ver the course of his career Romare Bearden created at least a dozen works on the subject of the "conjur woman." She emerges in many of these pictures as specter-like, hovering among low-lying tree limbs and sharing the dense turf with wayward sparrows and black snakes. Her composite body gives next to no indication of her gender, apart from a kerchief-covered head and a calf-length "Old Mother Hubbard" dress. Her race, rather than being identifiable through the typical phenotypic markers, manifests itself in the work's external, African American context, and in Bearden's carefully selected and collaged facial features, mostly lips and noses cut from photographs of African masks. Collaged eyes and hands, intentionally mismatched and evoking the "too big" and "too small" fairy-tale modes of observation, hint at her abilities for prescient sight and root work: the attributes of a bonafide conjurer.

Works such as *Prevalence of Ritual: Conjur Woman* (1964), *Prevalence of Ritual: Conjur Woman as an Angel* (1964), *Conjur Woman* (1971), *Conjur Woman* (1975), *Profile/Part I, The Twenties: Mecklenburg County, Conjur Woman and the Virgin* (1978), and *The Conjur Woman* (ca. 1979), all form a fascinating assemblage of distinct yet unified works. If one adds to this group those early paintings, mid-career collages and prints, and later watercolors and monotypes that, within their broad panoply of pictorial subjects and themes, include folkloric, female characterizations that strongly resonate with the conjur woman *proper,* then one could easily say that Bearden was smitten with this figural/visual trope.[1]

LEFT: *Prevalence of Ritual: Conjur Woman as an Angel,* 1964. Collage on board, 9 3/16 × 6 7/16 in. John P. Axelrod, Boston, Massachusetts. Courtesy Michael Rosenfeld Gallery. Copyright Romare Bearden Foundation/Licensed by VAGA. OVERLEAF: *Illusionist at 4 P.M.,* 1967. Collage with ink and graphite on fiberboard, 29 1/2 × 40 in. Collection of halley k harrisburg and Michael Rosenfeld. Copyright Romare Bearden Foundation/Licensed by VAGA.

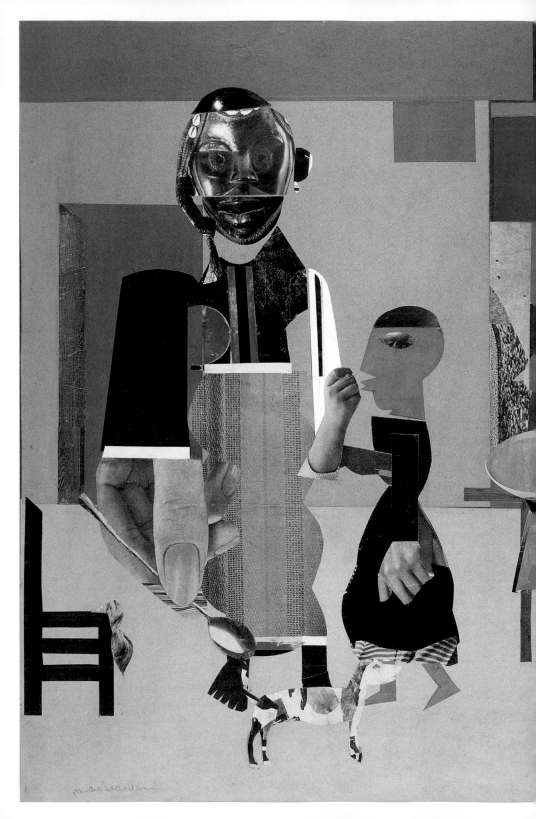

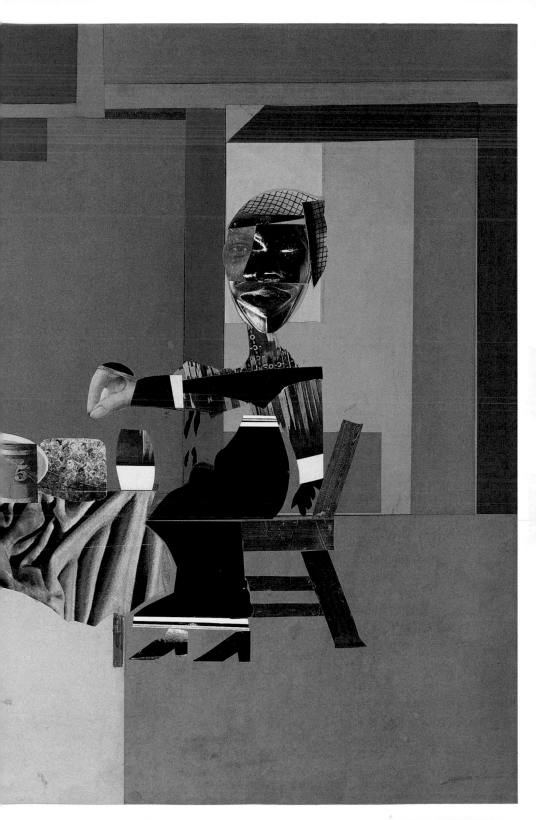

On the occasion of the conjur woman's official debut—the *Projections* exhibition at New York's Cordier and Ekstrom Gallery in October of 1964—Bearden wrote the following about her: "Only the conjur woman, alone in the woods, seems unaffected by her solitude; therefore no train defaces her woods. A conjur woman, they say, can change reality, but for the rest of us, it is too late. The World is without her kind of mystery now."[2] Apart from his explanation about the absence within this work of yet another one of his pictorial absorptions—the train—Bearden strikes a nostalgic tone, reminding viewers that the conjur woman's mutable powers were no longer a significant feature of life. The preoccupations of the contemporary man and woman and the shift to a post-industrial, urban existence had created a world in which "her kind of mystery" was not so much a relic as entirely extinct. The conjur woman's "train", figuratively speaking, had already left the proverbial station, leaving the public to ponder other, more immediate concerns.

Yet the conjur woman and her various personae (e.g., She-ba, Salome, Circe, Maudell Sleet, the anonymous female blues singers) persisted, winding their way through Bearden's work like deep, ineradicable taproots. The space that Bearden allowed in his art for such sphinxlike sentinels begs the question of why they were there in the first place, and prompts an inquiry into what they signified for him beyond a transubstantiating, reality-altering embodiment of mystery.

In one of her earliest incarnations, *Prevalence of Ritual: Conjur Woman as an Angel,* the conjur woman is a handmaiden in charge of a lady's toilet and, as the picture's title and her wings suggest, in disguise as a divine caretaker. Whether the jagged, brown horizon above the conjur woman and lady is sufficiently impassable to keep a menacing longhorn in the distance at bay is unclear, although the conjur woman's cockeyed and besmirched expression introduces other fears and anxieties into this scenario. In this otherworldly send-up of the classic *Europa and the Bull* theme, Bearden has added the conjur woman as a kind of third wheel, creating a *ménage-à-trois* in which seduction is shown by way of this figure's masked, hypnotic dominion, rather than through the lady's beauty or the bull's brawn. Novelist Ralph Ellison's comparison of Bearden's conjur woman "with the ubiquity of the witches who haunt the drawing[s] of Goya" aptly delineates this character, likening her to a part nurturing, part carping chaperone who, without warning, is capable of transforming herself from protector to procuress.[3]

That same year Bearden created two additional collages of this subject, one set loosely in a portrait format and the other featuring her full figure and the previously referenced forest. This latter con-

jur woman—a fragmented and bizarre woodland creature—carries none of the narrative baggage that these other two *Prevalence of Ritual: Conjur Woman* collages have. Rather, she is a stoic, inscrutable presence, whose cut and torn reprographic formation is an appropriate state of being given her debut during that media-conscious, Marshall McLuhanesque moment in the 1960s.

While not explicitly mentioned by name she appears in another early collage, *Illusionist at 4 P.M.* Here two opposing figures—one prominently standing in front of a dog and a small inconsequential figure, and the other seated alone at a dining table—compete for the "conjur woman" title. But the robust singularity of the standing figure gives her the advantage over the seated one, as well as the former woman's wielding of a long-handled, scepterlike spoon, held by an incongruous, colossal hand. The implied rivalry here brings to mind cultural historian Marina Warner's definition of *conjuring*: "Used both for devilry and natural magic; witnesses and participants play a crucial part in establishing the shifting boundary between the entertainer's sleight of hand and the paranormal. . . ."[4]

Although Bearden often expressed his concerns about commentators overemphasizing what they believed to be the social elements in his art, the works themselves—comprising a virtual universe of black folk types and characterizations—countered his own argument, and illustrated rarely broached perspectives on racial and cultural identity.[5] "I felt that the Negro was becoming too much of an abstraction," Bearden famously stated about popular, circa 1960s representations of African Americans, "rather than the reality that art can give a subject. . . . What I've attempted to do is establish a world through art in which the validity of my Negro experience could live and make its own logic."[6] And the logic of the female conjurer in *Illusionist at 4 P.M.,* in charge of a domestic interior in which a late afternoon repast becomes part of an elaborate, mysterious sacrament, defies common, modern sense. "As a Negro," Bearden told art critic Dore Ashton, "'I do not need to go looking for happenings, the absurd, or the surreal, because I have seen things that neither Dali, Becket, Ionesco or any of the others could have thought possible.'"[7]

Singer Nina Simone, herself a musical "conjure woman" in nightclubs and concert halls at the time, made disclaimers and declarations similar to Bearden's visual and verbal overtures to the conjur woman, singing

Baby, you'll understand me now
If sometimes you see that I'm mad;
Don't you know no one alive can always be an angel
When everything goes wrong you see some bad;

But I'm just a soul whose intentions are good;
Oh, lord, please don't let me be misunderstood.[8]

In these autobiographical lyrics, Simone pairs her tempestuous behavior with a prayer for indulgence. And despite the conjur woman's anachronistic appearance, supposed ferocity, and superhuman powers, she is not an altogether unsympathetic character. By presenting her in a forest abundant with medicinal herbs and plants, or in tense domestic settings, Bearden alluded to her pharmacological and prophylactic aspects (e.g., preparing love potions, providing herbs to cure various illnesses, and counseling clients in regards to vexing personal and family problems).[9] Similarly, Nina Simone reminded listeners that the heterodoxical belief systems and conjure women which she often sang about were also occasionally therapeutic and psychological restoratives for the community, or what literary critic Richard Brodhead (in his treatise on the conjure figure in American literature) has described as "a recourse, a form of power available to the powerless in mortally intolerable situations."[10]

By locating these evocative, spiritual currencies in the archaic figure of the conjur woman, Bearden was casting his lot with the folk romantics of his day (like anthropologist Mircea Eliade and folklorist Richard M. Dorson), intellectuals who, rather than privileging the pronouncements of the then-popular structuralists, Neo-Freudians, and Marxist theoreticians (e.g., Roland Barthes, Norman O. Brown, and Herbert Marcuse), looked toward modernism's more pedestrian counterpart—folk and popular culture—for philosophical confirmation. The conjur woman's origins in a place and time as far removed as anyone could be from the stainless steel luminosity and Day-Glo colors of the 1960s and 1970s gave Bearden's art an idiosyncratic, appreciable vantage point: an ironic version of the self-segregated theater balcony from which "the innerness of the Negro experience" could be savored by blacks without pandering to racist pigeonholing or racial propaganda.[11] As committed as Bearden was to the efforts to restore and expand civil rights, he vehemently resisted the call to place his art in service to a political agenda. Instead he chose to effect social change via a shrewd cultural strategy: artistically invoking the iconic heroes and heroines of the disenfranchised African American majority. In that era of debates, demonstrations, and riots, the prospect of changing the subject (or "changing reality") was appealing, even if such substitutions for "the Negro problem" might reside, as Bearden provocatively proposed, in an old black woman's body.

Bearden's conjur woman was neither eroticized nor made into a passive, objectified figure for ridicule or pity. Instead, she jump-

starts each work of art in which she appears, and introduces cultural and spiritual variables into social discourses that were too often drowned out in the din of technological advancements and the despair of community disintegration. She was a power figure and a possessor of secrets that societal/political structures could not eliminate or buy off. In *Profile/Part I, The Twenties: Mecklenburg County, Conjur Woman and the Virgin* (1978)—arguably one of Bearden's most enigmatic renderings of her—she performs plein air "surgery" on the "Virgin," alongside a dark blue stream and under a tall canopy of pine trees. Parenthetic witnesses (or co-conspirators) to this bloodletting—a white egret attacking a snake and a tawny-complexioned fisherman sitting on the water's edge—further complicate the scene, and introduce decidedly symbolic and perhaps autobiographical dimensions to the proceedings. Is this a cold-blooded murder being shown here, or is this a Romare Bearden allegory on the loss of idealized virtue and the acquisition of true wisdom? As a folk character who historically was both knowledgeable about the past and capable of revealing horrific, yet fundamentally liberating truths, the conjur woman was, indeed, a human razor, cutting away the psychological chastity belts of the uninitiated and educating the innocents about the often ruthless, cutthroat ways of the real world.[12]

Although feminism was not a part of Bearden's lexicon, he implicitly understood that this new/old image of his had to reside in the most appropriate personage: a figure recognizable as being a fitting vessel and vehicle for these changes to the standard racial script. And like Ralph Ellison's largely silent, but all-seeing/all-knowing, apocryphal black folk critic, Bearden's catalyst would also have to be an agency-filled representative of old. That such an entity would ultimately be a woman meant that she was drawn from Bearden's deep, deep memory reservoir of the women he knew or had known and considered elemental, powerful, and transforming in his life.[13] His great-grandmother Rosa, grandmother Cattie, mother, Bessye, and wife, Nanette, were all certainly forces of nature with which to contend, but the woman whom he repeatedly spoke of as his personal fomenter to rethinking his art was Ida, a prostitute-turned-cleaning-lady that Bearden met in 1940. After Bearden rejected Ida's suggestion to paint her, Ida's retort (which Bearden paraphrased in subsequent interviews) is telling. "'I know what I look like,' she said. 'But when you can look and find what's beautiful in me, then you're

OVERLEAF: *Profile/Part I, The Twenties: Mecklenburg County, Conjur Woman and the Virgin*, 1978. Collage on board, 13 ¾ × 19 ¾ in. Collection of the Studio Museum in Harlem. Museum Purchase. 97.9.14. Copyright Romare Bearden Foundation/Licensed by VAGA.

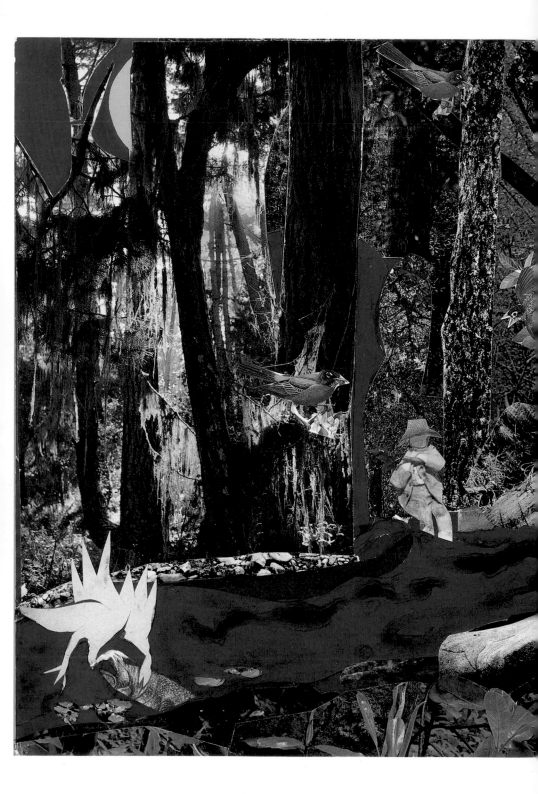

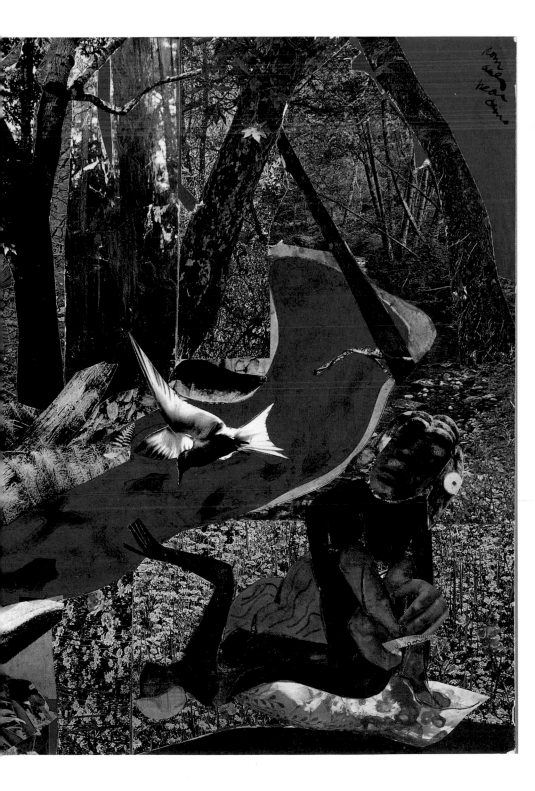

going to be able to do something on that paper of yours.' That always sort of stuck with me," Bearden acknowledged.[14]

Placing this statement with Bearden's conjur woman imagery (as well as opposite New York photographer Sam Shaw's well-known series of studio shots of a young Bearden pondering a black female model) drops Bearden's (and Ida's) words in a bubbling cauldron of ideas and possibilities: rethinking commonplace (and often racist) Western notions of beauty, the juxtaposition of desire and representation, revelations and self-discoveries as advanced from the social margins, and returning to one's originary (female) roots as a way out of the artistic routine and into a new, cultural rebirth, among other thoughts. It is precisely the conjur woman's corporeal detachment from the conventional male gaze (whose alternative was deftly articulated to Bearden by Ida) that empowers her and shifts her visual allure to the natural world and, on the cultural front, to the African diasporic principles of art-as-healing, art-as-metamorphosis, and art-as-spiritual-renewal. And Bearden's methods for introducing this figure in his art—by distilling Cubist and Dadaist fracture through the deconstructive aesthetics of jazz composition and African American folk collage/assemblage—matched this new/old female subject perfectly.

Along with his claims (like those of his friends and colleagues Ralph Ellison and Albert Murray) on the universalizing principles of art, Bearden was a "race man" who presented his modernist self through assorted facets of cultural blackness and hybrid, formalist strategies of image-making. Subjects like the conjur woman became the thematic substratum that anchored many of these explorations. As seen in a detail from an *Untitled* quilt (1976), a black female cameo forms the core design element of the repeated silkscreen patterns in this rare example of textile art by Bearden. The paired leaves and appendage-like roots that, from top to bottom, sprout from the woman in the cameo are the telltale signs of her conceptual allegiance to the conjur woman: medicinal roots and herbs being the conduits through which she puts her clients in contact with the spirit world.[15]

Indeed, the reality-altering attraction to the conjur woman was predicated on Bearden's fervent belief in the social and political importance of traditional black culture, especially in the face of what he perceived as an encroaching, modern amnesia.[16] The Mecklenburg County, Pittsburgh, and Harlem communities where he had

Untitled (Medallion Quilt), detail, 1976. Silkscreen on cotton, 94 × 76 in. Collection of Susie Ruth Powell and Franklin R. Anderson. Copyright Romare Bearden Foundation/Licensed by VAGA.

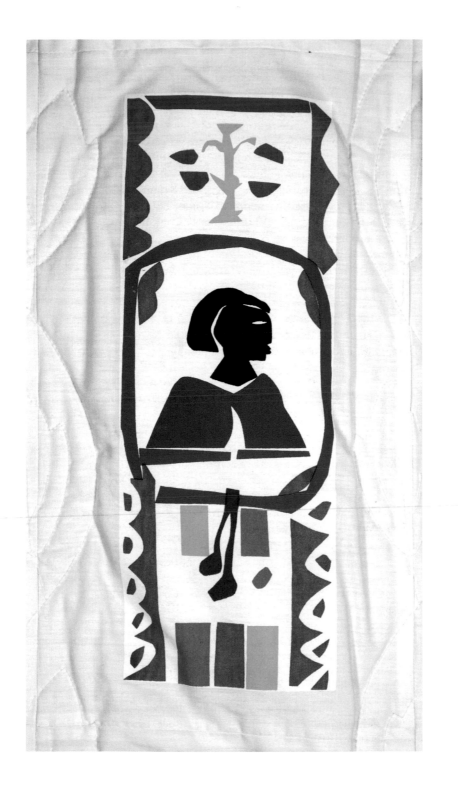

grown up had all been razed, repaved, and emptied of their pictur-esque "Negro-ness" by the 1960s. While the Civil Rights Movement had certainly brought about needed improvements in the economic, political, and social lives of African Americans, what accompanied these changes was what Bearden viewed as a declining sense of race solidarity across generations and, more importantly, the loss of a cultural memory: the shared experiences of blacks during the pre-civil rights era that, although debilitating in terms of one's interra-cial dealings or broader aspirations in the world-at-large, provided black people with a nurturing if insular sphere in which to operate. As Bearden's art demonstrates, that world was just as much about Duke Ellington's music and Harlem nightlife as it was about racial epithets; as much about patchwork quilts and rousing church ser-mons as it was about lynching; and was as much about the wisdom of elders and sympathetic teachers as it was about blocked school entrances. For all of her rustic, superstition-filled associations, the conjur woman represented a third stream for Romare Bearden. At a time when "for the rest of us, it is too late," Bearden's conjur woman reminded audiences of the enduring, ghost-like presence of the past: redolent with the aura of the ancestors and yet endowed with enough spiritual authority to transform and breath life into a soulless, ahis-torical reality.

NOTES

1. Scholars of American modernism are eternally grateful to National Gal-lery of Art curator Ruth Fine for her Promethean efforts in assembling that museum's 2003 Bearden retrospective. Unless otherwise noted, all biographi-cal references in this essay come from: Ruth Fine, *The Art of Romare Bearden* (Washington, D.C.: National Gallery of Art, 2003).

2. Dore Ashton, "Romare Bearden—Projections," *Quadrum* 17 (1964): 99–110.

3. Ralph Ellison, "Introduction," in *Romare Bearden, Paintings and Projec-tions* (Albany: The Art Gallery, State University of New York, 1968), np.

4. Marina Warner, *The Inner Eye: Art Beyond the Visible* (London: The South Bank Centre, 1996), 33.

5. Romare Bearden, "Rectangular Structure in My Montage Paintings," *Leonardo* 2 (January 1969): 18.

6. Charles Childs, "Bearden: Identification and Identity," *Art News* 63 (Octo-ber 1964): 24–25, 54, 61–62.

7. Dore Ashton, 109.

8. Nina Simone, "Don't Let Me Be Misunderstood" (1964) on *Nina Simone/ Jazz Masters* 17 1994 CD Reissue, PolyGram Records, Inc. 314 518 198–2.

9. For an exegesis on the African American conjurer's immersion in the world of spiritually charged plants and natural phenomena, see: Theophus H. Smith, *Conjuring Culture: Biblical Formations of Black America* (New York: Oxford University Press, 1994), 5–6.

10. Richard Brodhead, "Introduction," in *The Conjure Woman and Other Conjure Tales, Charles W. Chesnutt,* (Durham: Duke University Press, 1993), 9.

11. Childs, 62.

12. I am indebted to Mary Schmidt Campbell, Dean of the Tisch School of the Arts, New York University, and a leading Bearden scholar, for bringing the complexities of *Conjur Woman and the Virgin* to my attention.

13. Mary Schmidt Campbell, "Introduction," in *Mysteries: Women in the Art of Romare Bearden* (Syracuse: Everson Museum of Art, 1975).

14. Calvin Tomkins, "Putting Something Over Something Else," *The New Yorker* 53 (November 28, 1977): 58.

15. See Donald J. Waters, "The Persuasive Nature of Superstition: A Matter of Health," in *Strange Ways and Sweet Dreams: Afro-American Folklore from the Hampton Institute* (Boston: G.K. Hall & Co., 1983), 75–84.

16. Similar sentiments were shared by friends Ralph Ellison and Albert Murray, as evidenced in: Ralph Ellison, *Shadow and Act* (New York: Random House, 1964), and Albert Murray, *The Omni-Americans: New Perspectives on Black Experience & American Culture* (New York: E.P. Dutton, 1970).

An obeah woman once told me she took in the moon before dawn and held it as a locket on her breast and then threw a rooster out in the sky who spun himself in the rising sun. . . .

1985

Frank Stewart, *Romare Bearden, Blackout, St. Martin*, ca. 1975. Photograph, 25 1/2 × 18 in. Copyright Frank Stewart/Black Light Productions.

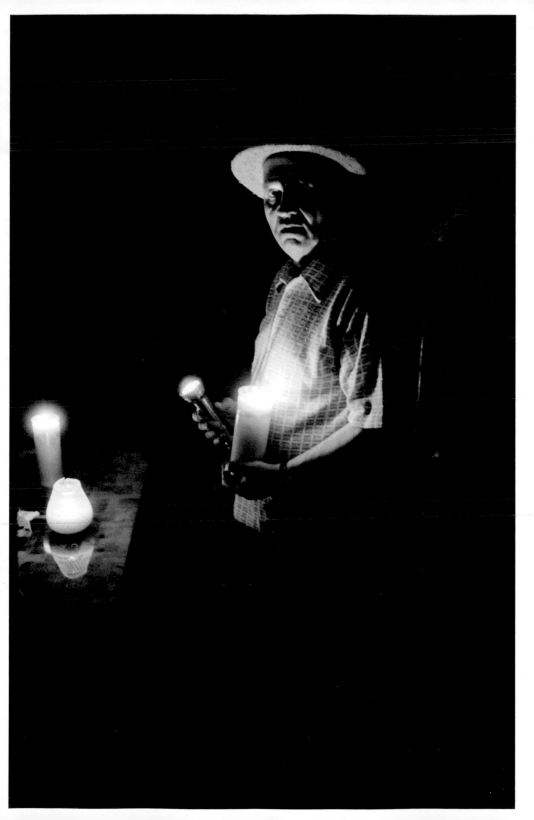

Alicia Garcia

Muse and Method in Romare Bearden's *Obeah* Watercolors

R omare Bearden's *Obeah* series (1984) occurs at the nexus of the artist's newfound fascination with the colors and rhythms of the Caribbean and an artistic consciousness deeply rooted in cultural and religious tradition. Though visually distinct within a repertoire most famed for its highly structured collage work, the *Obeah* watercolors mark the culmination of Bearden's career-long infatuation with paint and the formal qualities of the two-dimensional surface. Their hypnotic palette and raw freedom of form are unequaled elsewhere in Bearden's expansive body of work. While these watercolors were not the artist's first foray into the medium, they provide an unparalleled illustration of his preoccupation with magical spiritualism, as well as his belief in painting as the foundation of his composition. As such, the *Obeah* watercolors merit further examination within the context of Bearden's life and work.

Born of his studies at the New York Art Students League in the 1930s, Bearden's love for watercolor came to fruition while studying under the exiled German painter George Grosz.[1] An examination of Grosz's socially conscious and largely cubist work in watercolor reveals clear sources of inspiration for a young Bearden. It was under the influence of Grosz's use of bold colors and corrosive lines (and with the realization of the power of this work for sociopolitical commentary) that Bearden first began to consider himself a painter. Despite his later and more widely known works in the media of collage and photomontage, all of Bearden's art is, in essence, an expansion upon his initial experiments in painting.

Bearden created numerous works in tempera before joining the Army in 1942. A few years after completing his military service, he used the G.I. Bill to fund a travel/study trip to Paris. There Bearden immersed himself in the world of abstract art that was only then beginning to significantly manifest itself in the United States. While

abroad, Bearden established contacts with such European artists as Constantin Brancusi, Fernand Leger, and Georges Braque.[2] The impact of these artists on Bearden is at times depreciated in contrast to his oft-quoted indebtedness to the compositional influences of Pieter Brueghel and other great Dutch masters, but these Parisian sources of inspiration are important for the ways in which they helped transform Bearden's understanding of color and form. Upon his return to the States, Bearden produced a series of abstract paintings which encompassed brilliant swaths of flowing, dissipated oil pigments—a marked departure from the closed forms and earth tones of his circa 1940 tempera paintings. These paintings (along with earlier explorations in watercolor) set an important standard for comparisons against the *Obeah* series produced some 30 years later.

In 1973, shortly after a major showing of his work at the Museum of Modern Art in New York,[3] Romare Bearden and his wife, Nanette, made a second home in the Caribbean. It was at this moment in his career—while dividing his time between a studio/living loft in New York's Chinatown and a hilltop cottage in L'Embouchure, Quartier d'Orléans, on the Caribbean island of St. Martin—that Bearden began to create the watercolors in his *Obeah* series. With these works, Bearden departed from his iconic cityscapes and returned to his roots in painting to address the figure of the Caribbean Obeah woman; a transition that marked a significant stylistic and, perhaps, philosophical change for the artist.

Far from the clamor of New York, Bearden relished his time on St. Martin and immersed himself in the culture and tempo of island life. Little has been published in detail regarding the artist's time in the Caribbean.[4] It is uncertain whether the vibrant subjects of Bearden's watercolors were derived from the artist's personal experience with religious ritual on the island or were, in fact, the conjurings of Bearden's own vivid imagination. "Subject matter," wrote Bearden, "is of no importance, except, of course, when it means a great deal to an artist who can transform it into something personal. . . . What an artist brings to the subject . . . is equally important, forming a synthesis out of many years in art and several cultures."[5] With this in mind, Bearden's dealings with the Obeah in his watercolors find deeper resonance when divorced from the idea of individualized representations and, instead, are digested as a historical stream of consciousness from which viewers may absorb what they wish. For Bearden, the truth of his work was derived from the method of its creation and the broader essence of its sentiment, rather than its placement in the linearity of his own lived experience.

Regardless of the legitimacy of Bearden's exposure to Obeah magic, he was well aware of both its presence in St. Martin and its

place in the lexicon of Afro-Caribbean cultural history. Widely refer-
enced throughout the region, the practice of Obeah encompasses the
use of herbal remedies, spiritual possession, and divination through
trance for purposes ranging from the healing of physical illnesses
to solving (or intensifying) disputes among people.[6] The practitioner
of this magic is both feared and revered in Caribbean communities
and, as such, provides an outlet for both comfort and retribution.

The predominance of the Obeah in female form suggests her the-
matic evolution from the well-known historical figure of Maroon
Nanny, a member of the rebel group known as the Jamaican Wood-
ward Maroons.[7] Although tales of Nanny have become the stuff of
legend, she is remembered today as a small, wiry woman who uni-
fied and empowered Jamaica's enslaved peoples in times of crisis,
leading them in battle against the British in 1738. Her power to
lead and inspire an unruly group of rebels was attributed in great
part to the influence of Obeah magic. A British officer sent to sub-
due the uprising described Nanny in the following manner: "The old
Hagg . . . had a girdle round her waste, with . . . nine or ten differ-
ent knives hanging in sheaths to it, many of which [I doubt not] had
been plunged into human flesh and blood."[8] Despite her fierceness,
Nanny's Obeah magic is often balanced in folk literature by an in-
nate maternity. Like the mother whom, without contradiction, both
comforts and punishes her children, the Obeah woman is at once
nurturing and terrifying, a duality that captivated Romare Bearden
during his time in St. Martin.

The Caribbean Obeah woman was not alone in her influence over
Bearden, despite her predominance within the artist's repertoire
during the early to mid-1980s. Two additional female figures of con-
siderable importance preceded the Obeah woman: the seemingly om-
nipresent conjur woman, and Maudell Sleet, a mythic gardener from
Mecklenburg County, North Carolina.[9] Like the Caribbean Obeah
woman, the southern conjur woman is closely tied to the cultural
mythology of her birthplace. In southern and rural African Amer-
ican communities the conjur woman, though greatly feared, was
called on to "prepare love potions; to provide herbs to cure various
illnesses; and to be consulted regarding vexing personal and fam-
ily problems."[10] Works like *Illusionist at 4 P.M.* (1967) speak to this
sense of trepidation and transformation. Here Bearden employs im-
ages of African masks to form the faces of his conjur women, playing
upon notions of secrecy, mysticism, and ties to African culture and
spirituality. While Bearden's conjur women are shrouded in mystery,

Obeah in a Trance, ca. 1984. Watercolor on paper, 30 × 22 in. Courtesy of
the Romare Bearden Foundation & Estate of Nanette Bearden. Copyright
Romare Bearden Foundation/Licensed by VAGA.

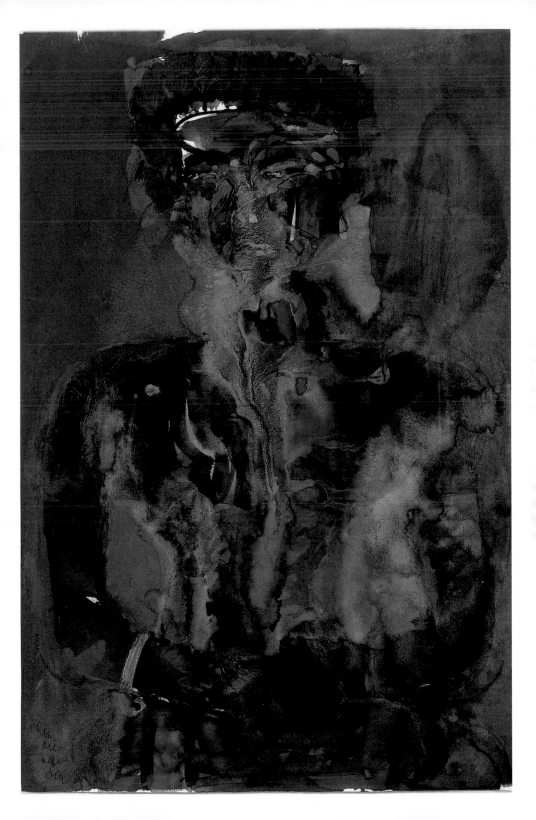

his Maudell Sleet is a spiritual, comforting, and matriarchal visage not explicitly supernatural. What Maudell Sleet lacks in raw, primal power is compensated for by her down-home southern warmth and vernacular, homegrown mysticism. Bearden's fascination with these women resides in their fusion of divine and commonplace attributes within the African American experience.

In the context of the major female figures that preceded her, Bearden's fascination with the Obeah woman comes as little surprise. "The Obeah," Bearden wrote, "is part of magic, while Mecklenburg is a recall of things that were most often pleasant to me. They both deal with myth and ritual which, however different in their particulars, are universal to human experience."[11] This statement should not be interpreted as defining Bearden's Obeah figure as simply a permutation of his other iconic female subjects in art, however. Although the *Obeah* series coincides with the matriarchal, ritualistic themes of his past work, the Obeah woman is distinguished from the conjur woman and Maudell Sleet by her depiction via watercolor. The *Obeah* series reveals none of the deliberate compositions and angular forms of Bearden's previous collages. Instead the Obeah woman is fluid and transient—a reflection of the artist's life on the island of St. Martin. Bearden's shift from the representation of the southern conjur woman to the Caribbean Obeah woman and, concurrently, from collage to watercolor, parallels the changes in his physical environment while still adhering to a vocabulary of signature subjects.

The strength of Bearden's *Obeah* series lies in the parallels between muse and medium. The flowing and bleeding of Bearden's watercolors symbolically echo the accelerating pulse of religious devotees in the throes of possession. In order to create the *Obeah* series Bearden applied his pigments directly and somewhat liberally to dampened paper and, in doing so, surrendered a measure of control over the spread of the colors. The effects of this technique are evident in works such as *Obeah in a Trance* (1984). Acid greens consume the figure of the seated Obeah woman, making it unclear whether the colors bleed from her garments or chromatically represent the onset of her trance. Though the composition is highly reminiscent of traditional portraiture (e.g., the Obeah woman sits facing forward, with shoulders squared and hands clasped in her lap), the figure's spiritual ecstasy is manifested through the dissolution of line and form and in the daring suffusion of the watercolor pigments.

Following his return from St. Martin, Bearden discussed his opin-

Obeah with Sun, ca. 1984. Watercolor on paper, 30 × 22 in. Courtesy of the Romare Bearden Foundation & Estate of Nanette Bearden. Copyright Romare Bearden Foundation/Licensed by VAGA.

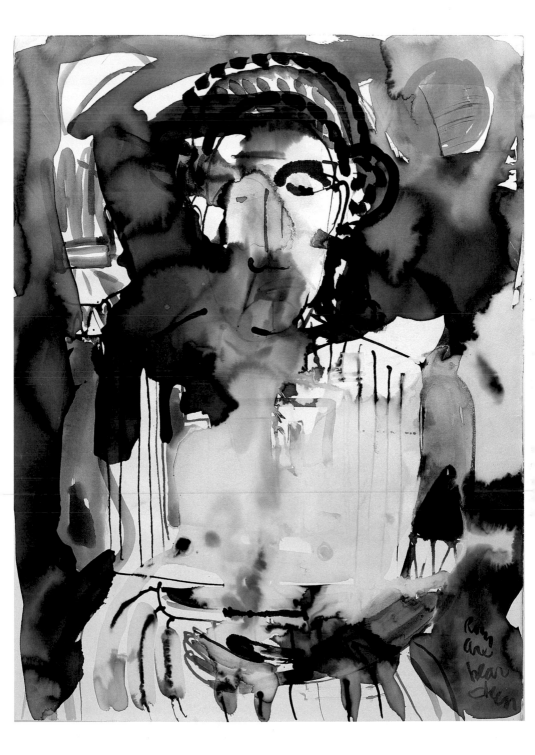

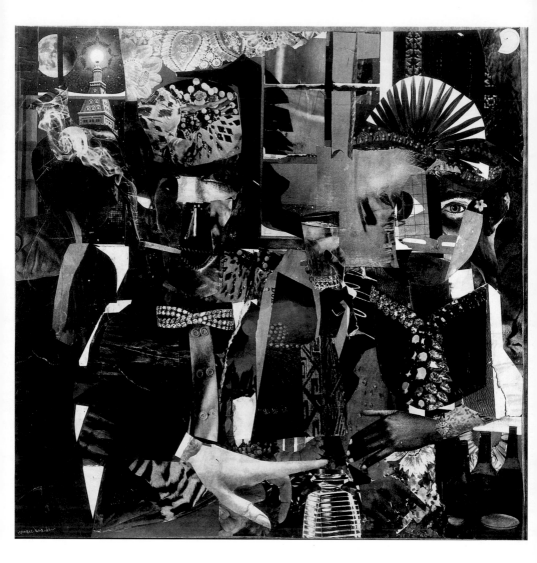

Other Mysteries, ca. 1984. Watercolor on paper, 30 ½ × 30 ½ in. Courtesy of the Romare Bearden Foundation & Estate of Nanette Bearden. Copyright Romare Bearden Foundation/Licensed by VAGA. RIGHT: *No Wish to Know More*, ca. 1984. Watercolor on paper, 30 × 22 in. Courtesy of the Romare Bearden Foundation & Estate of Nanette Bearden. Copyright Romare Bearden Foundation/Licensed by VAGA.

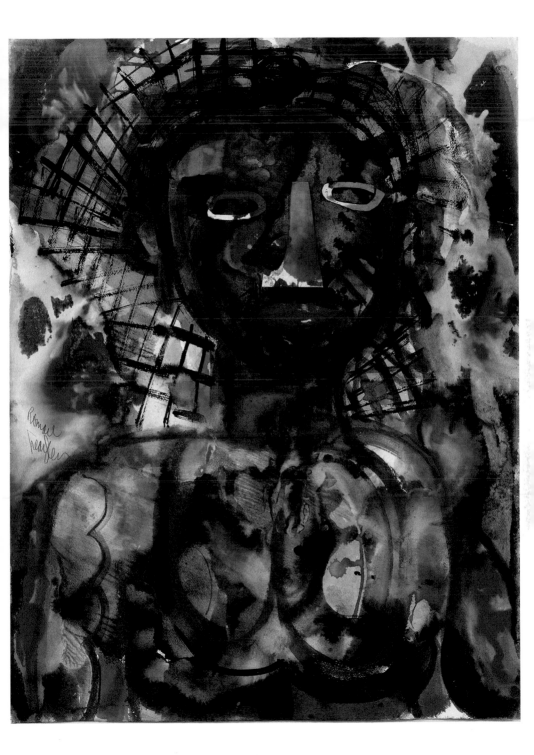

ions on spiritual possession with interviewer Myron Schwartzman. While Bearden gave Schwartzman the impression that he could never succumb to an Obeah's possession, when asked if he thought himself capable of falling into a trance, the artist responded:

> I imagine a hypnotist, or something like that, might be able to put one into me. But not a trance in this sense, where you're shaking and all. I've seen, as a little boy going to Baptist church, people be possessed, or what they would call "gettin' holy." But I never have . . . just gone outside of myself. . . . That would be rather fearful to me, to lose myself. Because you wonder if you'll get it back.[12]

Bearden's desire for control extended beyond his own body and, predictably, straight into the realm of his art. The process of collage allowed for calculated decisions regarding the formation and placement of each scrap of paper, and gave Bearden (who already had a predilection for calculated decisions) full command over his creation. While the appearance of relinquishing control in Bearden's *Obeah* series might be attributed to the fundamental nature and freedom of watercolor, one should never forget that Romare Bearden rarely, if ever, acted unconsciously as an artist. If the watercolors in his *Obeah* series seem to be the product of someone intensely connected with the ritual and soul of Caribbean folk beliefs, it is because this is precisely what Bearden wished his viewers to believe. Bearden's entry into the relatively autonomous medium of watercolor was therefore significant, not only for its symbolic parallels to states of physical and spiritual ecstasy, but also for the calculated surrender of control that it required on the artist's part.

Bearden's marked departure from the angular rhetoric of his early work in collage is perhaps most evident in this series in the virtual liquification of the Obeah woman's facial features. In *Obeah in a Trance*, the face exists only in loosely defined eye sockets with areas of lime green on an otherwise dark face, where the nose and mouth have seemingly melted away. This is a considerable evolution from earlier figurative works in collage like *Memories* (1964), in which the eye contact between subject and viewer is essential to understanding the aggression and intimidation inherent to aspects of Bearden's urban imagery. Though the Obeah woman stares out from the picture, she does not look at the viewing audience but indiscriminately gazes into space. Her ephemeral composition accents her isolation: she exists exclusively in and of herself, resists deeper

Sorcerer of High Power, ca. 1984. Watercolor on paper, 30 × 22 in. Courtesy of the Romare Bearden Foundation & Estate of Nanette Bearden. Copyright Romare Bearden Foundation/Licensed by VAGA.

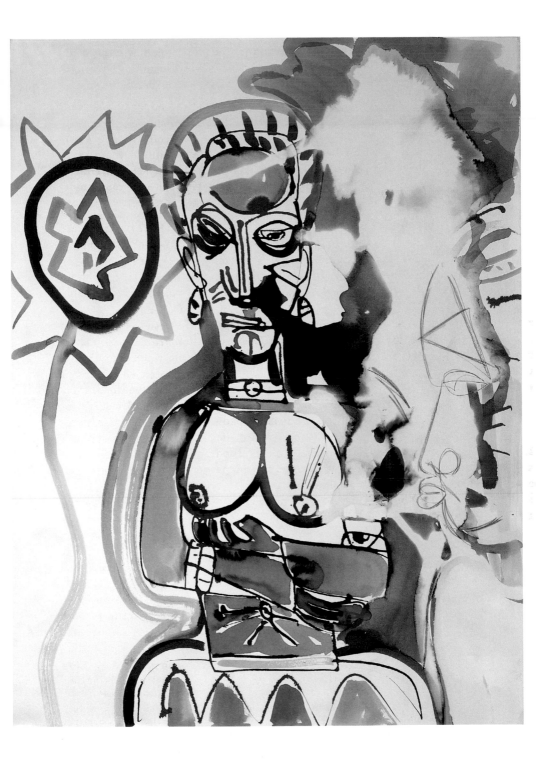

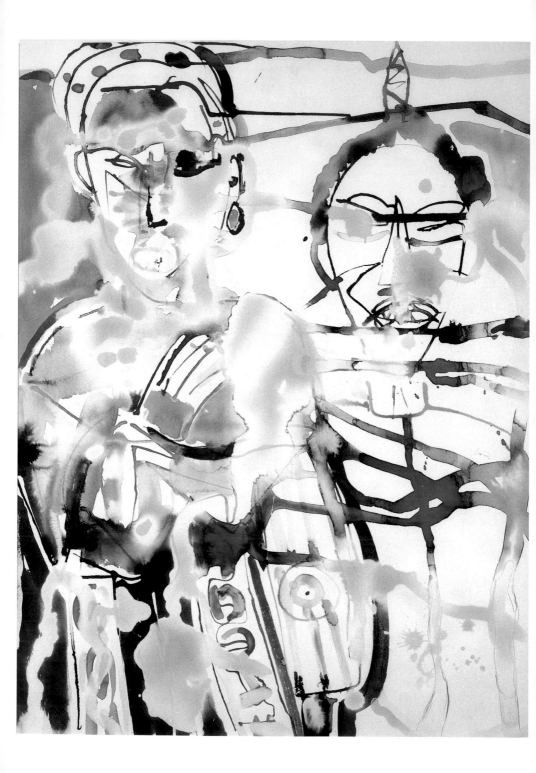

Two Women in a Harlem Courtyard, 1964. Photomontage, 41 ⅜ × 30 ¹⁄₁₆ in. Courtesy of the Romare Bearden Foundation & Estate of Nanette Bearden. Copyright Romare Bearden Foundation/Licensed by VAGA. OPPOSITE: *Two Priestesses*, ca. 1984. Watercolor on paper, 30 × 22 in. Courtesy of the Romare Bearden Foundation & Estate of Nanette Bearden. Copyright Romare Bearden Foundation/ Licensed by VAGA.

connections with viewers, and is perhaps entirely unaware of their existence. Reflecting once again the conceptual exchange between muse and medium, it is as though these watercolors that address themes of enchantment and conjure have been shaped from within by their mystic subject matter. Though the Obeah woman seethes with possession, the formal allure of her chroma actively ensnares or repels viewers independent of any direct connection between the two spheres.

In contrast, *Two Priestesses* (1984) displays none of the full-surface saturation of many of the *Obeah* watercolors. Instead Bearden employs the whiteness of the paper to further define the figures of the two Obeah priestesses. Bearden creates palpable tension in his composition by separating the colored, biomorphic forms of the women's bodies from the line that defines the boundaries of their figures, Bearden creates a palpable tension. In this way *Two Priestesses* bears striking organizational and chromatic similarities to Bearden's *Two Women in a Harlem Courtyard* (1964), while the progression from collage to watercolor illustrates the circuitous path

of Bearden's formal explorations.[13] Though Bearden's background in literature and art history grounded him firmly in classical traditions, he also had an intuitive feeling for two-dimensional form, "as a painter and thinker of the mid-twentieth century" and by "exploring abstraction by considering the formal qualities of line, color, and materials on a flat surface."[14]

Nowhere in Bearden's *Obeah* series is his palette more intoxicating than in his portrait of the Obeah woman in *No Wish to Know More* (1984). Swirling stains of cobalt define the figure's muscled torso, eventually ebbing into a sanguineous red over the Obeah woman's heart. Though the physiology of the figure's upper body appears male, the magenta lips, styled hair, and long neck lend an air of distinct femininity. This figure is by no means the comfortable, motherly Maudell Sleet of past collages. Here the Obeah spiritually churns to such an extent that rapture seems to overflow the boundaries of her form, demolishing the linearity of her body, only to be contained by the paper's edge.

The transience of the Obeah woman's body in *No Wish to Know More* is steadied by Bearden's inclusion of solid black lines, without which the entire form might be absorbed into the swirling energy of its colorful surroundings. Composed of dry, fairly rapid brush strokes, the Obeah woman's gridded halo—while deifying her in its allusions to Christian iconography—is reminiscent less of a holy light than the folksy familiarity of chicken wire or chain-link fencing. These linear inclusions recall the synthesis of structure and broad color fields apparent in Bearden's abstract paintings of the 1950s, and reinforce the notion of the coexistence of geometric structure in Bearden's sweeping watercolors and painterly stylization in his angular collages.

During his time in the Caribbean, Romare Bearden produced a significant body of work that highlights the beginnings of his artistic education while chronicling the evolution of his investigations into the female figure in sociocultural and religious contexts. Despite Bearden's successes through the medium of the collage, there was perhaps something about his time in St. Martin (or simply in his temporary exodus from the city) that inspired the distillation of his work to its purest form.

Born of the rhythm of the Caribbean and the freedom of a fluid brush stroke, Bearden's *Obeah* series arises from what Charles Childs describes as Bearden's persistent "gnawing compulsion to re-estimate what he believes to be the possibilities for a fuller maturation and extension of his art."[15] In an article for *The New York Times Magazine* in the 1980s, Bearden recounts a moment from his stay in St. Martin, writing "An obeah woman once told me she took

in the moon before dawn and held it as a locket on her breast and then threw a rooster out in the sky who spun himself in the rising sun. . . ."[16] This, in Bearden's own inherently ambiguous stream of consciousness, describes the force of the artist's *Obeah* series—an intense connection between the energy that produces myth and the energy that produces art.

NOTES

1. Romare Bearden, "Rectangular Structure in my Montage Paintings," *Leonardo* 2 (1969): 11.

2. Charles Childs, "Bearden: Identification and Identity," *Art News* 63 (October 1964): 56.

3. Entitled *Romare Bearden: The Prevalence of Ritual*.

4. Richard and Sally Price will be the first to write extensively on this subject in their forthcoming work from the University of Pennsylvania Press (French edition by Vents d'ailleurs), *Romare Bearden: The Caribbean Dimension*, to be published in spring 2006.

5. Childs, 25.

6. Loretta Collins, "We Shall All Heal: Ma Kilman, the Obeah Woman, as Mother-Healer in Derek Walcott's Omeros," *Literature and Medicine* 14.1 (1995): 146–162.

7. Though either gender may employ Obeah magic, representations of the Obeah practitioner in female form appear with greater frequency in Caribbean lore. Romare Bearden reflects this fact in his portraits of both Obeah men and women; see *Green Man* (1984) and *Obeah Man* (1984). Margarite Fernández Olmos, *Creole Religions of the Caribbean: an Introduction from Vodou and Santería to Obeah and Espiritismo* (New York: University Press, 2003).

8. Quoted by Barbara Bush, *Slave Women in Caribbean Society: 1650–1838* (Bloomington: Indiana University Press, 1990), 69.

9. Romare Bearden's birthplace.

10. Romare Bearden, "Rectangular Structure in my Montage Paintings," *Leonardo* 2 (1969): 19.

11. Ibid. 121.

12. Myron Schwartzman. "A Bearden-Murray Interplay: One Last Time," *Callaloo* 36 (Summer 1988), 410–415.

13. Bearden's *Two Women in a Harlem Courtyard* (1948) is also worthy of comparison to *Two Priestesses* (1984).

14. Matthew S. Witkovsky, "Experience vs. Theory: Romare Bearden and Abstract Expressionism," *Black American Literature Forum* 23, no. 2 (Summer 1989): 257–282.

15. Childs, 25.

16. Romare Bearden, "Treks for the Sophisticated Traveler. Magic Mountains: Clouds in the Living Room," *The New York Times Magazine,* Part 2 (October 6, 1985): 80–81.

Sometimes the mind relives things very clearly for us.... There are roads out of secret places within us along which we all must move as we go to touch others.

1967

Mecklenburg Evening, ca. 1982. Collage and paint on masonite, 11 × 14 in. Private collection. Copyright Romare Bearden Foundation/Licensed by VAGA.

Margaret Ellen Di Giulio

Memory, Mysticism, and Maudell Sleet

What is it?
I'm trying really to remember
The clock has stopped
Now I can never know
Where the edge of my world can be
If I could only enter that old calendar
That opens to an old, old July
And learn what unknowing things know . . .
—Romare Bearden[1]

I n a culture obsessed with the present, where history is kept only as a record of what has been achieved, Romare Bearden worked in the context of his memories and their constant evolution in his mind. Cultural theorist Pierre Nora wrote that the "quest for memory is the search for one's own history."[2] Societies tend to devalue memory due to its inability to accurately archive the past and its failure to focus on the future. While history is chronicled to celebrate past achievements and prepare for the future, memory is more often associated with notions of loss, of forgetting where the car keys are, or what is needed from the grocery store. Romare Bearden's art works against this paradigm by employing memory and tradition as his subjects. In other words, the images that evolved in Bearden's mind are privileged over the actual, historical entities from which they were originally derived.

The art of Romare Bearden is inextricably linked to the artist's own memories. Paradigmatic of this *l'art de memoire* is *Summer (Maudell Sleet's July Garden)* (1985). Memory, a fluid and ever-evolving process (as theorized by philosophers Henri Bergson and Pierre Nora), becomes palpable within this "image" of Maudell Sleet, a woman from Mecklenburg county recalled in many of Bearden's collages. While neither the curve of her hip nor the glimmer in her eye is pictured, her strength and mythic aura permeate this col-

Maudell Sleet, ca. 1980. Watercolor and collage on paper, 40 ¼ × 31 ⅝ in. Lent by Evelyn Boulware and Russell Goings. Copyright Romare Bearden Foundation/Licensed by VAGA.

painterly techniques of watercolor onto h's collaged surfaces, allowing the colors to bleed into one another. ... treated his artworks with bleach to both remove and modulate the ... creating sharp, visual counterpoints b... ween erasure and chro... ndance. He had finally come to an art-making process that ... ular in its fusion of collage and painting, creating works tha... ...ed photographic realism with the abstraction of the brush. ... nterview with Myron Schwartzman, Romare Bearden confid... he "had a little book, and [said to himself], 'Whatever I drea... I can remember it, I think I'll draw it.'"[5] One of these memorie... s realized in *Summer (Maudell Sleet's July Garden)*. It is a dream... ...orld, fusing his memories of Mecklenburg with images of the C... n, and his encounters with Maudell Sleet with the mysticisı Obeah woman.

Strength and beauty proliferate in Bearden's images of ... women. Ruth Fine identified the subject of black women as one ... Bearden was intimately devoted to throughout his career.

> Nude, muse, lover, mother, grandmother, sister, protector,
> friend, healer—her persona varies. She is at the center of home
> and family; in verdant gardens; quietly bathing in tropical
> pools . . . awaiting clients in brothel parlors; on stage in New
> York's jazz clubs; dancing in Mecklenburg County; as conjure
> woman and Obeah woman; and in numerous literary guises.[6]

She appears toiling in the sun, apron tied neatly across her waist, wearing a straw hat, and answering to the name of Maudell Sleet; a woman who was a permanent fixture in Bearden's art and imagination.

In *Maudell Sleet* (1980) Bearden presents an iconographic image of this prototypical woman. She stands in her garden facing the viewer, tools in hand, with a steadfast gaze focused beyond the realm of the picture. Her presence is one of strength as well as softness; she is not menacing or threatening like many of Bearden's depictions of conjur women, and yet she possesses a sense of power with her wide-eyed expression and sinewy limbs, one hand firmly clutching a garden hoe and the other hanging energetically by her side. The size of her hands suggests her manual dexterity and the command she wields in the garden. Her figure dominates both the landscape and the composition. The moon is linearly aligned with her face and its luminosity offsets her dark, dreamy visage.

This image of Maudell Sleet exudes enchantment, much like the conjur and Obeah women that occupy many of Bearden's collages. According to the artist, "Mrs. Sleet . . . would be appalled at the Obeah people: they don't go to church, and have all this mys-

ticism. . . . Mecklenburg has nothing to do with magic or enchant-
ment."[7] And yet her figure is tangential to the moon and saturated
with color and strength; she *is* mystical. She confronts the viewer
in a manner comparable to that of Bearden's *Conjur Woman* (1975),
shown in the same frontal pose with wide eyes and large hands.[8]
The distinguishing features of these two pieces are the women's
dresses and the environments in which they are placed. While Sleet
is visually anchored by the horizon and the moon (an environment
that viewers can, figuratively speaking, step into), the conjur woman
is surrounded by impenetrable trees, leaves, flowers, and junglelike
vines, as well as foreboding birds and snakes. The conjur woman
and Maudell Sleet are each placed in an environment that is her
own, and it is this singular environment that separates them from
each other. Their figures, expressions, stances, and physical pres-
ences create feelings of mystery and authority for both women.

Philosopher Henri Bergson wrote that "little by little [a memory]
comes into view like a condensing cloud; from the virtual state it
passes into the actual; and as its outlines become more distinct and
its surface takes on colour, it tends to imitate perception. But it re-
mains attached to the past by its deepest roots."[9] A memory can be
a moment, a place, a person, a smell, an emotion; it can be pain or
pleasure. As Pierre Nora writes, "it takes root in the concrete, in
spaces, gestures, images, and objects . . . memory is absolute."[10] Un-
like history, which chronicles events and the sequential aspects of
life, memory "remains in permanent evolution, open to the dialectic
of remembering and forgetting, unconscious of its successive defor-
mations, vulnerable to manipulation and appropriation, susceptible
to being long dormant and periodically revived."[11]

Bearden's mind conjured memories from his past and he allowed
these images to be altered as a consequence of remembering and for-
getting. Initially Bearden did not see any relationship between the
conjur women and Maudell Sleet, and yet these two image types pos-
sess striking similarities. According to Bergson this is because they
are both subject to Bearden's unconscious. At some point Maudell
Sleet transcended Bearden's described memory and previous defini-
tion of her, and she became more closely aligned in his mind's eye
with the potentiality and mystery originally reserved for his conjur
and Obeah women.

Working in the constantly changing, novelty-obsessed realm of
New York City, Bearden grappled with the images in his mind and
the memories that lived and evolved over time. Bearden once said,
"Sometimes the mind relives things very clearly for us. Often you
have no choice in dealing with this kind of sensation, things are just
there. . . . There are roads out of secret places within us along which

we all must move as we go to touch others."[13] ... bes memory in transient terms; the comings and goings of ... h the filter of the mind. Instead of focusing on palpable thi... ...den allows his work to reflect the images from within.

After his return from the Caribbean and the completion of his *Obeah* series, Bearden returned to Maudell Sleet and her lush garden. The image of a woman in the natural setting of a garden or Caribbean rain forest was one that Bearden had created in collages throughout his career. In 1985 Bearden replaced the figure of Maudell Sleet with nature's riches in *Summer (Maudell Sleet's July Garden),* allowing the landscape to emanate the same visual beauty and arcane attributes formerly reserved for her figure. Though her image is lost here, her presence remains.

Apart from the absence of Maudell Sleet, the most striking aspect of this collage-painting is the juxtaposition of tightly collaged photographic images of flowers, leaves, ferns, and branches, with areas of pure color organically formed by the addition of bleach to the collaged and painted surface. It is like looking into a dream; parts are so clear they could be touched, while others are completely void of imagery. The entire composition is filled with colors that collide and mingle with one another. Bright blues and greens are highlighted by radiant pink flowers, red butterflies, and a single, stark-white bird which breaks up the brilliant colors with its purity. A diagonal line, formed by the sharp edge of a cutout, breaks the fluidity of the piece and recalls Bearden's blade-and-scissor-produced collages of the 1960s and 1970s. In other parts of the picture these lines are softened by the use of watercolor and scratching on the picture's surface. This is not the garden of *Maudell Sleet* (1980); this is the jungle of vines and colors that surrounded Bearden's representations of the conjur woman. By eliminating her figure and filling the entire composition with the vibrancy of a tropical rainforest, Bearden has placed Maudell Sleet in the same energetic and enigmatic surroundings in which he first realized his earlier images of conjur woman.

With his words Bearden imposed a spiritual austerity on Mecklenburg County and Maudell Sleet. But these words are incongruous with the visual evidence in *Summer (Maudell Sleet's July Garden).* His words were spoken at a time when Maudell Sleet impressed Bearden with her nurtured and well-ordered gardens. Yet Sleet was obviously more to him than the average gardener—he consistently returns to her evocative image and garden as representative of his past. By 1985 her garden had completely subsumed her figure: her essence permeated the colorful flowers and foliage and had taken on an entirely new identity.

Pierre Nora claims that the need to remember and refine our

memories comes from a fear of "a rapid and final disappearance [of memory that] combines with anxiety about the meaning of the present and uncertainty about the future to give the most humble testimony, the most modest vestige, the potential dignity of the memorable."[13] Perhaps Bearden continually returned to Maudell Sleet because he was never satisfied with his ability to portray who she really was and what she meant to him. In *Summer (Maudell Sleet's July Garden)* he created the garden of Maudell Sleet that bloomed inside his mind, not in Mecklenburg County. By freeing himself of the restraints of the physical person, he allowed Maudell Sleet to be consumed by nature and defined by the plants and vegetation worked by her own hands. Suddenly her Mecklenburg County garden is transformed into the untamed, feral surroundings of the conjur woman. The garden through which Maudell Sleet percolates is a dense rainforest, but it also becomes the bright blues and pinks that complement his jazz singers, and it is the dream-world of his *Obeah* watercolors. Through the constant transformations and manipulations of Bearden's memories, Maudell Sleet has evolved into a figure that encompasses the magic, mystery, and power that he had previously reserved for his other female muses.

Was Maudell Sleet a real person? Bearden conveys as much, but the truth is perhaps inconsequential. Her image was a memory that developed throughout the artist's lifetime. Who she was does not matter as much as who she *became* through his collages.

In *Maudell Sleet* (1980) her figure dominates the composition and she is defined by the strength that is visible in her physical presence; her horticultural creation is secondary to her searing eyes and powerful hands. In *Summer (Maudell Sleet's July Garden)* the beauty is found within Bearden's treatment of the collage-painting's surface; in the delicate flowers and vines and their vivid colors. This image is pure metamorphosis; she loses the straw-hat-wearing-grandmother form and gains the metaphysical qualities and vibrancy of the Obeah woman. Her physical absence from the picture signals her singularity and spiritual presence in Bearden's mind. In very few collages by Bearden is a human figure named and not physically portrayed.[14] But the care with which he treats the surface and the applications of color and design in Maudell Sleet's 1985 garden is comparable to the care with which he treated all female figures in his work.

Amid the foliage and bright colors, Maudell Sleet takes on the evocative roles of Bearden's decidedly mystical women. Her garden thrives as she tends to it with ritualistic devotion, untamed and wild like the backdrops for his conjur women; filled with the rhythms and vibrations of the blues singers in his jazz clubs; chromatically merging and blending into itself like his *Obeah* watercolors; signal-

ing the beauty, cryptic aura, and omnipresence of the women in Romare Bearden's life and art. In 1985 Bearden triumphs in *Summer (Maudell Sleet's July Garden)* through an acquiescence to the evasive and manipulable quality of memory. He surrenders his categorizations and clear definitions and allows the personalities of his women to bleed into one another. Memory finds its redemption within recollections just as Maudell Sleet's salvation lies within the lush garden of Romare Bearden's mind. Through the saturated flowers and snaking vines, Maudell Sleet becomes emblematic, possessing that same figural expressiveness and cultural agency exuded by all of Bearden's women.

NOTES

1. Romare Bearden, as quoted in Gail Gelburd and Thelma Golden, *Romare Bearden in Black-and-White: Photomontage Projections, 1964* (New York: Whimsical Wades, 1997), 63.

2. Pierre Nora, "Between Memory and History: Les Lieux de Mémoire" in *History and Memory in African Culture*, eds. Genevieve Fabre and Robert O'Meally (New York: Oxford University Press, 1994), 289.

3. For biographical information on Romare Bearden, see: Ruth Fine, *The Art of Romare Bearden* (Washington, D.C.: National Gallery of Art, 2003).

4. Amiri Baraka, "Henry Dumas: Afro-Surreal Expressionist," *Black American Literature Forum* 22 (Summer 1988): 165.

5. Myron Schwartzman, "Conversation: The Prevalence of Ritual," in *Romare Bearden: His Life and Art* (New York: Harry N. Abrams, Inc., 1990), 254.

6. Fine, 92.

7. Schwartzman, 244–248.

8. See Romare Bearden's *Conjur Woman* (1975), Allen Memorial Museum, Oberlin College, Oberlin, Ohio.

9. Henri Bergson, *Matter and Memory*. Trans. Paul and Palmer (London: George Allen and Unwin Ltd., 1911), 171.

10. Nora, 285–286.

11. Nora, 285.

12. Romare Bearden, *Six Panels on a Southern Theme* (Waitsfield, Vermont: Bundy Art Gallery, 1967), np.

13. Nora, 290.

14. Notably, Bearden also disembodies a titular subject in his collage *Farewell, Eugene* (1978). Collection of Laura Grosch and Herb Jackson, Davidson, North Carolina.

But the more
I just played
around with
visual notions
as if I were
improvising
like a jazz
musician, the
more I realized
what I wanted
to do as a
painter, and
how I wanted
to do it.

n.d.

Victoria Trout

Romare Bearden's Urban Rhythms

Got a little rhythm, a rhythm, a rhythm
That pit-a-pats through my brain;
So darn persistent,
The day isn't distant
When it'll drive me insane . . .
Comes in the morning
Without any warning,
And hangs around me all day . . .
—George and Ira Gershwin, "Fascinating Rhythm"[1]

onjuring Bearden represents an attempt to marry the concepts of Romare Bearden's work with his creative essence, bringing these two, relatively distinct spheres into one, unified exhibition. Part of *Conjuring Bearden* presents the artist's conjur woman–related collages and watercolors, with a particular focus on the frequently explored theme of folk mysticism. The other part of this exhibition extends this same idea to the representational enterprise of imagining Romare Bearden *himself,* as an artist and personality. Works of art, Bearden's own words, and photographic images are all used here to "conjure" for viewers what his life and work represent. This process of an exhibition-based portrayal is especially valid in that Bearden consistently used life experiences and personal memories as both the starting point and *raison d'etre* for much of his work. Because these artistic acts of memory were paramount for Bearden (as well as essential for audiences to grasp in order to enter the heart and soul of his art), this essay focuses on one, key component of that life—Bearden's experiences in New York City and the rich culture that surrounded him there—as a potential channel for *Conjuring Bearden.*

Romare Bearden delved deeply into his past to create works of art that were both universal and particular. Chief among these memories were Bearden's formative years in Harlem, the place that be-

OVERLEAF: Sam Shaw, *Romare Bearden, Harlem, New York*, 1952. Photograph. Courtesy of the Romare Bearden Foundation. Copyright Sam Shaw.

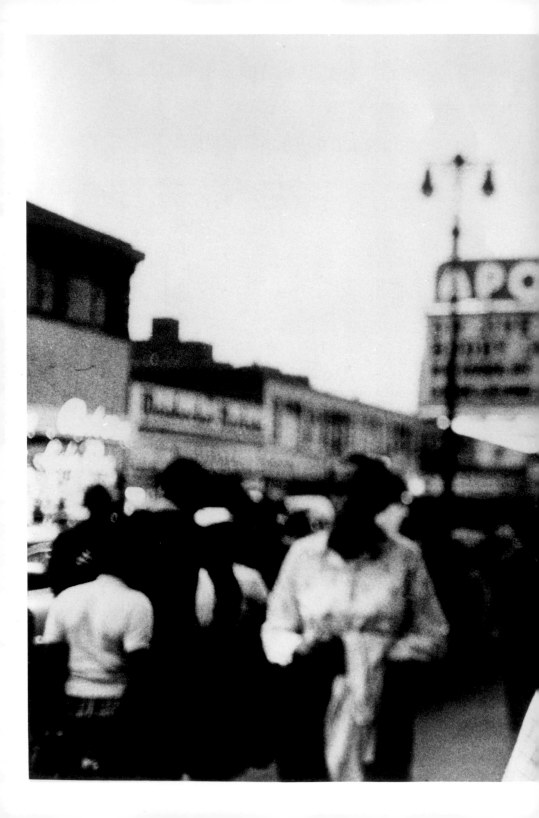

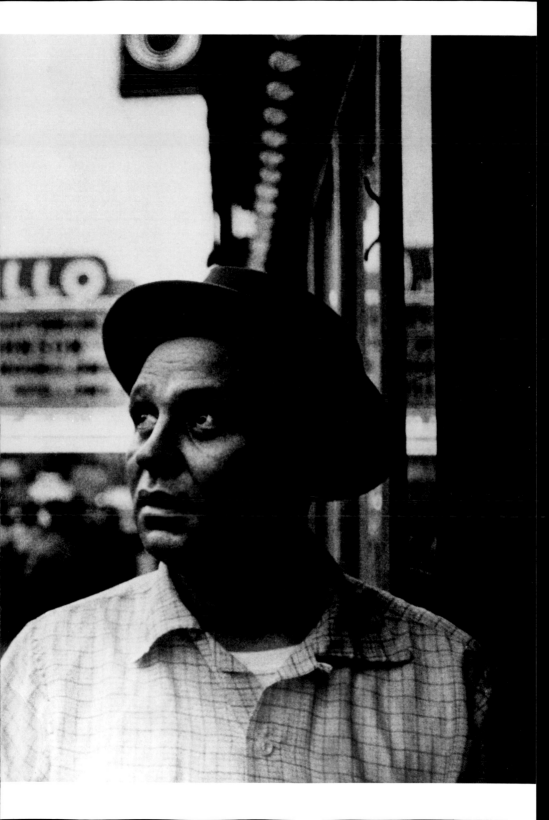

came ingrained in his consciousness and where he developed into an individual member of a thriving and creative community. In his depictions of Harlem, he described the urban aspects of the black experience and the realities of his own particular state of being. An analysis of Bearden's urban experience is crucial to an overall understanding of Bearden's art, as the themes and feelings prevalent in his city scenes are echoed throughout his work. The urban experience of Romare Bearden helped shape him into the robust spirit and personality that the world acknowledges today, and forms a part of what one visually and emotionally encounters through his work.[2]

"When I came to New York," remarked Bearden about his family's arrival there in the 1920s, "everybody was coming to Harlem from some place: first from the South, then from the West Indies, and later from every place."[3] As the twentieth century locus for modern black culture, Harlem provided Bearden with artistic references and connections to all types of people from different places and backgrounds. Bearden's most valuable learning experience in Harlem came from his association with a group of artists who assembled at 306 West 141st Street (at the time popularly referred to as "the Studio" or "306"). It was there that Bearden encountered such artistic talents as composer Duke Ellington, novelist Ralph Ellison, and fellow painters Charles Alston and Jacob Lawrence. Beyond the confines of 306, a larger movement was also taking place in that community. Traditionally referred to as the "Harlem Renaissance," this social movement represented a rebirth of African American culture in which the arts helped many blacks to reformulate their identities in a world historically dictated by the cultural ideals of a white-dominated society. While Bearden was more or less removed from the specific objectives and concerns of the Harlem Renaissance proper, his location in that community placed him at the core of a black cultural movement that would have future repercussions for him and his art.

Through 306 and other Harlem organizations, Romare Bearden became a visible presence in the community where he lived and worked. A 1952 photographic portrait of Bearden by Sam Shaw, taken on the streets of Harlem with a view of the Apollo Theater in the background, underscores his close and complex ties to that community and can be seen as both a visual document and symbolic depiction of Bearden's urban life.[4] The photograph depicts Bearden gazing upward with large, open eyes. The whites of his eyes stand out from the shadows cast upon his face, emphasizing an expression that portrays him as somewhat wary or daunted by his surroundings. Light shines directly onto his face, highlighting him as the key figure in this scene. The other details of this cityscape—people walk-

ing, storefronts, and signs—are all out of focus, which draws even more attention to Bearden's figure. Compositionally, the diagonal line drawn from the perspectival views of the Harlem cityscape creates a link between Bearden's face and the only other distinguishable feature of the photograph: the large sign in front of the Apollo Theater. This Harlem landmark is further accentuated because it appears in the center of the photograph. Bearden's figure has been relegated to the extreme bottom right, perhaps unconsciously suggesting that, while in focus and more prominent in relation to the other pictorial elements, he is somehow removed from and on the periphery of the city that surrounds him.

While Bearden's figure in this photograph stands independent from the blurred community in the background, in autobiographical terms his personality and artistic development were inextricably linked to the influences of Harlem. The photograph portrays Bearden as a member of the community, his body intersecting both the large sign for the Apollo Theater and the bodies of the people around him. However, this image offers a rather ambivalent view of Bearden's attitudes about, and interactions with that community.

While Harlem represented an invaluable wealth of culture and was universally recognized as a community rich in the arts, it is important to acknowledge Harlem's harsher side and how that tough urban reality manifested itself for many. Just as New York City was an oasis of artistic expression and influence for Bearden, the city also represented a formidable obstacle for him in his efforts to overcome its many pitfalls and disappointments. This photograph suggests that Bearden was at times isolated and set apart from the city. While the crowds continue to move purposefully around him, Bearden stands still, as if he is not sure of his own sense of direction or purpose in life. His face is turned upward and his wide eyes stare off into the distance. His mouth forms a small frown, and his wrinkled brow provides the final details that allude to a momentary sense of trepidation in the city.[5] In a sense, this photograph insinuates that Bearden has been overwhelmed and swallowed up by Harlem.

The adverse side of the Harlem experience that Shaw's photograph alludes to, intentionally or not, is captured perfectly by the main protagonist of "Sonny's Blues," a short story by James Baldwin. Told through the eyes of Sonny's older brother, the story recounts the struggles of a young musician trying to fight for his art and identity in the city. After growing up surrounded by the dangers of a rough and violent neighborhood, Sonny eventually turns to jazz and the solace of heroin to escape his troubled existence. Sonny views Harlem as terrible; a place where "you walk these streets, black and

funky and cold, and there's not really a living ass to talk to. . . . and there's no way of getting it out—that storm inside."[6] Sonny uses his musical talents to understand Harlem on his own terms: the conditions of a tormented soul attempting to find meaning in a bleak situation. One might extrapolate that Baldwin's fictional portrait of Sonny and Shaw's photographic portrait of Bearden are both images of people who are disturbed by the realities that surround them. As a result, they desperately use their respective art forms to make sense of their situations, to find their respective places in the city, and to discover life's real purpose. Bearden's photographic portrait embodies the idea that the city is both a blessing and a curse for someone trying to make it as an artist. As Sonny declares, "All that hatred down there . . . all that hatred and misery and love. It's a wonder it doesn't blow the avenue apart."[7]

Beyond the multiple perspectives of what city life offers, this photograph also illustrates the constant flux and rapid movement of city life. Although each inhabitant has his or her own pace and path, all of the figures merge to create one grand setting: the whirl of the quotidian urban experience. This discordant picture of city life resonates with one of the most popular cultural outlets for the Harlem community at that time: jazz.

Bearden was conscious of the parallels between his own creative workings and comparable expressions found in jazz music. As Albert Murray states, Bearden was keenly aware "of the relationship of his procedures to those of Jazz musicianship . . . of hitting upon and playing around with details of both color and form as if with visual riff phrases."[8] Bearden recognized the intersection of his art with the jazz sensibility as being paradigmatic of a larger, black cultural enterprise in the twentieth century. Bearden acknowledged the parallels between jazz and the visual arts by blending the techniques of painting and collage. In describing the manner in which he created these combination artworks, Bearden explained that he imposed "a kind of spacing in [his] paintings by listening to the music of Earl Hines[9] . . . I always think of a work as making a melody. . . . so there is variety, or there are people moving along."[10] In this statement, Bearden describes the harmonies and rhythms of jazz as comparable and structurally related to the rhythms of his own art.

According to Murray, jazz is the process of "working up" arrangements, or reconceptualizing blues-based compositions by "playing around with chords, phrases, trial runs and potential riff patterns" on various musical instruments.[11] Jazz is a musical form that represents the combination of numerous layers of notes and rhythms to produce one larger work of art. It is this complexity that attracts the listener and allows for so many interpretations of the music; each

time one hears a jazz composition, a new stratum of harmony and meaning becomes apparent. Sometimes a listener can get lost in the musical intricacies of any given jazz composition, much in the same way someone might get lost in the details, events, and relationships of one's own life. Just as the individual rhythms and musical notes of a jazz composition are often formed by disjointed parts that combine to form a cohesive whole, so is Bearden's work the product of many individual shapes, colors, and materials coalescing to form a larger picture and idea.

Beyond the conceptual similarities, the most obvious links between Bearden and his appreciation for the jazz sensibility can be found in his many depictions of jazz scenes and figures. In his piece *Time for the Bass* (1979) Bearden depicts the lone figure of a jazz musician with his bass, set against a myriad of colors and shapes.[12] The man is dressed in a black suit, and this same black color and material is used to depict the hands and face of the figure as well. The whiteness of the man's shirt and his brightly-colored tie stand in stark contrast to the ascetic darkness of the man's figure. His head is bent down, concentrating deeply on the movement of his hands along the neck and on the strings of his bass. The instrument intersects at many points with the figure of the man, establishing a literal connection between the musician and his instrument. The bass appears as large and overwhelming in size as the man himself, creating the visual suggestion that the two are equal in their relative importance to the artwork and the music being created. The majority of the bass is in deep shades of brown; however, splotches of watercolor interrupt the monochromatic shadings and drift mystically over the instrument. These whimsical spots of paint breathe life into the bass, giving the instrument the appearance of an object seized by magic. Perhaps this magic comes from the music itself; the watercolor successfully alluding here to the conjuring power that the bass possesses. The bassist and his instrument effectively cast a spell over the audience, using rhythm and melody instead of the magician's words and the conjurer's chants.

The background in *Time for the Bass* is composed of a myriad of colors, shapes, lines, and intersecting patterns. The sheer variety of the setting and the bright colors give the piece an overall feeling of movement and energy. It is as if the explosion of colors around the bassist is evocative of the volatile music ostensibly being played. The colors themselves correspond to different emotions and, by extension, musical notes. The reds and yellows convey a sense of fast movement and high volume, corresponding to the more upbeat harmonies in the music being performed. The blues and greens provide emotional and musical counterparts to these bright colors, slowing down the

Time for the Bass, 1979. Collage on board, 9 × 6 in. Courtesy of the Grant Hill Collection of African American Art. Copyright Romare Bearden Foundation/ Licensed by VAGA.

rhythms as they connote softer, more low-key melodies. The lines and shapes superimposed on these colors echo the stronger, more definitive notes being played within this pictorial and musical narrative. Each line seems to jump out at the viewer, with its own shape and intent, just as certain notes and chords stand apart within jazz compositions, each with its own special effects. The shorter, more angular lines are the visual equivalents to staccato beats, while the longer, more fluid and circular lines visually represent more sonorous chords and tonalities.

This work of art provides a two-dimensional, collaged parallel to the jazz sensibility. Through his use of a multiconstituent, mixed-media technique, Bearden combines disparate pieces of paper and fabric to create a larger, conceptually cohesive visual statement. Each piece of paper and fabric has been cut and placed strategically on the board to produce, in this particular instance, the depiction of a musician playing his instrument. Bearden's selected art materials and shapes are like the individual notes and inherent rhythms that are present in a jazz composition. Bearden's method for creating his collages is much like the methods and processes for creating jazz, as both transform disparate or discordant elements by merging them into aesthetically unified works of art. It is this variety of materials, colors, shapes, and emotional content that gives Bearden's *Time for the Bass* the same artistic intensity and rhythmic complexity that is often present in jazz. Furthermore, it is the act of creating this and other collages that makes Bearden akin to a jazz musician composing his or her own masterpiece. *Time for the Bass* effectively becomes a self-portrait of sorts; Bearden is the musician, and he uses his scissors, paint, brush, and glue to the same end that the bassist uses his instrument: to create a work of art and captivate an audience.

As evidenced in the many interviews conducted with Bearden during his lifetime, his personality is that of a showman: a creator extraordinaire who focused not only on constructing a world of art in which the validity of his Harlem-centered, African American experience could make its own logic, but on using his platform as an artist and cultural spokesperson to disseminate his resounding voice to the world at large. His immense persona would lure spectators and listeners into his world, and he would perform his one-man rendition of the life and loves of Romare Bearden. This extroverted aspect of Bearden is present as well in Shaw's photographic portrait. Bearden's head is placed directly below the sign for the Apollo Theater, the largest cultural icon for performers in Harlem, and his hat literally intersects with the bright lights of the sign. This strategic placement of Bearden underneath the Apollo's marquee subconsciously indicates Bearden's own connections to the art of per-

formance and his deep-seated desires to be a part of that glittery, public world.[13]

Romare Bearden was a product of Harlem, and the relationships he formed there with other artists, his encounters with the range of artistic and creative expressions in that community, and the rich and complex culture that surrounded him there would influence him for the remainder of his career. He used the medium of collage to create artistic worlds that were full of the movement and excitement that everyday urban life afforded him. In essence, Harlem was his greatest muse. In the many works by him that interrogated the jazz sensibility, he captured the music's essence, especially its aural intensity and cultural context. In Bearden's art, jazz became emblematic of Harlem itself, just as much as Harlem and its artists came to define the music and other expressive forms of modern art. Through his words and art, Romare Bearden evokes the spirit and structures of jazz and provides the interpretive pathways through which we can appreciate this American art form. Like a talented jazz musician, Bearden used a myriad of colors and forms that combined in unexpected ways to produce a distinctive picture of our world: a cultural sphere informed by occasionally discordant but always enriching urban rhythms.

NOTES

1. This song was composed by George and Ira Gershwin in 1924 as part of the musical "Lady Be Good." "Fascinating Rhythm" was sung by Ella Fitzgerald ca. 1947–51, and can be heard on *Ella Fitzgerald / Oh, Lady Be Good! Best of the Gershwin Songbook*, 1996, CD reissue, Polygram 29581.

2. This and all other general biographical information on Romare Bearden, unless otherwise noted, is from: Ruth Fine, *The Art of Romare Bearden* (Washington, D.C.: National Gallery of Art, 2003).

3. Romare Bearden and Charles H. Rowell, "'Inscription at The City of Brass': An Interview with Romare Bearden," *Callaloo* 20 (Summer 1988): 430.

4. A version of this photograph was originally published in: M. Bunch Washington, *Romare Bearden: The Prevalence of Ritual* (New York: The Museum of Modern Art, 1973).

5. It should be noted that around the time this photograph was taken (in the mid-1950s), Bearden experienced a major nervous breakdown. For an account of this experience, as described by Bearden, refer to Barbaralee Diamonstein's interview with Bearden on *Inside New York's Art World*. Videocassette, 1987.

6. James Baldwin, "Sonny's Blues" in Beverly Lawn, ed., *40 Short Stories: A Portable Anthology* (Boston: Bedford/St. Martin's, 2001), 365.

7. Baldwin, 367.

8. Albert Murray, "Bearden Plays Bearden: The Visual Equivalent of Blues Composition," in *Romare Bearden: Finding the Rhythm* (Norman, Oklahoma: Museum of Art, The University of Oklahoma, 1991), 2.

9. Earl "Fatha" Hines (1905–1983) was an American jazz pianist whose style is generally characterized as incorporating "intricate rhythms and [the] dynamic use of octaves."

10. Bearden, 431.

Conjuring Bearden

11. Murray, 1.

12. This piece is currently on display as part of the spring 2006 Nasher Museum of Art at Duke University exhibition *Something All Our Own: The Grant Hill Collection of African American Art*. This exhibition is being shown simultaneously with *Conjuring Bearden* and represents a thematic partnership with the latter exhibition.

13. In the 1950s Bearden was a modestly successful songwriter, which fuels the idea that there was a strong performing-arts dimension to Bearden's personality.

A quality of artifi-
ciality must be re-
tained in a work of
art . . . the reality
of art is not to be
confused with that
of the outer world.
Art [is] a creative
undertaking, the
primary function of
which is to add to
our existing concep-
tion of reality.

1969

Bayou Fever #17: Past, Present, Future, and Beautiful Dreams, ca. 1979. Col-
lage on masonite, 9 × 6 in. Courtesy of the Romare Bearden Foundation
& Estate of Nanette Bearden. Copyright Romare Bearden Foundation/Li-
censed by VAGA.

Christine Wang

Romare Bearden's *Bayou Fever*

Pulsating rhythms, feverish passions, and bodies moving in effortless perfection all set the stage for Romare Bearden's sojourn through the dance-theater world. In a vibrant mixture of color and collage, his panel series *Bayou Fever* is a visual storyboard intended for the stage, encompassing the mysterious qualities of both the conjur woman and Louisiana's bayou country. By embracing his own past and a hybrid, Afro-Caribbean aesthetic, Bearden produced a narrative full of mysticism and drama. *Bayou Fever*'s bold use of color, coarsely cut fabrics, and found objects all aid in summoning the conjur woman's spirit and her benevolent role as savior in the fight of good versus evil. Reflecting his own experiences and thematic interests from earlier works (including the cultural concerns of his fellow artists both during and following the Harlem Renaissance), Bearden's *Bayou Fever* is both a visual interpretation of a dramatic stage production and an intimate self-portrait of the artist.

After completing set designs for a 1977 Alvin Ailey ballet entitled *Ancestral Voices*, Romare Bearden became increasingly intrigued by dance theater: a discipline which he described as a superior art form, embracing dance, art, music, and writing.[1] It was under Ailey's influence that Romare Bearden created the *Bayou Fever* series as a proposed visual storyboard for a narrative dance production. Accompanied by a two page script including stage directions and suggestions for the types of dances to be performed, *Bayou Fever* unfolds

Bayou Fever #9: The Lizard, ca. 1979. Collage on masonite, 13 × 9 in. Courtesy of the Romare Bearden Foundation & Estate of Nanette Bearden. Copyright Romare Bearden Foundation/Licensed by VAGA. OVERLEAF: *Bayou Fever #5: Untitled (The Mother Hears the Train)*, ca. 1979. Collage on masonite, 6 × 9 in. Courtesy of the Romare Bearden Foundation & Estate of Nanette Bearden. Copyright Romare Bearden Foundation/Licensed by VAGA.

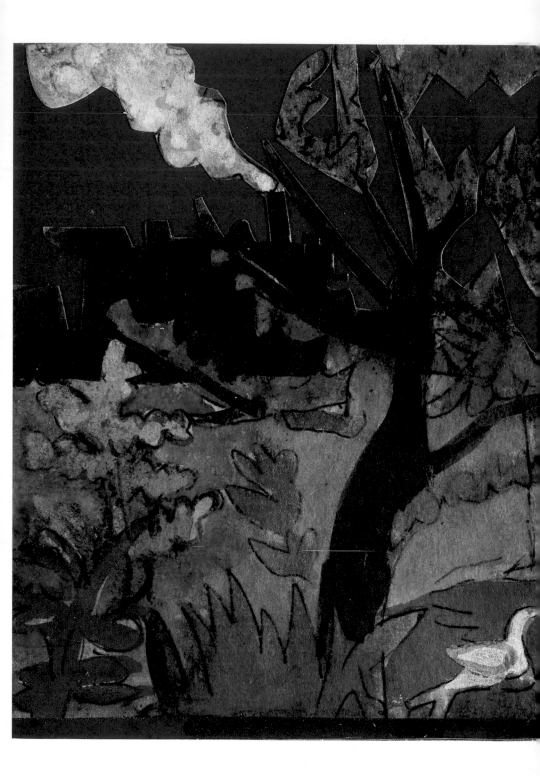

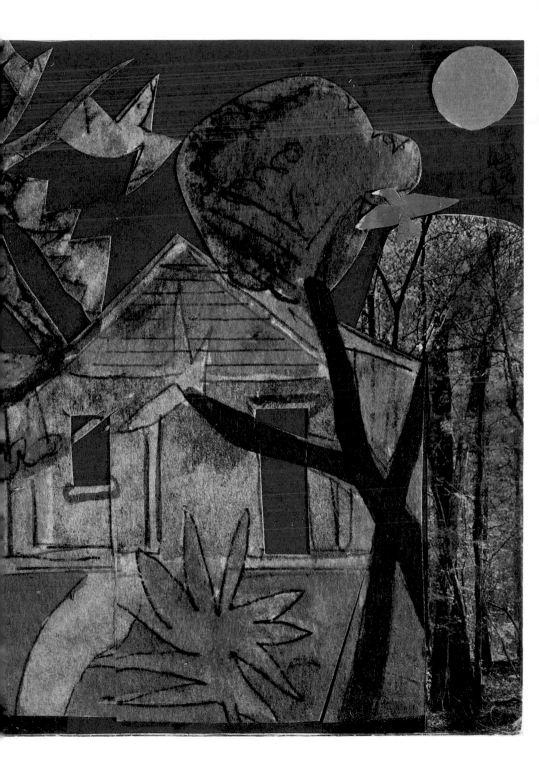

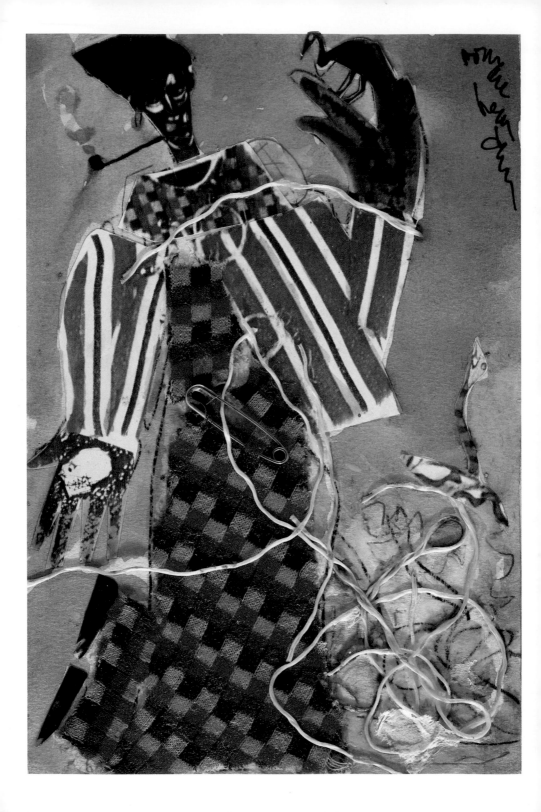

through a succession of exotic locations and colorful, unforgettable characters.

Set in the Louisiana bayou, the story begins as the Father returns home to his wife and ailing child. In accordance with Afro-Caribbean folk traditions, the Father sets out to solicit the local Herb Woman for a remedy. Suggesting a brew that required a rare magical root, the Herb Woman sends the Father on a dizzying search for ingredients within the forest. As the Father searches, terrible creatures from the bayou (such as the Swamp Witch, the Lizard, and the Hatchet Man) haunt the Mother and Child. Eventually the conjur woman appears and battles these evil demons. Following an intense struggle for power, the conjur woman emerges victorious and a Mardi Gras–like festival is held to celebrate the recovery of the Child from the "Bayou Fever."

The existence of an original document authored by Romare Bearden introduces an essential ingredient to the storyline, recounting each character's specific traits through Bearden's voice and vision of the performance. Bearden's descriptions of each character's dance style (e.g., "raucous," "squirming," or "fierce") summarized for subsequent interpreters the tone and tenor of the figures that were to appear on stage. As these descriptions define the traits that each character is to articulate, the collages serve as visual representations of each character's innate qualities.

In addition to revealing the script's sequence of events, these collages exude a raw, unpolished quality that is powerful and appealing on its own terms. Each panel is a unique concoction of materials formulating a specific narrative and ensemble of set and costume designs. For example, the figure of the conjur woman—who seems to almost leap out of her intended space on the panel—is realized by Bearden in the form of a small head, proportioned feet, and oversized, grotesque hands protruding from her robes. Scraps of striped and checkered fabrics define the contours of the conjur woman's body and set her apart from her mossy, lime green background. A safety pin in the middle of the composition symbolically holds this wild collection of scraps and loose strings together. The patchwork quality of the conjur woman not only conveys something about her folkloric background and personality, but specifically communicates which materials should be used in the creation of her costume for the stage.

The different materials and methods that Bearden used to create these collaged figures provide subtle clues to their stage perso-

Bayou Fever #12: Untitled (The Conjur Woman), ca. 1979. Collage on masonite, 9 × 6 in. Courtesy of the Romare Bearden Foundation & Estate of Nanette Bearden. Copyright Romare Bearden Foundation/Licensed by VAGA.

nas. For example, the conjur woman's face is painted and, in a sense, naturalized in the broader context of this dance-theater production. In contrast, Bearden gives the demonic Swamp Witch a face cut from a photograph of an African mask. Bearden's primary role as the creator of *Bayou Fever* naturally places the production's visual elements over and above its dance aspects. In this way, set and costume designs take on a larger role in *Bayou Fever* as compared to a choreographer's emphasis on dance and movement.

Even in this newly envisioned medium, Bearden is capable of recreating the same images and themes that he first imagined in previous works. Themes such as the train passing through a rural landscape and the conjur woman reappear in the *Bayou Fever* series, often within Bearden's stock settings of the southern United States and Caribbean landscapes.[2] Bearden's train imagery and its role in rural-to-urban migration narratives are very much a part of *Bayou Fever.*[3] Images such as *Untitled (The Mother Hears the Train)* use this theme and, again, recall similar subjects from earlier works by Bearden.[4] In this panel, the black silhouette of a train spewing clouds of white smoke, a rustic cabin partially hidden by trees, and a white dove in the foreground all bear an uncanny resemblance to his 1970 work *The Flight of the Pink Bird.*[5]

These pictorial allusions to the rural South serve as a kind of autobiographical reference for Bearden. The recurring image of a pastoral and forest-covered landscape underscores the influence Bearden's own early history had on his work. Visually conjuring the same motifs time and time again, Bearden nurtures the idea of Mecklenburg County, North Carolina and southern United States culture in general throughout his work, no doubt realizing the impact these influences had on him. The reinvention of specific themes is a common thread connecting all of Bearden's work. It seems that whenever he may have encountered a mental block that threatened his artistic process, Bearden would conveniently revert to a theme stored in his memory.

In a sense, Bearden approached his art in the manner of a jazz musician, as his work "evolved out of what the juxtaposition of the raw materials at hand brings to his sensibility as he plays around with them."[6] Beginning on an empty surface, Bearden created his own riffs of cacophonous melodies layered together in a distinctively rich and unique "sound." Bearden's collages were seldom preconceived and began simply as neutral shapes whose final forms were realized only as each gradually evolved.[7] With this in mind, *Bayou*

Bayou Fever #6: The Swamp Witch, ca. 1979. Collage on masonite, 9 × 6 in. Courtesy of the Romare Bearden Foundation & Estate of Nanette Bearden. Copyright Romare Bearden Foundation/Licensed by VAGA.

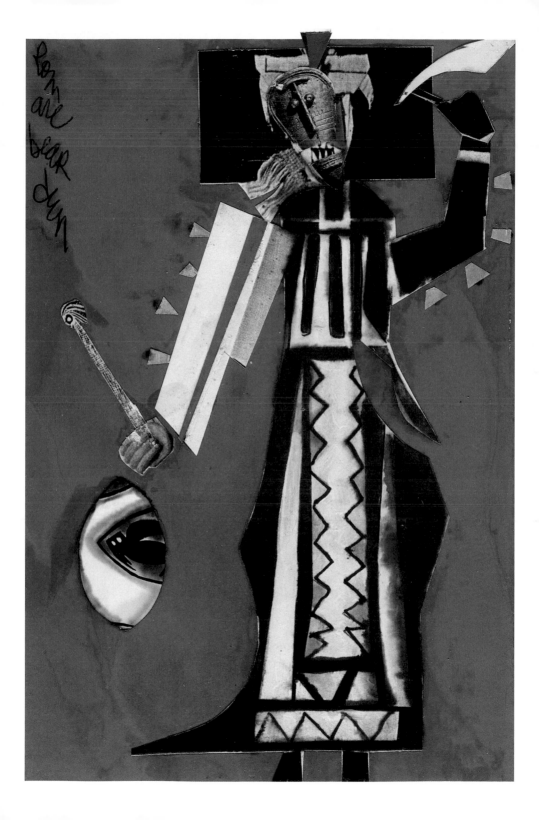

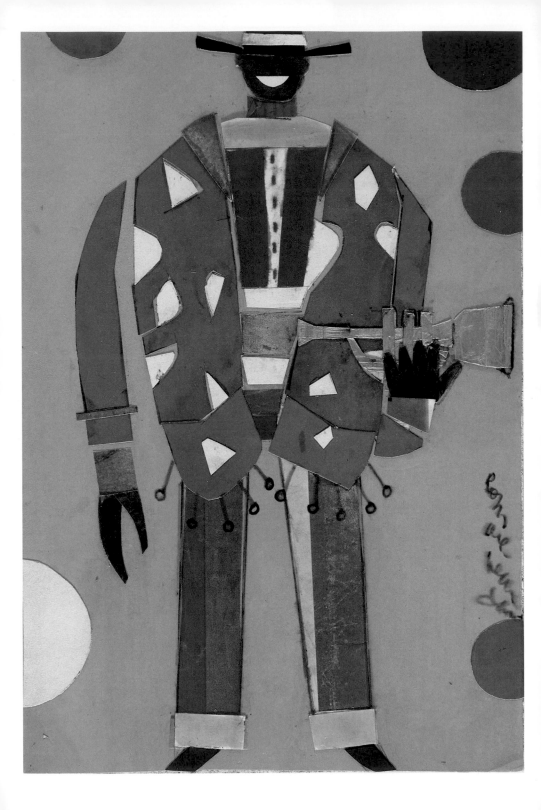

Fever's narrative becomes, itself, an improvisation. The disjointed qualities contained in each panel reverberate within the series as a whole, suggesting that *Bayou Fever* is a collage of fleeting thoughts and arbitrary images.

Creatively, *Bayou Fever* is the result of a spontaneous burst of artistic energy, but visually, Bearden's images are well developed and processed, as subjects are recycled continuously throughout his works. Tracing the conjur woman's evolution in Bearden's collages reveals an interesting shift in her character, from a mysterious and often frightening figure in the 1960s and 1970s to a motherly and somewhat reassuring presence in the ca. 1979 *Bayou Fever* narrative. When the conjur woman appears in *Bayou Fever* she is an image of familiarity, a comforting sight based on earlier depictions of her that provided a basis for appreciation and veneration by the audience. The conjur woman is a reminder of a strong yet maternal South. She evokes bucolic feelings through her oversized hands, smoking pipe, and the overall rustic character of her dress. It is appropriate, then, that the once "greatly feared" conjur woman has successfully reemerged here as heroine and savior to an innocent child suffering from the dreaded "Bayou Fever."[8]

Romare Bearden hoped that Alvin Ailey would eventually choreograph *Bayou Fever*, but the production was never brought to the stage. For Bearden *Bayou Fever* personified corporeal and artistic vitality as he captured each figure in midaction, ready to explode into life from each panel. This containment and release of energy recall comparable motion/status dynamics in African dance. "No matter how violent it may appear to the beholder," wrote author and anthropologist Zora Neale Hurston about black dance, "every posture gives the impression that the dancer will do much more."[9] This observation about black dance is particularly applicable in *Bayou Fever #9: The Lizard* (ca. 1979). With its raised arms, bent legs, and arched back, the Lizard epitomizes an unfurled yet anticipated dynamism.

Bearden apparently viewed *Bayou Fever* as a serious undertaking in the dance-theater mode, as suggested in his rendering of yet another version of this series, which also combined collage and painting. Despite a few minor changes in some of the panels and storyline, the similarities between the two versions are striking. The materials used in the collages are identical in both series, with similar scraps of cloth and collaged objects (i.e., confetti, string, and the

Bayou Fever #19: The Emperor of the Golden Trumpet, ca. 1979. Collage on masonite, 9 × 6 in. Courtesy of the Romare Bearden Foundation & Estate of Nanette Bearden. Copyright Romare Bearden Foundation/Licensed by VAGA. OVERLEAF: *Bayou Fever #11: The Conjur Woman*, ca. 1979. Collage on masonite, 6 × 9 in. Courtesy of the Romare Bearden Foundation & Estate of Nanette Bearden. Copyright Romare Bearden Foundation/Licensed by VAGA.

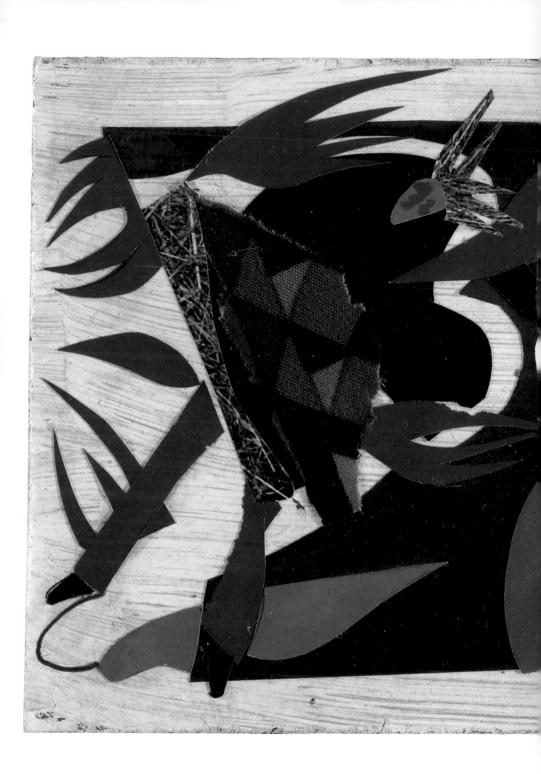

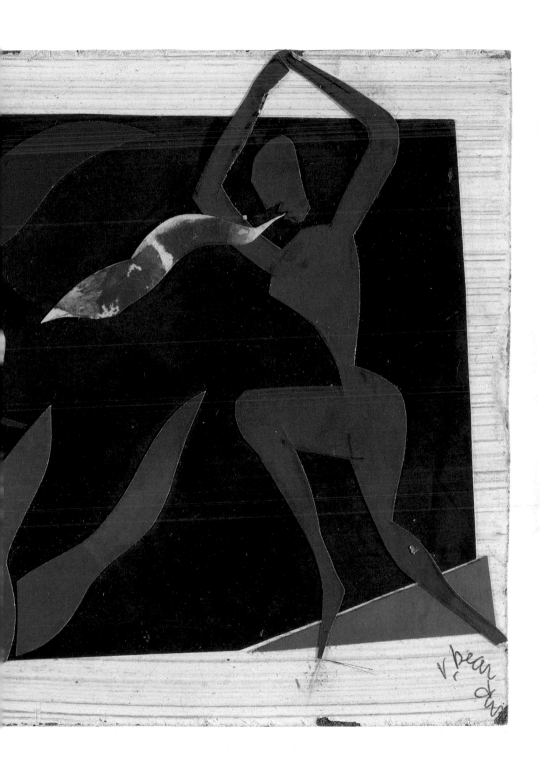

remains of chewing gum wrappers) found in both. The most obvious difference between the two versions would be the stark contrasts in backgrounds. The color-rich settings of the version on exhibition are absent from the "second" series (1979) which leave blank, white backgrounds for each figure. The discrepancies between the two versions shift the emphasis from an overall sense of pictorial unity in the exhibited version to the design-based function of the second version. Without the decorative, integrated backgrounds, the second version gives the impression of having been created largely for instructional purposes—detailed steps to making the costumes—while the exhibited version conveys a more visually resolved design sensibility.

Inspired by the Afro-Caribbean spirit of the Louisiana bayou and reflecting that region's colorful street parades and carnival traditions, the second version of *Bayou Fever* includes a panel depicting the production's final curtain call. *All Come Back* (1979) reassembles all of the characters, good and evil, on stage to take part in a celebration at the end of the performance. The omission of this final scene from the series on exhibition suggests Bearden's still unresolved storyline at the moment of this version's creation. Based on this marked distinction and other differences, it seems likely that the series on exhibition is the original storyboard, but no documentation has been located to determine the sequencing of these two versions of *Bayou Fever.* Again, it appears that in the second version Bearden emphasized the individual costumes of the production, while in the *Bayou Fever* series on display the intention was to evoke an overall visually expressive and magical atmosphere for the characters and creatures to inhabit on the stage.

I n Bearden's concurrent, more extravagantly developed *The Conjur Woman* (ca. 1979), the figure is significantly larger than its counterpart found within the *Bayou Fever* series which, as discussed above, added a coincidental background to this figure's costume specifications. "Incorporating fabric, safety pins, and string," observed Bearden specialist Ruth Fine about *The Conjur Woman,* "is exemplary of Bearden's more finished costume conceptions relating to [the conjur woman] in the series for *Bayou Fever.*"[10] However, the key differences between these two images include the addition of semi-abstracted foliage at the bottom and circular, planetary orbs at the top of the larger collage. These embellishments provide a more visually integrated composition and generate greater insight into this character's conjuring persona. Another notable dif-

Bayou Fever #16: Star, ca. 1979. Collage on masonite, 9 × 6 in. Courtesy of the Romare Bearden Foundation & Estate of Nanette Bearden. Copyright Romare Bearden Foundation/Licensed by VAGA.

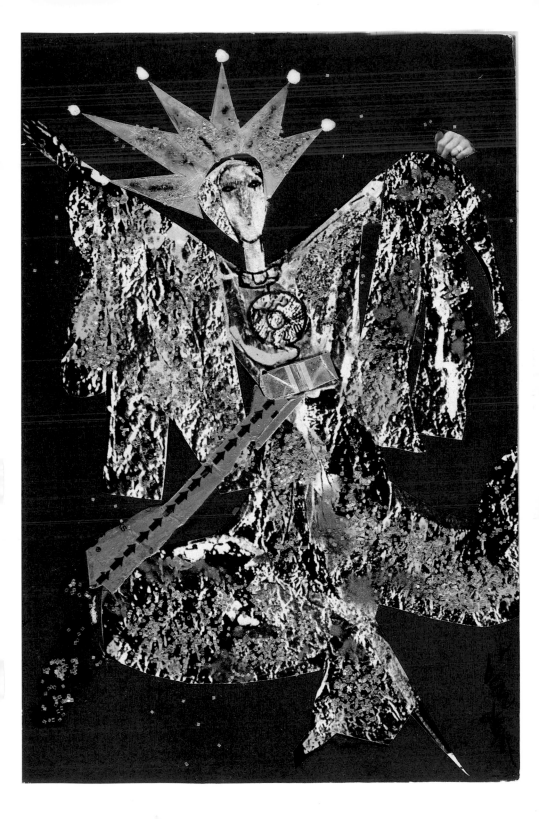

ference is each figure's stance: *The Conjur Woman*'s figure stands relatively straight and tall, while *Bayou Fever*'s conjur woman is depicted dancing, her feet caught in midair. These distinctions lend themselves to viewing the conjur woman and other characters in the *Bayou Fever* series as dance-theater "storytellers" and, in contrast, the ca. 1979 *The Conjur Woman* as more representative of a collaged and costumed figure who is unencumbered by a preexisting narrative.

Bayou Fever is a collection of Bearden's personal anecdotes and pictorial memories. Each piece in the series is a reminder of years past: the ghosts of Maudell Sleet, the jazz life, the visual pleasures of Paris, and, of course, the Caribbean.[11] Bearden's intentions in much of his work were "to reveal through pictorial complexities the richness of [the] life [he knew]."[12] Bearden succeeds in creating this alternative reality as he exposes his audience to the *Bayou Fever*'s exhilarating effects and the whirlwind of his own heated thoughts. The magnificent image of *Bayou Fever #16: Star* (ca. 1979) from the series is a perfect example of this visual delirium. As a figure from the divine world, Star, with her silver wings and crown, floats against a fantastic, midnight blue realm, and visually resonates with a Bearden anecdote about this apparition's appearance before him one magical night in Paris. "That was the one painting I wanted to do," Bearden reminisced, ". . . the angel walking across the Seine."[13] As images and memories like these imply, Bearden's collages trafficked in liberal adaptations of the truth, but as Bearden himself noted

> I think a quality of artificiality must be retained in a work of art, since, after all, the reality of art is not to be confused with that of the outer world. Art, it must be remembered, is artifice, or a creative undertaking, the primary function of which is to add to our existing conception of reality.[14]

Always willing to experiment in various artistic media, Bearden was naturally disposed toward undertaking creative challenges. Bearden's friends and fellow artists in music, dance, literature, and theater fueled his inquisitive nature and encouraged him to explore many different forms of art. With his close connections to the jazz scene, Bearden was inspired to create musically themed works, incorporate jazz-inflected designs and rhythms, and write many of his own musical compositions. In a similar manner, Bearden's associations with Alvin Ailey and other choreographers led him to create works of art that were envisioned for the stage and meant to be set into motion. Working in this new, hybrid style, Bearden interjected his sense of visual imagination and collaged wholeness to create the *Bayou Fever* series, melding images of his Southern upbringing, the

Caribbean and, in this instance, Louisiana's colorful folk traditions. Through *Bayou Fever* Bearden created a visual canvas of Afro-Caribbean culture, and with it a melting pot of themes and influences that have become fundamental in characterizing him.

Ultimately, *Bayou Fever* is a revealing look into Bearden's life and mind. "The clarity and beauty of Romare Bearden's evaluation is remarkably achieved," wrote critic Charles Childs, "like a personal dictionary whose self definition is its own voice and its own authority."[15] Creating his universe through *Bayou Fever* and extending that world beyond the edges of what the visual arts typically offer, Bearden fashioned his own special place in art, incorporating painting, collage, dance, music, and the stage to express his recollections and reveries of both the past and the present.

NOTES

1. Sharon F. Patton, *Romare Bearden: Narrations* (New York: Neuberger Museum of Art, 2002), 13. Unless otherwise noted, subsequent references to the *Bayou Fever* series are from this source. Romare Bearden's description of dance theater is from: Nelson E. Breen, ed., "To Hear Another Language: A Conversation with Alvin Ailey, James Baldwin, Romare Bearden and Albert Murray," *Callaloo* 40 (Summer 1989): 674.

2. Other motifs that Bearden embraced throughout his career also resurface in the *Bayou Fever* series. Themes such as urban life and the jazz scene are included in panels such as *The Emperor of the Golden Trumpet*.

3. Sharon Pruitt, "Collage and Photomontage: Bearden's Spiralist Reflections of America and Africa," in *A Century of African American Art,* ed. Amalia K. Amaki (New Brunswick, New Jersey: Rutgers University Press, 2004), 27.

4. Individual titles of the panels from *Bayou Fever* were either found on the back of each panel or appropriated from the version of the *Bayou Fever* series found in the *Narrations* catalog.

5. Romare Bearden, *Flight of the Pink Bird* (1970), in *The Art of Romare Bearden: The Prevalence of Ritual* (New York: Harry N. Abrams, Inc., 1973), 205.

6. Albert Murray, "The Visual Equivalent of the Blues," in *Romare Bearden, 1970–1980* (Charlotte, North Carolina: Mint Museum of Art, 2002), 17.

7. Murray, 17.

8. Romare Bearden, "Rectangular Structure in My Montage Paintings," *Leonardo* 2 (January 1969): 17.

9. Zora Neale Hurston, "Characteristics of Negro Expression: Drama, Will to Adorn," in *Negro: An Anthology,* ed. Nancy Cunard (1932, reprint; New York: Frederick Ungar Publishing, 1970), 26.

10. Ruth Fine, "Romare Bearden: The Spaces Between," in *The Art of Romare Bearden* (Washington, D.C.: National Gallery of Art, 2003), 124.

11. Maudell Sleet is a rural, motherly figure that appears repeatedly in Bearden's work depicting the woman in her garden, often at dawn or dusk.

12. Bearden, "Rectangular Structures in My Montage Paintings," 18.

13. Romare Bearden, "To Hear Another Language," 661.

14. Bearden, "Rectangular Structures in My Montage Paintings," 18.

15. Charles Childs, "Bearden: Identification and Identity," *Art News* 63 (October 1964): 62.

Chronology

1911 Born in Charlotte, North Carolina (Mecklenburg County), September 2.

1914 Family moves to Harlem, New York City.

1920s Lives from time to time with grandparents in Pittsburgh, Pennsylvania. Subsequent recollections mention the presence there of an old woman, "much feared for her power to put spells on people."

1929 Enters Lincoln University, Oxford, Pennsylvania.

1930 Transfers to Boston University.

1932 Transfers to New York University.

1933–39 Attends classes at Art Students League, New York. Graduates from NYU. Serves as an illustrator and editorial cartoonist for assorted publications. Begins to associate with other Harlem artists at 306 West 141st Street (popularly referred to as "the Studio" or "306").

1940 Exhibits several "conjur woman"–related oils, gouaches, and watercolors at 306, New York.

1942–45 Serves in the U.S. Army.

1945–48 Exhibits regularly at the Kootz Gallery, New York. *He is Arisen,* a watercolor, is acquired by the Museum of Modern Art, New York.

1950 With the support of the G.I. Bill, travels to France to study for six months. Meets a great many artists and intellectuals.

1951–56 Writes lyrics for popular music. Marries Nanette Rohan. Experiences a nervous breakdown. Moves from Harlem to an apartment loft in New York's Chinatown.

1950s–60s Begins to experiment with both abstract painting and the collage medium.

1963 Helps found the artists group Spiral.

1964–65 *Projections* (which introduces to the public several works with the "conjur woman" subject) opens, Cordier & Ekstrom Gallery, New York. Exhibition travels to the Corcoran Gallery of Art, Washington, D.C. Begins to regularly exhibit collages.

1968 Novelist Ralph Ellison's essay on Bearden appears in the exhibition catalog for *Romare Bearden: Paintings and Projections,* Art Gallery, State University of New York, Albany, New York (traveling exhibition).

1969 Bearden and Carl Holty's *The Painter's Mind: A Study of the Relations of Structure and Space in Painting* is published.

1970 Creates the *Ritual Bayou* series and *Conjur: A Masked Folk Ballet,* which include numerous collages that incorporate the "conjur" theme.

1971 *Romare Bearden: The Prevalence of Ritual* opens, Museum of Modern Art, New York (traveling exhibition).

1973 M. Bunch Washington's *The Art of Romare Bearden: The Prevalence of Ritual* is published. Takes up a second residence on the Caribbean island of St. Martin.

1975 *Mysteries: Women in the Art of Romare Bearden* opens, Everson Museum of Art, Syracuse University, Syracuse, New York.

1976 *Of the Blues (Second Chorus)* (which probes the transcendental possibilities in black music) opens, Cordier & Ekstrom Gallery, New York.

1977 Designs the collage-inspired sets and costumes for Alvin Ailey Dance Theater's performance of Diane McIntyre's *Four Elements*, and the scrim for Ailey's production of *Ancestral Voices*.

1977 "Putting Something Over Something Else," a lengthy profile on Bearden, is published in *The New Yorker*. An exhibition of the *Odysseus* series (set in an Afro-Caribbean inspired milieu) opens, Cordier & Ekstrom Gallery, New York.

1978 *Profile/Part I, The Twenties* (which includes conjur-related themes) opens, Cordier & Ekstrom Gallery, New York.

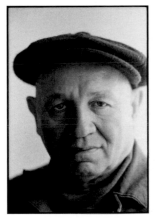

1979 Creates the *Bayou Fever* series.

1980 *Romare Bearden, 1970–1980* opens, The Mint Museum, Charlotte, North Carolina (traveling exhibition).

1981 *Profile/Part I, The Thirties* opens, Cordier & Ekstrom Gallery, New York.

1983 *The Caribbean Poetry of Derek Walcott and The Art of Romare Bearden* is published. Designs the sets for Alvin Ailey Dance Theater's performances of Talley Beatty's *Blueshift* and *The Stack-Up*. *Romare Bearden: Mecklenburg Autumn: Oil Paintings with Collage* (which reintroduces the "conjur woman"–like character of Maudell Sleet) opens, Cordier & Ekstrom Gallery, New York.

1984 *Romare Bearden: Watercolors from St. Martin* opens, Sheldon Ross Gallery, Birmingham, Michigan. *The Rituals of the Obeah* opens, Cordier & Ekstrom Gallery, New York.

1985 Continues to create pieces that draw heavily from aspects of both collage and watercolor, creating a style he terms "collage-painting."

1986 *Romare Bearden: Origins and Progressions* opens, Detroit Institute of Arts, Detroit, Michigan.

1988 Dies in New York City, March 12. *Riffs and Takes: Music in the Art of Romare Bearden* opens, North Carolina Museum of Art, Raleigh, North Carolina.

1990 Myron Schwartzman's *Romare Bearden: His Life and Art* is published. Comments on black folklore and mysticism appear for the first time here.

1991 *Memory and Metaphor: The Art of Romare Bearden* opens, Studio Museum in Harlem, New York (traveling exhibition).

1994 *Joy of Living: Romare Bearden's Late Work* (which features imagery from St. Martin) opens, North Carolina Central University Art Museum, Durham, North Carolina (traveling exhibition).

1997 *Romare Bearden in Black-and-White: Photomontage Projections, 1964* opens, Studio Museum in Harlem, New York (traveling exhibition).

2002 *Romare Bearden: Narrations* (which includes one of the *Bayou Fever* suites) opens, Neuberger Museum of Art, Purchase, New York (traveling exhibition). *Recollections of Charlotte's Own Romare Bearden* opens, Mint Museum of Art, Charlotte, North Carolina.

2003 *The Art of Romare Bearden* opens, National Gallery of Art, Washington, D.C. (traveling exhibition).

2004 *Romare Bearden: Photographs by Frank Stewart* is published.

2006 *Conjuring Bearden* opens, Nasher Museum of Art at Duke University, Durham, North Carolina.

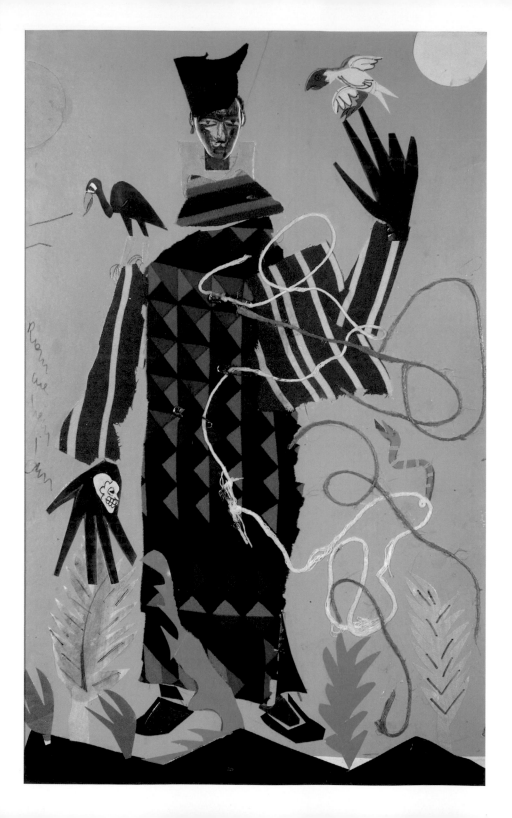

Chronological Exhibition Checklist

Conjur Woman #1, 1964. Photomontage, 38 $^{15}/_{16}$ × 30 $^{9}/_{16}$ × 2 $^{3}/_{4}$ in. Courtesy of the Romare Bearden Foundation & Estate of Nanette Bearden.

Prevalence of Ritual: Conjur Woman as an Angel, 1964. Collage on board, 9 $^{3}/_{16}$ × 6 $^{7}/_{16}$ in. John P. Axelrod, Boston, Massachusetts. Courtesy of Michael Rosenfeld Gallery.

Conjur Woman as an Angel, 1964. Photomontage, 40 $^{1}/_{2}$ × 28 $^{1}/_{2}$ × 2 $^{3}/_{4}$ in. Courtesy of the Romare Bearden Foundation & Estate of Nanette Bearden.

Other Mysteries, 1964. Photomontage, 30 $^{1}/_{2}$ × 30 $^{1}/_{2}$ in. Courtesy of the Romare Bearden Foundation & Estate of Nanette Bearden.

Two Women in a Harlem Courtyard, 1964. Photomontage, 41 $^{3}/_{8}$ × 30 $^{1}/_{16}$ in. Courtesy of the Romare Bearden Foundation & Estate of Nanette Bearden.

Illusionist at 4 P.M., 1967. Collage with ink and graphite on fiberboard, 29 $^{1}/_{2}$ × 40 in. Michael Rosenfeld Gallery, New York.

She-ba, 1970. Collage on board, 48 × 35 $^{7}/_{8}$ in. Wadsworth Atheneum Museum of Art, Hartford, Connecticut. The Ella Gallup Sumner and Mary Caitlin Sumner Collection Fund.

Junction Piquette, 1971. Fabric collage, 92 × 68 in. ACA Galleries, New York.

The Train, 1974. Collage on paper, 15 $^{1}/_{4}$ × 19 $^{1}/_{4}$ in. Mint Museum of Art, Charlotte, North Carolina. Gift of Bank of America.

Untitled (Medallion Quilt), 1976. Silkscreen on cotton, 94 × 76 in. Collection of Susie Ruth Powell and Franklin R. Anderson.

Profile/Part I, The Twenties: Mecklenburg County, Conjur Woman and the Virgin, 1978. Collage on board, 13 $^{3}/_{4}$ × 19 $^{3}/_{4}$ in. Collection of the Studio Museum in Harlem. Museum Purchase. 97.9.14.

Bayou Fever #1: The Bayou (New Orleans), ca. 1979. Collage on masonite. 6 × 9 in. Courtesy of the Romare Bearden Foundation & Estate of Nanette Bearden.

Bayou Fever #2: Untitled (The Father Comes Home), ca. 1979. Collage on masonite, 9 × 6 in. Courtesy of the Romare Bearden Foundation & Estate of Nanette Bearden.

Bayou Fever #3: Untitled (Wife and Child in Cabin), ca. 1979. Collage on masonite, 9 × 6 in. Courtesy

The Conjur Woman, ca. 1979. Collage with fabric, string, pins, and photomontage on board, 23 × 15 in. Lent by Evelyn Boulware and Russell Goings. Copyright Romare Bearden Foundation/Licensed by VAGA.

of the Romare Bearden Foundation & Estate of Nanette Bearden.

Bayou Fever #4: The Herb Woman, ca. 1979. Collage on masonite, 9 × 6 in. Courtesy of the Romare Bearden Foundation & Estate of Nanette Bearden.

Bayou Fever #5: Untitled (The Mother Hears the Train), ca. 1979. Collage on masonite, 6 × 9 in. Courtesy of the Romare Bearden Foundation & Estate of Nanette Bearden.

Bayou Fever #6: The Swamp Witch, ca. 1979. Collage on masonite, 9 × 6 in. Courtesy of the Romare Bearden Foundation & Estate of Nanette Bearden.

Bayou Fever #7: The Blue Demons, ca. 1979. Collage on masonite, 9 × 6 in. Courtesy of the Romare Bearden Foundation & Estate of Nanette Bearden.

Bayou Fever #8: The Wart Hog, ca. 1979. Collage on masonite, 17 ¾ × 11 in. Courtesy of the Romare Bearden Foundation & Estate of Nanette Bearden.

Bayou Fever #9: The Lizard, ca. 1979. Collage on masonite, 13 × 9 in. Courtesy of the Romare Bearden Foundation & Estate of Nanette Bearden.

Bayou Fever #10: Untitled (The Hatchet Man), ca. 1979. Collage on masonite, 9 × 6 in. Courtesy of the Romare Bearden Foundation & Estate of Nanette Bearden.

Bayou Fever #11: The Conjur Woman (The Buzzard and the Snake), ca. 1979. Collage on masonite, 9 × 6 in. Courtesy of the Romare Bearden Foundation & Estate of Nanette Bearden.

Bayou Fever #12: Untitled (The Conjur Woman), ca. 1979. Collage on masonite, 6 × 9 in. Courtesy of the Romare Bearden Foundation & Estate of Nanette Bearden.

Bayou Fever #13: Untitled (The Swamp Witch, Blue-Green Lights & Conjur Woman), ca. 1979. Collage on masonite, 6 × 9 in. Courtesy of the Romare Bearden Foundation & Estate of Nanette Bearden.

Bayou Fever #14: Earth and the Magic Drummer, ca. 1979. Collage on masonite, 9 × 6 in. Courtesy of the Romare Bearden Foundation & Estate of Nanette Bearden.

Bayou Fever #15: The Magic Root, ca. 1979. Collage on masonite, 6 × 9 in. Courtesy of the Romare Bearden Foundation & Estate of Nanette Bearden.

Bayou Fever #16: Star, ca. 1979. Collage on masonite, 9 × 6 in. Courtesy of the Romare Bearden Foundation & Estate of Nanette Bearden.

Bayou Fever #17: Past, Present, Future, and Beautiful Dreams, ca. 1979. Collage on masonite, 9 × 6 in. Courtesy of the Romare Bearden Foundation & Estate of Nanette Bearden.

Bayou Fever #18: Wisdom, ca. 1979. Collage on masonite, 9 × 6 in. Courtesy of the Romare Bearden Foundation & Estate of Nanette Bearden.

Bayou Fever #19: The Emperor of the Golden Trumpet, ca. 1979. Collage on masonite, 9 × 6 in. Courtesy of the Romare Bearden Foundation & Estate of Nanette Bearden.

The Conjur Woman, ca. 1979. Collage on board, 23 × 15 in. Lent by Evelyn Boulware and Russell Goings.

Maudell Sleet, ca. 1980. Watercolor & collage on paper, 40 ¼ × 31 ⅝ in. Lent by Evelyn Boulware and Russell Goings.

Mecklenburg Evening, ca. 1982. Collage and paint on masonite, 11 × 14 in. Private collection.

Obeah with Sun, ca. 1984. Watercolor on paper, 30 × 22 in. Courtesy of the Romare Bearden Foundation & Estate of Nanette Bearden.

Obeah in a Trance, ca. 1984. Watercolor on paper, 30 × 22 in. Courtesy of the Romare Bearden Foundation & Estate of Nanette Bearden.

Printed in an edition of 3,000

March 2006

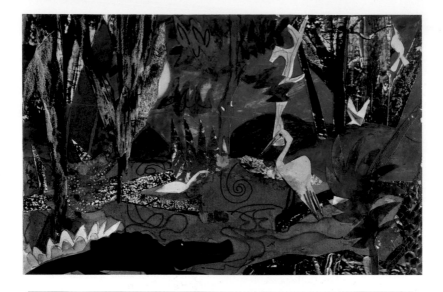

Bayou Fever #1: The Bayou (New Orleans), ca. 1979. Collage on masonite, 6 × 9 in. Courtesy of the Romare Bearden Foundation & Estate of Nanette Bearden. Copyright Romare Bearden Foundation/Licensed by VAGA.

No Wish to Know More, ca. 1984. Watercolor on paper, 30 × 22 in. Courtesy of the Romare Bearden Foundation & Estate of Nanette Bearden.

Two Priestesses, ca. 1984. Watercolor on paper, 30 × 22 in. Courtesy of the Romare Bearden Foundation & Estate of Nanette Bearden.

Sorcerer of High Power, ca. 1984. Watercolor on paper, 30 × 22 in. Courtesy of the Romare Bearden Foundation & Estate of Nanette Bearden.

Sunset Express, 1984. Collage on board, 12 ⅝ × 14 in. Lent by the Asheville Art Museum.

Summer (Maudell Sleet's July Garden), 1985. Collage on board, 11 ⅞ × 13 ½ in. Private collection, Charlotte, North Carolina. Courtesy of Jerald Melberg Gallery.

Sam Shaw, **Romare Bearden with Model, New York**, ca. 1947. Photograph, 14 × 11 in. Courtesy of the Romare Bearden Foundation. Copyright Sam Shaw.

Sam Shaw, **Romare Bearden, Harlem, New York**, 1952. Photograph, 11 × 14 in. Courtesy of the Romare Bearden Foundation. Copyright Sam Shaw.

Frank Stewart, **Romare Bearden, Blackout, St. Martin**, 1975. Photograph, 25 ½ × 18 in. Copyright Frank Stewart/Black Light Productions.

Frank Stewart, **Romare Bearden, New York**, 1979. Photograph, 36 ½ × 18 in. Copyright Frank Stewart/Black Light Productions.

Conjure Bearden: Long-Ago Faces, 2006. A 15-minute video by Tom Whiteside with music by Anthony Kelley, drawing from *Movies of Local People*, filmed by H. Lee Waters, 1936–1942. Footage courtesy of the Rare Book, Manuscript, and Special Collections Library, Duke University. Funding provided by the Duke Semans Fine Arts Foundation.

LIFT HIGH THIS CROSS

Dr. Eugene F. A. Klug
November 26, 1917–May 19, 2003

During the production of this volume,
the Lord called Dr. Klug to Himself in heaven.

LIFT HIGH THIS CROSS

THE THEOLOGY OF MARTIN LUTHER

EUGENE F. A. KLUG

CONCORDIA PUBLISHING HOUSE · SAINT LOUIS

Copyright © 2003 Eugene F. A. Klug
Published by Concordia Publishing House
3558 S. Jefferson Ave., St. Louis, MO 63118-3968

All rights reserved. No part of this publication may be reproduced, stored in a retrieval system, or transmitted, in any form or by any means, electronic, mechanical, photocopying, recording, or otherwise, without the prior written permission of Concordia Publishing House.

Scripture quotations are from The Holy Bible, English Standard Version, copyright © 2001 by Crossway Bibles, a division of Good News Publishers. Used by permission. All rights reserved.

Manufactured in the United States of America

Library of Congress Cataloging-in-Publication Data
Klug, Eugene F. A., 1917–2003
 Lift high this cross : the theology of Martin Luther / Eugene F. A. Klug.
 p. cm.
Includes bibliographical references (p.).
 ISBN 0-7586-0276-6
 1. Luther, Martin, 1483–1546. I. Title.
 BR333.3.K58 2003
 230'.410'92—dc21 2003011449

1 2 3 4 5 6 7 8 9 10 12 11 10 09 08 07 06 05 04 03

CONTENTS

PREFACE

The sheer volume of works by or about Martin Luther witnesses to the central place he holds in history from the time of the Reformation to the present day. It is difficult to account for modern world history without due attention to Luther's life and the impact he had on the spiritual, social, and intellectual foundations of Western civilization. Although a study of the sixteenth century may be selective, the figure of Luther looms large, like a skyscraper on the horizon by which all else is seen in perspective.

This is not to claim that the reformer's influence spawned or shaped everything in the world from the Reformation forward. But history since that time—whether in the political, intellectual, or social realm—has taken its contours from the powerful impact of the Reformation on all humanity, especially the so-called Western world. Without question there were movements and individuals that preceded the Reformation and helped prepare the way, not the least of which was the Renaissance. With sundry gifted individuals and its questioning of the status quo, this period contributed significantly to the awakening awareness of the need for reform. All this

prompts the age-old question: Do times and events incubate and give rise to champions? Or do champions spawn and shape events? The Russian writer Tolstoy pondered this question in his classic *War and Peace*, leaving the reader to conclude that it works both ways, depending on the observer's perspective.

As Christians ponder history, they find God's hand guiding and directing events and people in His eschatological design and wisdom, toward the end and fulfillment of His purposes for humankind on planet Earth. There were reformers and giants who preceded Luther, but it is impossible to explain Christianity or the contemporary church without grasping Luther's significant role in its ongoing development. The Reformation came first in Luther, then in the church and the world.

It has rightly been observed that it is hardly necessary to speak the praises of famous people. Their achievements speak for themselves. But it is necessary to know and understand what brought them to the world's attention. This is certainly true of Luther. Other reformers have deeply affected people's thinking, notably John Calvin, but the figure and contribution of the Wittenberg reformer stands highest, with all others taking their position relative to Luther. This position is not based on the incredible total of his literary works (the Weimar edition of Luther's writings runs more than 100 volumes!). Rather, it is what he stood for and how he answered the world's need that has set Luther apart. This gives impetus for our inquiry into his thinking, specifically Luther's theological legacy to the world.

This book is not intended as another biography of Luther. Many excellent portrayals of his life already exist. Rather, our interest lies in the direction of Luther's theological contributions, more specifically the building blocks that were

foundational to the Reformation. What did Luther believe? What did he teach and preach? What undergirded his insights that made them enduring? Of course, Luther's faith and convictions were forged in living. For that reason, a brief sketch of his life is provided, but readers interested in more detail will be referred to existing biographies. "Luther was someone who had an accessible personality," one scholar has said. Therefore, he is "the first figure in history about whom a biography can actually be written."[1] His many treatises, vast correspondence, recorded table talk, and so on provide a virtually inexhaustible volume of recorded information, even rivaling and out-distancing contemporary methods of electronic preservation. In recorded history Martin Luther stands alone.

1

SETTING THE PLAYING FIELD

LUTHER'S LIFE IN REVIEW

BEGINNINGS

The first child of Hans (Johannes) and Margaret Luther, Martin Luther was born November 10, 1483, in Eisleben, Germany. Six months later, the young family moved to Mansfeld, where Hans began employment as a hard-rock miner, extracting zinc and copper ore. Hans hailed from free peasant stock in the rural area adjacent to the small town of Moehra, about 8 miles south of Eisenach. His father, Heinrich, owned and worked a small farm. The family was not tied into the feudal system, however, so the Luthers enjoyed greater freedom.

In that region of Saxony, the small farms were not further subdivided when a father turned the acreage over to his heirs because the youngest son—not the eldest, as was often the case—inherited and assumed responsibility for the land. Apparently, youngest sons needed the most help getting started in a vocation. Therefore, older sons were prodded to strike out for themselves, to find some other niche, working, perhaps, at a trade or profession. (Of course, if an older son experienced difficulty on his quest, he could return to the

ancestral home for help.) For Hans Luther, the mining industry seemed the best opportunity to support his family and establish his own home.

Four sons and four daughters were born to Hans and Margaret Luther. But infant mortality and disease took a heavy toll, and some of Luther's brothers and at least one sister died in childhood. Hans and Margaret were firm parents, combining strict discipline and customary piety.

Hans was an achiever, a no-nonsense and naturally able sort of man, and he soon attained success in the mining enterprise. Although lacking the benefit of formal education, in a few years he gained control of a number of ore pits in addition to a smelting operation. He rose to the status of a small-time industrialist and became a community leader. Hans was financially able and interested in furthering the education of his children, especially his sons.

ELEMENTARY EDUCATION

During his elementary education at Mansfeld, Martin Luther demonstrated competence and promise for study beyond the basics. Specifically, he mastered Latin, the academic tool necessary for advanced study. At 14, Martin was sent to the prestigious school at Magdeburg for one year. He moved on to the school in Eisenach for three years, completing what would now be considered a high school or prep school academic program. He was now ready for university work. Martin's teachers strongly urged Hans to allow his son to undertake university studies.

UNIVERSITY EDUCATION

Erfurt was the university of choice in the Germany of Luther's day. Established in 1392 as a municipal institution, it was the

pinnacle of higher education in sixteenth-century Germany. Erfurt also was unique because its sponsorship came from the townspeople, which was unusual because the more prominent schools of the time were typically sponsored by the church, the territorial prince or monarch, or, in a few instances, by a ranking scholar who gathered students around himself. Because Erfurt operated at the behest of the community, it was congruent with a deep and abiding principle in Luther's life: a democratic pattern of existence in which each individual matters and is accountable for what occurs. Because of its beginnings and governance, the University of Erfurt was in a class by itself, and Luther was never out of touch with the common people. In fact, the university was the pride of the people of Erfurt. There also was an intense religious emphasis throughout the city, evident not only in the people's pious practices but also in the many buildings—estimated to be more than 100— devoted to churchly functions. Most of these buildings were connected in some way with the Dominican or Augustinian orders.

The baccalaureate program at Erfurt laid the foundation for students in their quest for academic excellence. Courses focused on grammar, logic, natural philosophy, physics, and rhetoric. A degree generally required three terms or semesters of study, culminating in the baccalaureate examination. Luther began his studies at Erfurt in the early summer of 1501. He was ready for his examination by September 1502. Upon earning his baccalaureate, he immediately continued on for the master's degree with the goal of accreditation for a career in jurisprudence or governmental service. This meshed admirably with his father's ideas and aspirations for his talented son. There was little doubt concerning the young man's ability and potential: Luther ranked second in his class for the master's degree. Hans was proud and from this point on, with

sincere deference, addressed his son with the German *Ihr* instead of the informal *du*.

By early 1505, Luther had completed the master's program, but he remained at Erfurt, teaching courses for the university. He registered in the middle of May 1505 for advanced study in jurisprudence. In June, Martin paid a short visit to Mansfeld, probably to discuss with his parents the proposed program in law, but turmoil apparently was brewing. It was not merely vocational indecision—a normal crisis when college graduates contemplate the future. Ultimately, Luther was concerned with the meaning of life. He was a well-rounded, sociable young man, but he also was an introvert. At Erfurt, often referred to as "little Rome" because of its religious atmosphere and life, Luther had come to know the Holy Scriptures and to probe them deeply. Prompted also by courses in philosophy, questions about human existence began to occupy his mind, becoming part of his daily dialogue with friends and classmates.

For Luther, such ultimate concerns seemed to be heightened by a series of disturbing incidents. Several classmates and friends succumbed to the plague sweeping through the local population. While he escaped sickness and disease, Luther did sever a blood vessel in his leg with his sword, a customary piece of equipment for students of his academic rank and social position. Such "accidents" raised his awareness of the precariousness of human existence—especially his own. One event in particular stands out. On the return trip of his visit to Mansfeld, near the town of Stotternheim, a bolt of lightning struck nearby and knocked Luther to the ground. In fear, he petitioned St. Ann to save him, pledging to devote his life in service to God for such action on St. Ann's part.

Luther's decision was abrupt, but the real impetus for it was his yearning for peace with God. Although his life was nor-

mal, his earlier brushes with danger and death had caused Luther to question his own preparedness for meeting his Maker. Aware of personal imperfections, Luther longed for the assurance of forgiveness of sin and reconciliation with God. In the monastic lifestyle, he believed he had found the answer and the means to pursue a life of repentance. Thus he resolved to enter the monastery and devote himself wholly to the Lord.

Monasteries in Europe did not always enjoy a favorable reputation with the common people. Hans Luther could be numbered among those who did not hold the monastic system in high regard, a perspective prompted largely by perceptions of indolence and corruption among the monks. But Martin's firsthand experiences in Erfurt, where Augustinians were highly esteemed, led him to view the monastery as an ideal setting for one who aspired to devote himself to the service of God. In the monastery, Luther would be able to pursue not only pious disciplines of faith and life but also regular study of God's Word. His yearning for this kind of environment won out, so on July 16, 1505, he invited his close circle of friends to a farewell gathering. They tried to dissuade him from his plans but without success. The next day, accompanied by several friends, Luther walked to the monastery gate, said farewell, and crossed the threshold to become a monk. His father was completely unaware of Martin's plans and was deeply offended when he found out. He and Martin were not reconciled for many years.

Luther the Monk

Luther devoted himself fully to the rigors of the Augustinian order and its discipline, and by the fall of 1506, he successfully completed the probationary period. The Augustinians were divided into two factions in Germany, the Conservatines and

the Conventuals, both of which were under the supervision of Johann von Staupitz. The two orders differed chiefly on the rules and rigors of their communal and worship life. Luther intentionally selected the conservative group because it stressed diligence in the study of the Bible, along with the usual monastic requirements: vows of poverty, chastity, obedience, and training in humility, including begging. Luther never complained about begging, though he appears to have conformed mostly out of a sense of duty. He embraced devotion to Mary more willingly, and later, even after his break with Rome, Luther always retained a high regard and place for Mary as the mother of his Lord.

On April 4, 1507, in the Erfurt cathedral, Martin Luther was ordained for ministry and preaching. On May 2, he celebrated his first Mass. This event, according to custom, occasioned a great celebration. Many of Luther's relatives were present, including his father. As Luther later acknowledged, it was an awesome and fearful moment to handle, literally, his Lord's body and blood. At the social reception that followed the service, Hans Luther's comments included a recitation of the Fourth Commandment. His rebuke called to mind the fact that Martin had acted contrary to his father's will when he entered the monastery.

During his years as a monk, Luther's considerable talents were increasingly put to use by the order. The prior, Johann von Staupitz, recognized Luther's gifts and potential for specialized service at higher levels in the church. For his part, Luther had opted for the monastery not because he wanted a quiet life devoted to theological study, but because he wanted to find salvation for his soul. Introspective by nature, he probed deeply for the assurance of acceptance, of a righteous standing before God. Events had caused Luther to ponder deeply his spiritual readiness and the tenuous and transitory

nature of human existence. He needed to have solid ground on which to rest his faith.

The philosophy courses at the university had not resolved matters in Luther's mind. He knew Aristotle provided the underpinning for scholasticism, which argued that church dogma was demonstrable and provable by human reason. This school of realism, known also as the *via antiqua*, taught that all truth was to be understood from things in the world. On the other hand, nominalism, also called the *via moderna*, acknowledged that certain truths could be known by powers of reason, yet fundamental truths lay beyond reason's capacity and could be known only by revelation from God. Duns Scotus (ca. 1265–1308) was one of the foremost advocates of this thinking, as was William of Occam (ca. 1285–1347). Luther inclined more in this direction.

But neither of these schools of thought answered Luther's deep inner quest for the certainty of his salvation before God. Nor had Luther's own reading and study of Scripture to this point satisfied his quest for a conscience free from blame, one that was righteous and forgiven before God. Both scholasticism and nominalism emphasized free will in humankind. Moreover, most theologians taught that by conforming to God's holy will, devout people could personally gain a measure of congruent merit, the starting point for a further inpouring of God's grace. For this process, the sevenfold sacraments of the church provided the necessary input and enabling power. Christ's sacrificial suffering and death constituted and provided the chief, though not the sole, merit or ground for such grace. The treasury of merits achieved by the saints also contributed. Thus sinners themselves, with these helps, were afforded the ecclesiastical "ladder" by which they could climb into the presence of God.

Conscientious believers were left, however, to doubt

whether they had done enough, whether their "fund" of grace was sufficient. This was Luther's troubling question as he toiled up the spiritual ladder established for the faithful. Under this ponderous structure of the church's theology, a sinner's justification before God depended not only on the righteousness won by Jesus Christ, the Son of God and true man, born of the Virgin Mary, but also in part on the individual's own good works and piety.

The sevenfold sacraments as administered by a validly ordained priest were crucial to the church's teaching and practice. The sacraments were valid only when performed by one who had been ordained by a bishop because such an ordination conferred authority and power. Moreover, theologians conceived of the church in terms of ecclesiastical structure under the papacy; the church is where the bishop is, just as the disciples gathered around Christ. Therefore, whoever separates himself from the bishop or the bishop's God-given authority is outside the church. Thus in Luther's day, theologians tended to define "church" as the ecclesiastical structure of ordained clergy under apostolic bishops, especially the chief bishop, the pope in Rome. Less frequently, they wrote and taught about the church as the totality of all the members or people within its communion and governance. From the pope down through the line of consecrated bishops and priests came the *charisma*, or gifts for spiritual nurture, that afforded salvation to the faithful via the sevenfold sacramental system.

As a devout monk Luther conformed willingly to the rigors of the vows he had taken. He also submitted himself to the ecclesial rule and teaching that in centuries past had shaped itself into a pyramid of power. Staupitz was duly impressed with Luther's piety and with his potential for leadership in the regional administration of the Augustinians. Early on, Luther was tabbed a vicar general, or a superior, in the order. He car-

ried out his assignments and performed his clerical duties conscientiously. He was regarded highly by his peers and associates. Luther's sincerity in his practice of the faith, especially in making confession, was almost obsessive as he sought perfection in his life and in his pursuit of peace before God. Some of his fellow monks tried to temper this obsession, especially Staupitz, whom Luther frequently chose as confessor. In fact, Staupitz wearied of Luther's fixation on making confession, gently pointing out the impossibility of obtaining a sense of full perfection and peace by one's own pious efforts. Staupitz directed Luther instead to the bloody wounds of Christ for forgiveness. Years later, Luther recalled how his mentor had thus proclaimed pure Gospel to him: The world has no other hope; Christ alone is the Savior that sinners have and trust. In time this would be the truth, drawn from Holy Scripture, that Luther would affirm and proclaim boldly to the world.

In 1508, Luther was appointed instructor at the University of Wittenberg. Founded in 1502 by Elector Frederick the Wise of Saxony, the university was intended to rival and compete with the University of Leipzig, which was in Ducal Saxony, where Frederick's brother Duke George was the ruling prince. To staff the new institution the elector called on Staupitz and the more than 40 Augustinian monasteries in Germany. Thus Luther came to live at the Augustinian monastery in Wittenberg, which was known as the Black Cloister because its members wore black cowls.

Wittenberg was a grubby little town in those days, lying in flat rural countryside about midway between Leipzig and Berlin. But the town could boast of one of Frederick's castles, a key fortress and military post in Electoral Saxony. Frederick expected the fledgling university to inject new life and stature into the town and into the surrounding region.

In his first year of teaching, Luther lectured primarily on Aristotle's writings, particularly the philosopher's works on logic and ethics, though Luther would have preferred to teach theology. After the school year, Luther returned to Erfurt for a year. Apparently Staupitz wanted Luther to complete graduate studies toward a doctorate. These studies focused on theology, including Luther's first intensive study of Greek and Hebrew, the languages of the Bible.

In late fall 1510, Staupitz asked Luther and an older monk to carry out a mission to Rome for the Augustinian Order. The assignment concerned the ongoing dispute between the two rival Augustinian factions concerning interpretation of the order's rules for disciplined living. Staupitz hoped that Rome might resolve the differences. The rigorous trip, accomplished mostly on foot, consumed four months and took the two monks over the Septimer Pass on the way to Rome and across the Brenner Pass on the return trip through the Alps. Rome, with its grandeur and sights, impressed Luther. But he also observed all manner of evil.

During his sojourn in Rome, Luther stayed with his fellow Augustinians, but he visited many of the city's churches and shrines in pursuit of his personal spiritual edification. The splendor, luxury, and wonders of the capital city did not disillusion the young monk from Saxony. The quest for adjudication ended, rather simply, with the counsel that the rival factions carry on peaceably with each other. By early spring 1511, Luther had returned to Erfurt as a good and devout monk, committed to the vows he had taken when he became an Augustinian.

By the end of summer 1511, Luther had returned to Wittenberg, poised to continue as a faculty member at the university. Staupitz, however, wanted Luther to complete the requirements for his doctoral degree. Although Luther did not share

his prior's enthusiasm, he acceded to his mentor's wishes. Andreas Bodenstein von Karlstadt served as Luther's faculty promoter or adviser, and his candidacy for a doctorate was announced on October 4, 1512. On October 18, in formal proceedings at the castle church of Wittenberg, the doctor of theology degree was conferred on Martin Luther. Already deeply interested in biblical studies, Luther took seriously the charge placed on him as lecturer on the books of Holy Scripture.

LUTHER THE PROFESSOR

Among Luther's first assignments as university professor were lectures on Genesis and the Psalms. His *scholia*, or lecture notes, of this early period are mostly lacking. In addition to these books, Luther also lectured on Romans and Galatians. Sometime between the conferral of the doctorate and the summer of 1513, Luther's so-called "tower experience" occurred. The light had dawned for him concerning the meaning and significance of Romans 1:17: "For in [the Gospel] the righteousness of God is revealed from faith for faith, as it is written, 'The righteous shall live by faith.'" Luther realized the apostle Paul was speaking of the righteousness imputed freely to sinners by faith, not the inherent righteousness of God's holy person. Luther later wrote that a heavy, oppressive load was lifted from him to know that by God's grace sinners who believe in Christ were freed of their sins and declared righteous. Pious works and the pursuit of holiness did not constitute the ultimate ground or reason for the hope of salvation. Rather, the all-sufficient sacrifice of the Savior once and for all time was the solid base for salvation and righteousness. "The righteous shall live by faith" in Christ's righteousness!

Luther's responsibilities at Wittenberg were soon expanded beyond teaching. Staupitz appointed him vicar, or

overseer, of ten regional monasteries. Luther also was put in charge of devotions at the local chapter. In 1514, the pastor of St. Mary's, or the City Church, in Wittenberg became ill. Luther was called on to fill that office too, and he continued to serve the congregation as assisting pastor until his death in 1546. Luther became the parish's *Seelsorger*, or "caretaker of souls," in addition to his preaching responsibilities. He dealt firsthand with people's spiritual needs, which included, of course, administering the sacrament of penance, which brought Luther face-to-face with the church's indulgence system.

Indulgences were chits or vouchers that bore official papal endorsement. When making confession and receiving absolution from a parish priest or confessor, individuals presented the indulgence and petitioned for a waiver, asking to be released or excused from arduous works of satisfaction that could be prescribed by the priest as evidence of genuine repentance. During the previous four centuries—especially since the time of the crusades—indulgences had evolved into a vital, lucrative stewardship mechanism to finance costly building projects in Rome. In some cases, regional efforts, sponsored by a governing bishop or archbishop but always under papal authorization, generated funds for local projects.

Luther soon realized that indulgences compromised people's professed repentance and contrition, especially as they casually and confidently set indulgence vouchers before him. Some of Luther's parishioners even bought indulgences with future sins in mind. No doubt many individuals wrongly interpreted official church teaching and intentions, but by Luther's day, indulgences had become an offensive practice, interpreted by the common people to be a church-blessed means of obtaining forgiveness of sins for a price. As a conscientious pastor of a flock, this deeply troubled Luther. It concerned other pastors too.

Already in 1516, Luther had publicly preached about the abuse of indulgences, decrying the peddling of wares in the name of the church. As both pastor and professor of theology at the university, he felt prompted to post theses that would call for a debate on the subject of indulgences. It was, in fact, his prerogative and right; it was also his calling as a protector of the faith. On October 31, 1517, the eve before All Saints' Day, Luther put his concern into action.

2

CAPTURING THE WORLD'S ATTENTION

THE NINETY-FIVE THESES

The selling of indulgences in Wittenberg in 1517 was exacerbated by another evil in the church: simony, which is the buying and selling of church offices. Both abuses reached into the chambers of the reigning pope, Leo X. The family of the Duke of Brandenburg, one of the electors of the Holy Roman Empire, was also involved. Duke Joachim wanted his younger brother, Albert, appointed archbishop of Mainz, a position that was vacant at the time. The position was politically important because the archbishop was one of three ecclesial electors for the realm. (The others were the archbishops of Trier and Cologne.) Electors from the political side, each a head of state in his own territory, were the ruling princes of Brandenburg, Saxony, Palatinate, and the king of Bohemia.

The emperor of the Holy Roman Empire, Maximilian, was old and ailing; soon a successor would have to be chosen. Holding one of the electoral posts was, therefore, imperative in the view of Duke Joachim of Brandenburg. The appointment of Albert to the archbishopric would give their family two crit-

ical votes in the election of the next emperor. To gain the vacant office, however, a hefty exchange of money was required, so a deal was worked out with the papal office in Rome that granted Albert's appointment as archbishop. But Pope Leo X had to waive several obstacles. First, Albert had no theological training. Second, he was only 23 years old, restive, and inexperienced. Above all, Albert already held bishoprics in two other dioceses—Magdeburg and Halberstadt. The office of bishop carried the promise of power, influence, and revenue, which encouraged Rome to ask for its share of funds in exchange for the title. The banking house of Augsburg, the Fuggers, handled the financing between the duke of Brandenburg and the papal office. The money borrowed and paid out in this instance was large. The Fuggers demanded adequate security for the loan, a security that turned out to be the projected sale of indulgences. Through the jubilee indulgence of 1510, Pope Leo X extended the right of indulgences to this region of Germany.

These "details" were known to few at the time. The sale of these indulgences went on freely in various regions of Germany, especially around Mainz, where until then they had been unavailable. The Dominican monk Johann Tetzel, a somewhat bombastic hawker, vigorously promoted the availability of what he proclaimed to be the most generous spiritual papal vouchers for the pious faithful. Now people could be assured of release from penalties and works of satisfaction in this present life and, eventually, in purgatory. Moreover, indulgences could be procured for one's deceased loved ones to ease their burden in purgatory and shorten their stay. However, Elector Frederick the Wise had forbidden Tetzel's trafficking in Electoral Saxony because he was interested in promoting his own collection of religious relics. For a small fee, pious worshipers who viewed these relics could obtain indulgences, thus removing onerous

works of satisfaction in the doing of penance.

Indulgences were, in theory, grounded on the church's treasury of merits. This treasury, established by Christ, had been supplemented over the years by the good works of the saints. But questions existed about the church's teaching and practice. Where did indulgences fit in the whole matter of a sinner's repentance? Could indulgences actually avail for a sinner's forgiveness? Theologians distinguished between guilt and penalty, or satisfaction in righteousness before God. A confessor absolved the penitent of guilt for Christ's sake, but true repentance required not only a sincere change of life but also the help of the treasury of merits available through the church's gracious dispensing of indulgences.

As a conscientious pastor and the confessor for his people, Luther questioned the confidence with which they viewed indulgences as vouchers that certified forgiveness of sins, even as guarantees against future sins! He was bothered, too, that indulgences could be purchased for the dead, in whom genuine repentance could no longer be expected or exhorted. Luther found no basis in Scripture for such a convoluted system. Therefore, he was deeply disturbed by the church's teaching and practice. He had preached against the abuses, but Luther took the next step toward a solution to a contradictory situation in church practice by posting his "Ninety-five Theses" on the door of the Castle Church in Wittenberg.

What are indulgences? Where do they really fit in proper pastoral care? How does the practice harmonize with Christian theology? Luther raised these questions in his theses. Christianity is rooted on the Word of God, the Holy Scriptures. Through Law and Gospel, God reveals His holy intentions toward the whole of sinful humanity and proclaims His salvation in Christ. Through His holy prophets and apostles, God also discloses how properly to preach and teach His saving

truth. Luther could not understand how indulgences harmonized with God's holy wrath and judgment against all sin and unrighteousness. Nor could he grasp how God's good and gracious purposes in Christ could lead to such a crass practice as indulgences, a practice with so many opportunities for abuse. Luther was deeply disturbed by the false conception of religion on which the system was grounded. It was offensive to Christianity on all counts. In short, Luther found no valid support or substantiation for indulgences in Christian theology. If theology were to remain faithful to God and the Gospel of Jesus Christ, then discussion of the key issues was essential.

Luther's posting of the "Ninety-five Theses" on October 31, 1517, followed the protocol of the day. Because the theses were written in Latin, the document was actually a call for an academic debate on the use and meaning of indulgences in the church. Luther was not the first to issue this call. For centuries other voices had questioned not only the tactics in marketing indulgences but also the theology behind the practice. Thus Luther proceeded with due respect for history and church polity when he voiced his concern about indulgences.

Luther nailed the theses on the side door of the Castle Church, facing the town's main street, which meant they were readable by anyone walking past the church. In fact, the church door was a sort of bulletin board for public notices, in this case, for the scholarly community. In addition to the copy on the church door, Luther made two others: one for the archbishop of Mainz, under whose aegis the current trafficking and sale of indulgences was taking place, and one for the ordinary, or bishop, of Brandenburg, who held ecclesiastical jurisdiction over the Wittenberg parish. None of the three original copies survive, though the furor they triggered resulted in the almost immediate preparation of additional copies, which were broadly disseminated.

The letter Luther sent with the copy of the theses to Archbishop Albrecht of Mainz urged that the indulgence hawkers in his diocese be silenced because of "the gross misunderstanding among the people."[1] This misunderstanding, Luther contended, came from those members of the clergy who were selling the indulgences and spreading the misconception "everywhere among common men."[2] Luther lamented:

> The poor souls believe that when they have bought indulgence letters they are then assured of their salvation . . . (whereas) on no occasion has Christ ordered that indulgences should be preached, but he forcefully commanded the gospel to be preached. What a horror, what a danger for a bishop to permit the loud noise of indulgences among his people, while the gospel is silenced.[3]

In Thesis 1, Luther pressed home the same point: "When our Lord and Master Jesus Christ said, 'Repent,' [Matt. 4:17], he willed the entire life of believers to be one of repentance."[4] In 1518, in his apologetic on the theses, Luther expounded the significance of repentance as a deep change of heart and mind before God that clings in faith to God and the Savior, Jesus Christ, laying aside trust in one's own self or in an indulgence.

> Christ must teach a repentance, I say, which can be done in every walk of life, a repentance which the king in purple robes, the priest in his elegance, and the princes in their dignity can do just as well as the monk in his rituals and the mendicant in his poverty, just as Daniel and his companions did in Babylon. For the teaching of Christ must apply to all men, that is, to men in every walk of life.[5]

In writing his defense of the "Ninety-five Theses," Luther asserted, "I desire to say or maintain absolutely nothing except, first of all, what is in the Holy Scriptures and can be main-

tained from them."[6] This conviction remained the platform for which he contended his entire life. He was formulating in his mind the article that later characterized the Reformation—salvation grounded on grace alone, for Christ's sake (*sola gratia propter Christum per fidem*). Luther clearly opposed the idea that the guilt of sin could be removed by indulgences or that the actual grace of salvation could thereby be bestowed. Those who believe these errors "will be eternally damned, together with their teachers" (Thesis 32).[7] Christians, he noted, "have no other hope of salvation except in Jesus Christ alone."[8]

Forgiveness of sins flows directly from Christ to every contrite sinner. Thesis 36 asserted: "Any truly repentant Christian has a right to full remission of penalty and guilt, even without indulgence letters."[9] Luther commented, "Those who neglect to purchase [indulgences] do not thereby sin, nor are they for that reason in danger of losing their salvation."[10] He argued that the canons and decrees of the church must not be perceived as punishments imposed by God for which Christians must make amends. Indulgences imposed by the church failed to do away with even the smallest sin, as far as guilt goes; moreover, Luther pointed out that the church had always officially distinguished between *guilt* and *punishment*. For guilt, only God's grace could intervene or avail; for penalties and punishments, Christians "made amends" or obtained indulgence through the church. But this was the point Luther targeted: People viewed indulgences obtained from the church as guarantees of God's grace, of God's forgiveness. Luther expressed his dismay in Thesis 6: "The pope cannot remit any guilt, except by declaring and showing that it has been remitted by God; or, to be sure, by remitting guilt in cases reserved to his judgment."[11] Luther explained, "It is questionable whether a man is also reconciled to God as soon as he is reconciled to the church."[12]

Luther sensed the clash between Scripture's pure and simple declaration of grace in Christ and the church's often misguided ministry that unduly burdened consciences. In a letter to Staupitz, Luther spoke from his heart, gratefully remembering his mentor's sage counsel to a troubled penitent: "Your word pierced me like the sharp arrow of the Mighty . . . [and] now no word sounds sweeter or more pleasant to me than *poenitentia* [penitence]. The commandments of God become sweet when they are read not only in books but also in the wounds of the sweetest Savior."[13] Luther thus credits Johann von Staupitz, the able, evangelical leader of the Augustinians in Saxony, with pointing him away from his own pious efforts for peace with God and toward the pure and simple Gospel itself.

The sacrament of penance, however, was cumbersome. First, sinners had to be contrite of heart, which is contrition or fear of punishment. Then sinners had to confess their specific sins to the priest, making auricular confession. Finally, sinners had to make satisfaction of works, fulfilling or carrying out the penalties or temporal satisfactions the confessor prescribed. Indulgences entered the picture at this last step. The burden imposed by the priest could be heavy. During the crusades, for example, satisfaction often became an instrument for forced conscription into the ranks of those fighting in the Holy Land. This "work" earned a plenary indulgence for all sin, provided the penitent entered military service and left home and family. Thus the indulgence system became a mechanism to control people's lives and fortunes; what once had been a means for a sinners to show the sincerity of their contrition became a valuable instrument for raising money and an army.

Because the focus of indulgences was on temporal penalities that were imposed for the spiritual health of the penitent, it also lay within the province of the church to lift or remove

these penalties. This was not conceived of as an arbitrary act but as a merciful dispensation of merits from an inexhaustible treasury built up by Christ and supplemented by heroic and noble saints. Such largesse was made available to the people by special edict of the pope, usually to mark some high moment in the church's life. The average person could then purchase an indulgence and use it at the time of confession to be absolved from the canonical penalties, which were the temporal satisfactions imposed on the individual at the time of confession. For many, this was tantamount to being forgiven by God. Many believed that forgiveness could be bought for a price, decreed by the pope himself, God's supreme minister of grace!

For Luther, preaching the forgiveness of sins for Christ's sake through faith alone was the church's mission. He upheld this position in Thesis 38: "Papal remission and blessing are by no means to be disregarded, for they are, as I have said [Thesis 6], the proclamation of the divine remission."[14] Luther appears to support a form of sacerdotalism, which sets the priest as God's representative in a higher station above the people. The priest is the sole possessor of the office of the keys. Later, Luther would affirm that the keys, the ability to forgive sins, belong to all believers in Christ as royal priests. Thus in his explanation of Thesis 7, Luther affirmed that "remission rests not upon the priest, but upon the word of Christ." He elaborated, "We are justified by faith, and by faith also we receive peace, not by works, penance, or confessions."[15]

Luther considered the Gospel to be the treasure all Christians have as they cling to God's Word. In comparison, indulgences dispensed by the church were a "cheap gift" because they availed only for the remission of canonical penalties imposed by the church, not the forgiveness of sins. "The true treasure of the church is the most holy gospel of the glory and grace of God" (Thesis 62).[16] Yet regrettably, Luther noted, "The

gospel of God is something which is not very well known to a large part of the church."[17] He continued:

> The gospel is a preaching of the incarnate Son of God, given to us without any merit on our part for salvation and peace. It is a word of salvation, a word of grace, a word of comfort, a word of joy . . . But the law is a word of destruction, a word of wrath, a word of sadness, a word of grief, a voice of the judge . . . of death . . . [But] . . . the light of the gospel comes and says . . . behold the Lamb of God, who takes away the sin of the world [John 1:29]. Behold that one who alone fulfills the law for you, whom God has made to be your righteousness, sanctification, wisdom, and redemption, for all those who believe in him [1 Cor. 1:30] . . . Therefore the true glory of God springs from this gospel . . . not through works but through faith, not by anything we offer God, but by all we receive from Christ and partake of in him. "From his fulness have we all received" [John 1:16], and we are partakers of his merits.[18]

Luther wrote this in early 1518 at a time when the Reformation was barely underway, but the tone and theme were clearly and firmly set. There would be no turning back.

In the "Ninety-five Theses," Luther questioned the need for and use of indulgences in the life of the church. In Thesis 13, he stated: "The dying are freed by death from all penalties," and they "are already dead as far as the canon laws are concerned."[20] He contended that "those who lead an ordinary life, which is not done without venial sins—have no need of indulgences."[21] Luther's immediate supervisor, the bishop of Brandenburg, to whom he had sent a copy of the theses, agreed. The bishop answered Luther, informing him that he found no error in the theses and that he thoroughly objected to the manner in which indulgences were being sold.[22]

It is evident at this juncture that Luther did not yet question the reality of purgatory. In fact, he devoted considerable attention to it, pointing out that in relation to hell—where despair is total—and heaven—where there is security and bliss for the soul—purgatory is the place of near-despair for those who have died. Therefore, if the pope has any continuing influence over the souls in purgatory, it is only that of intercessory prayer, not that of jurisdiction over souls. Although intercessory prayer can be offered by every priest, even by every Christian, jurisdiction over all souls belongs only to God. Therefore, Luther believed it was an obvious human error to claim that the jingle of money into the money chest would spring souls loose from the pangs of purgatory. With disgust Luther declared, "What madness!"[23]

Actually, what was especially offensive to Luther was the belief that indulgences could be bought by people for their loved ones who had died and were in purgatory, though these loved ones had not shown any sort of contrition. This, he reasoned,

> is altogether contrary to Scripture for a servant of the devil to redeem a child of God and do this even in the name of God himself. It is ridiculous for an enemy to intercede for a friend of the king. What kind of madness is this? . . . Why do we not call upon the Turks and Jews to contribute their money with us also, not, you understand, because of our greed, but for the redemption of souls? The fact that they are unbaptized does not pose any obstacle, for only the contributor of money matters, not at all the soul of him who is lost . . . I believe that even if a jackass deposited gold, he would also redeem souls. If any qualification is required, surely it is grace, since a Christian who is a sinner displeases God more than any infidel. And

braying does not distort the jackass as much as wickedness distorts the Christian.[24]

It would not be long, of course, before Luther would completely separate himself from the Roman Catholic theological distortion of penance in the lives of people, as well as from all notions of an intermediate place, a purgatory, between earth and heaven. Luther could not support the idea of purgatory because the Scriptures did not support such a teaching and belief. In Thesis 68, Luther declared the insignificance of indulgences in comparison with God's grace through Christ and His cross. Although the pope were to stake his own soul on it, Luther contended that indulgences could not avail to salvation (Thesis 52).[25] Luther noted that the preaching of the Gospel is the greatest and most important thing, and from it, the sanctified life—works of Christian love and mercy— flowed toward and around believers, especially within families (Theses 53–55 and 41–46).[26] What can indulgences contribute to the Christian's life when through faith in Christ the believer has already appropriated every blessing?

At this early point in his life, it is true that Luther was not yet ready to repudiate entirely the church's practice on indulgences. So ingrained had that faulty theology become in the lives of faithful people that total divorce from the place and use of indulgences seemed impossible. Therefore, Luther was only raising a warning flag against the danger of valuing indulgences above the Gospel itself. He considered the Gospel to be the church's true treasure, and it should not be lost nor despised by the faithful in any way, certainly not by running after indulgences or self-conceived pieties. Thesis 62 affirmed this with clarity, causing E. Gordon Rupp to term it "the noblest of them all."[27] That is why it was so contradictory, Luther argued, for the church to devote itself to indulgence

sales, letting Gospel preaching languish, chasing after people's gold and wealth rather than the salvation of people's souls.[28] According to Luther, indulgences were utterly insignificant when compared with the grace of God and the piety of the cross.

In Thesis 80, Luther called for the "bishops, curates, and theologians" to bring a halt to the offensive goings-on in the church in regards to the sale of indulgences because they will one day "have to answer for this."[29] His elegant appeal was to the ecclesiastical authorities, including the pope. Luther asked the thinking men of the day, those with jurisdictional authority, to consider carefully the evil implications of the indulgence traffic and the bad effect it would have on the reputation of the pope. The questions were pointed and embarrassing: Why, if he has the power, "does not the pope empty purgatory?"[30] Why do we even have funeral masses because "it is wrong to pray for the (already) redeemed"?[31] What is this new piety that allows "a man who is impious . . . to buy out of purgatory the pious soul of a friend of God?"[32] "Why does not the pope . . . build this one basilica of St. Peter with his own money rather than with the money of poor believers?"[33] "What does the pope remit . . . to those who by perfect contrition already have a right to full remission?"[34] This probably was the clincher, but Luther had another question: "Since the pope seeks the salvation of souls rather than money by his indulgences, why does he suspend" a good thing once begun by his gracious decree?[35]

Later, in his commentary on the theses, Luther confided in Thesis 89 his reservations regarding reform: "This disturbs and displeases me most of all . . . The church needs a reformation which is not the work of one man, namely the pope, or of many men . . . but . . . the work of God alone."[36] Yet Luther continued to support papal authority because he believed "if . . . indulgences were preached according to the spirit and inten-

tion of the pope, all these doubts would be readily resolved."[37] Thus he seemed resolved to defend the person and authority of the pope and target instead the greedy hawkers, such as Tetzel, holding them and mercenary bishops responsible for what was happening in the church, which was to the harm and detriment of the Gospel and the precious souls of the people.

Luther had not yet repudiated the ingrained thinking and practice of sacerdotalism, that the keys belonged to the pope as the servant of the keys in the church, along with the hierarchy of ordained clergy under him.[38] Thus Luther's severe critique of what was happening within the church because of offensive indulgence trafficking—selling and buying God's priceless, precious favor and forgiveness—stemmed from his humble bowing before the Word, before Holy Scripture's teaching concerning the saving grace of God, for Christ's sake, through faith. Thesis 36 said: "Any truly repentant Christian has a right to full remission of penalty and guilt, even without indulgence letters."[39] But Luther had not yet separated himself from the elaborate Roman Catholic system that reckoned in the pieties, the penitential guidelines, and so on, a system the church had used for centuries to define the pilgrim's pursuit of holiness before God. It was evident that Luther had already found comfort and peace in his heart based entirely on God's grace alone, for Christ's sake, through faith (*sola gratia Dei, propter Christum, per fidem*), which would become the rallying cry for the Reformation.

Perhaps the "Ninety-five Theses" do not clearly demonstrate it, at least not in the concessions Luther made toward the hierarchy of the church, but for himself and as he ministered to the people, Luther had found the Gospel of salvation clearly proclaimed in God's Word. For this reason, he challenged anything that diminished or caused this precious truth to be in jeopardy within the church. Thus Luther called for a halt to the

sale of indulgences because the Gospel was at stake. His challenge did not go unheard. The reformation needed by the church—of which Luther spoke and for which he prayed, which no person, not even the pope, could work but only God alone—had begun. Almost prophetically, Luther wrote in his explanations of the theses: "It is the work of God alone. However, only God who has created time knows the time for this reformation."[40]

3

LAYING THE FOUNDATION

THE HEIDELBERG DISPUTATION

Did Luther deliberately compose and post his "Ninety-five Theses" to start a new church? Because he wrote in Latin, the theses were not meant for the general public; instead, he sought scholarly debate. Luther's pastoral duties at the City Church of Wittenberg and his theological lectures at the university demanded clear guidelines for the care of souls, guidelines that were in harmony with biblical teaching and practice. Luther sought answers by calling for a disputation on what he perceived to be faulty theological premises and customs that had infiltrated the church. But such a high-level disputation never occurred. Instead, without his initiative or consent, the theses were quickly translated, published, and widely disseminated throughout the whole Christian world.

Luther was surprised by the widespread interest in and commotion created by the theses. He did not perceive a gulf between himself and the traditional faith of the church. In fact, he continued to be supportive of the church, its theology (as he had learned it), and its institutional structure. Luther believed his teaching and actions were in line with papal and ecclesiastical thinking. But he recognized that the official teaching and

practice of the church on penance, specifically the place and role of indulgences, grossly undermined the theology of the cross as it was taught in Scripture.

The Vatican was delayed in responding to Luther's theses until mid December 1517. At first the matter was treated lightly, but soon the machinery to deal with the "upstart" monk and professor in Wittenberg was set in motion. Appropriately, the Dominicans were placed in charge of the matter because they were the monastic order in charge of the Inquisition. Johann Tetzel, a member of the order and the monk whose indulgence selling drew Luther's ire, was appointed to take up Luther's challenge of debate on the theses. The Dominican order quickly equipped Tetzel with the necessary qualifications for the debate: a doctoral degree and a set of theses in response. Elector Frederick the Wise of Saxony, who was supportive of Luther, invited Tetzel to Wittenberg to debate the issue, but Tetzel did not make the trip. His theses, however, were published, and they clearly stated that any departure from papal authority and teaching was tantamount to heresy. Several hundred copies of Tetzel's theses were sent to Wittenberg. After reading a copy, Luther noted that they did not resolve the questions he had raised concerning indulgences. The students at the university ceremoniously burned the whole bundle.

In the months following the posting of the "Ninety-five Theses," life went on as usual for Luther in his dual role as lecturer at the university and as spiritual shepherd for the flock at St. Mary's parish. His challenge for a debate on the indulgence question never came to fruition in the public forum. Voices were raised, however, elsewhere in the church. One of the sharpest responses came from Johann Eck, a professor at Ingolstadt. His response, titled "Obelisks" ("daggers"), was intended to expose Luther as a simpleminded windbag in rebellion against papal authority. Because Eck was a man of

stature in the academic world, Luther was dismayed by the unjustified ruthlessness of the attack and saw the necessity of a reply. Luther titled his rejoinder "Asterisks," or "little stars." Luther gently pointed out the faulty and misinformed accusations that Eck had leveled against him. While Eck was fuming and arguing from a platform of Scholasticism, Luther's response rested firmly on the Scriptures and the church fathers. If it appeared to his opponent that he had questioned papal primacy, Luther pointed out that the Gospel and the theology of the cross took the place of highest authority. According to Luther, while human beings might and do err—and all did, including the pope—God does not, nor does His holy Word. It was becoming clear that what had begun as a questioning of the meaning and place of indulgences in the church's teaching and people's lives was now becoming a conflict over authority. What stood first and highest in the life of the church—God's Word or human tradition and institutions?

At this point, the indulgence controversy was set aside so Luther could focus on the business of the Augustinian Order, whose members were scheduled to convene April 25, 1518, for their triennial meeting. The gathering was to take place in Heidelberg, which was the capital city of the Palatinate electorate. Luther traveled to the meeting by foot in the company of his fellow Augustinian monk Leonhard Beier. They had been provided safe-conduct visas by Elector Frederick the Wise, who was troubled by Luther's absence from the university classroom. He admonished Staupitz that such prolonged absences from the institution were not to his liking. But Staupitz, the vicar of the Augustinians in Germany, had asked Luther to preside over the meeting, and he also asked Luther to prepare theses for the meeting's customary disputation. Luther, in turn, asked Leonhard Beier to make the actual presentation and defense of the theses.

The theses as prepared by Luther had a twofold focus, treating both theological and philosophical views. According to reports, it was a good program, and those in attendance expressed favorable opinions of the acumen of the Wittenberg leaders. No mention was made of the indulgence question. The conclave ended with the reelection of Staupitz as the vicar of the German Augustinians, while Luther's position as district vicar went to his friend Johannes Lang of Erfurt. Impressed by Luther's integrity and skill in the conduct of the conference, many Augustinians, especially from the younger set, became his supporters. Despite cries of "heretic" already echoing in the church, Luther had become the champion of the German Augustinians.

THE DISPUTATION

The disputation at Heidelberg focused on two basic areas: epistemology and theology. Within theology, *epistemology* explores how we come to know God and His purposes toward humanity. The central and key *theological* question was the distinction between a theology of glory and the theology of the cross. The theses Luther prepared and their accompanying explanations, provide early testimony of Luther's biblical orientation in doing theology. Luther believed that the fact that we know God at all and can speak of His purposes indicates that God has not left us without witnesses; God has not kept silent concerning His ways and will. For Luther, the terms "God hidden" and "God revealed" meant that for the natural mind—human beings after the fall into sin—the person of God remains shrouded in mystery, except where He draws back the veil to reveal who He is and His purposes toward sinful human beings. Luther recognized the validity of the natural knowledge of God, even by sinful humans. Only a fool acting against

what he knows in his heart would deny God's existence (Psalm 53:1). Such general knowledge of God, His being and existence, His creation and governance of the world, is something all people could perceive and acknowledge, according to Luther. The apostle Paul wrote: "For His invisible attributes, namely, His eternal power and divine nature, have been clearly perceived, ever since the creation of the world, in the things that have been made" (Romans 1:20).

Beyond such general revelation of God, however, Luther believed human beings needed God's special revelation. They needed to know what is in God's heart when He looks at sinful men and women, what He has done for their rescue and salvation. But these questions cannot be answered by nature or discovered by human beings. Yet God did not leave the world without a special witness. Luther stated that God made His gracious intentions toward sinners known through His Word and above all in His Son, the incarnate Word of God. Without this special revelation, the human situation would be like recognizing a person by face but not knowing in any way the person's disposition or intentions. In Heidelberg Thesis 19, Luther declared the insufficiency of natural knowledge, stating "that person does not deserve to be called a theologian who looks upon the invisible things of God as though they were clearly perceptible in those things which have actually happened."[1] He continued in Thesis 20: "He deserves to be called a theologian, however, who comprehends the visible and manifest things of God seen through suffering and the cross."[2] Luther unfolded Scripture's Gospel, the "foolishness of the cross," the Good News of Christ's coming to atone for the sins of the world. According to Luther, this Gospel reveals, as nothing else can, the gracious mercy of God toward every repentant sinner, calling human hearts to trust the Savior.

General knowledge of God, or natural theology, Luther

noted, was virtually useless because of its limitations. According to Luther, sinful people construe it to be all they need, and from it springs every form of idolatry. As a result, general knowledge leaves humans in a quandary of sin and guilt. But humans do see around them the evidence that God exists and is a mighty creator. These are the veils or masks that cover God's being and ruling from human eyes. They are not mere starting points but truly represent God on the stage of this world where He plays the principal role and governs all things. But, Luther averred, these attributes of might, omniscience, and sovereign rule do not tell humans what God is and what He has ordained for His human creations.

Luther stated that to know the mind and heart of God, that He has most graciously and wondrously come to us with love and forgiveness, comes through a special revelation that was initiated by God through the gift of His Son. God's gracious promise of a Savior was spoken first to Adam and Eve in the Garden of Eden after the fall into sin (Genesis 3:15). Throughout the centuries, God repeated the promise and His word of grace through the Old Testament prophets. Finally, and preeminently, He revealed His Word through Christ's coming into the world to save sinners at Calvary, fulfilling the promises He had made. The humanity, weakness, and foolishness of Christ along with His eternal power in the personal union of the God-man constituted the perfect sacrifice for our redemption. Luther stated that this glorious truth cannot be known without the special revelation given by our gracious God.

At Heidelberg, Luther's theses and explanations placed this truth clearly before the Augustinians who had gathered. Luther pointed to Scripture to demonstrate that this was the stance and proclamation of the apostles: "And there is salvation in no one else, for there is no other name under heaven given

among men by which we must be saved" (Acts 4:12). Luther pointed to Jesus Christ, crucified and raised from the dead, as the only hope and salvation of sinful people. This Gospel was given to the church to proclaim that sinners might have hope and eternal life. According to Luther, God remains hidden unless He is taken at the point of His approach and, like Moses, believers are satisfied and receptive of the glimpse from the cleft in the rock He grants through His works and Word. Luther said that going beyond this is to pry into the hidden nature of God.

In his commentary on Heidelberg Thesis 20, Luther stated: "It is not sufficient for anyone, and it does him no good to recognize God in his glory and majesty, unless he recognizes him in the humility and shame of the cross."[3] When Philip blurted out that the disciples would like to be shown the glory of God, Luther said Christ "set aside [Philip's] flighty thought about seeing God elsewhere and led him to himself, saying, 'Philip, he who has seen me has seen the Father' [John 14:9]."[4] Luther continued: "True theology and recognition of God are in the crucified Christ, as it is also stated in John 10 [John 14:6]: 'No one comes to the Father, but by me.' 'I am the door' [John 10:9], and so forth."[5]

Luther refused to pry further into the nature of God's person, His counsels and purposes, His creation and sovereign rule over all things, other than to know Him and perceive His divine counsels as He has revealed them to humanity. Luther pointed out that God has not left the world without witness of His sovereignty (Romans 1:18–25). He spoke through the prophets of old, then preeminently by His own Son, and ultimately through chosen apostles whom He sent with His Holy Word into all the world. And God has not left the world without witness of His gracious purposes for salvation. Thus Luther advised that we should let God be God in His majesty

and glory and not engage in harmful speculation concerning His holy person, trying to discern His purposes. According to Luther, human philosophies always fail. God as He is remains forever unknowable. Luther disapproved of the quest for knowing God as He is, like a mathematical equation that can be explained and proven. If you want to understand God, Luther admonished, go to the manger in Bethlehem and behold the virgin nursing the child.

Luther believed human beings always have difficulty when they attempt to mesh or harmonize God's revelation of Himself with events in their lives. God does work in human affairs, but why and for what purpose is often beyond human understanding. God's acts do not have to clear the bar of human reason, Luther averred. The Scriptures say that the clay may not ask the potter why it was made into a particular form (Isaiah 64:8; Jeremiah 18:6; Ephesians 2:10). The Old Testament prophets interpreted history for God's people as God gave them words to speak, but Luther said believers must not venture to speak of or for God in this same way. When we attempt to give rhyme and reason to God's actions and purposes, we inevitably do so in an anthropocentric manner. Such human philosophies of history are always doomed to failure.

At Heidelberg, Luther posed the thesis "that wisdom which sees the invisible things of God in works as perceived by man is completely puffed up, blinded, and hardened" (Thesis 22).[6] Luther pointed out that everyone has an insatiable desire to pontificate. As a result, everyone falls victim to "dropsy of the soul" and becomes "thirstier" the more they drink.[7] Thus Luther counseled: "The remedy for curing desire does not lie in satisfying it, but in extinguishing it."[8] Christians learn humbly to bow before God and accept His answers, just as they thank God for the wondrous mystery of His inexplicable mercy and forgiveness in Christ.[9] God does not deem it necessary for His

creatures to know more than this wondrous truth, though human tendency is to press for more. Moses, too, ventured to know more of God's holy person, petitioning in the wilderness of Sinai, "Please show me Your glory" (Exodus 33:18). God reminded Moses, "You cannot see My face, for man shall not see Me and live" (Exodus 33:20).

Luther reminded his Heidelberg audience that God "does not manifest Himself except through His works and the Word."[10] In his commentary on the Book of Genesis, Luther expanded on this point, explaining that God deigns to envelop "Himself in His works in certain forms, as today He wraps Himself up in Baptism, absolution, etc."[11] According to Luther, to attempt to know God beyond His chosen veils is to go immediately beyond one's depth of understanding. In his lecture notes on Genesis, Luther added:

> It is therefore insane to argue about God and the divine nature without the Word or any covering, as all the heretics are accustomed to do Those who want to reach God apart from these coverings exert themselves to ascend to heaven without ladders (that is, without the Word) When God reveals Himself to us, it is necessary for Him to do so through some veil or wrapper and to say: "Look! Under this wrapper you will be sure to take hold of Me."[12]

According to Luther, Christians are to be content with the manner in which God reveals Himself and His purposes. Faith is attentive and submissive; it trusts and waits on God in humility. Yet the mystery of God's person does not recede as the revelation of God's gracious love toward sinful humanity becomes clear. Every sinner needs to know God and His gracious intentions and to receive Him with trusting faith at the point of His approach. God does not reveal why Christian pilgrims are called to bear burdens, adversities, and crosses in this

life. But as with the grace they have in Christ, believers remain confident in God's providential care throughout their lives. Even in their deepest woes on this earth, believers are exhorted not to doubt but to trust firmly that from eternity God has graciously intended their salvation and elected them through the Savior to eternal life.

At Heidelberg, Luther publicly broke from a theology of glory—the frenetic effort to climb into God's favor through personal pious strivings—to a Gospel-centered theology of the cross. His Augustinian brothers were deeply impressed by what Luther shared with them; many acknowledged that only the theology of the cross harmonized with God's Word. E. Gordon Rupp has observed:

> It is a theology that emerges in its first freshness in 1516 in letters, sermons, and lectures during that year. It underlies the 95 theses and finds its clearest expression in the Explanation of the 95 Theses, which Luther wrote early in February 1518 and which were no mere afterthoughts; and finally in the Heidelberg Theses, which Luther prepared for the debate during the chapter of his Order in April 1518 and which are perhaps the real, first theological manifesto of the Protestant reformation.[13]

THEOLOGY OF THE CROSS

Medieval theology taught what came to be labeled "ascent theology," which was an escalator kind of endeavor. According to this theological understanding, humans were to strive to rise up more and more, closer and closer to God's level. Centuries earlier, Pelagius had taught that humans by their own free will could attain the lofty level of spiritual amity with God. Augustine countered that a human being's ascent to God could not be done without divine assistance, without God's enabling

grace. In his own life, Augustine had introduced the concept of love or charity as the all-important element in humanity's relationship with God. Love blooms in human beings through God's infused grace, and love in turn fleshes out faith in human hearts. In other words, faith is formed by love; love is preeminent, and assenting faith adorns and embellishes it. The whole monastic system, therefore, stressed the importance, priority, and significance of works of piety and pious practices as a means to gain God's approval and the hope of salvation. As taught by Augustine and medieval theology, human beings gradually gained mastery over sin and the sinful world and came to the realm of pure spirituality, repelling fleshly desires for things of the Spirit.

Religious mystics of all kinds followed Augustine's lead, some focusing primarily on human physical nature (the body) while others focused on the mind or the spirit. In each case, love, infused by God's grace was the force or dynamic that governed and activated everything else, including faith. Asceticism focused on mastery over the body by schooling and disciplining oneself in pursuit of piety, which usually included vows of poverty, celibacy, and obedience. Ascetics desired to achieve more and greater conformity with the will of the holy God, climbing rung by rung the ladder of God-pleasing acceptance before the throne of the loving Lord and Savior. Coupled closely with asceticism was the pious training of the mind, devoting oneself to schooling the reason and senses and fashioning rational proofs in support of God's revelation for the sake of the faith and the pursuit of piety. Not least on this anagogical ladder was the emphasis on the spirit, the elevation of heart and spirit through pursuit of celestial knowledge and truth. Thus in addition to mastery over the body and schooling of the mind, there was need for regularly devoting one's self to the things of the Spirit. Through pious devotion and self-mor-

tification, one could rise above this world's sense level to the level of the divine. Christ's ascension was perceived to be the model for this pious effort.

For centuries, the church, especially the monastic system, embraced these religious practices in pursuit of acceptance before God. But was such religion a charade? "The person who believes that he can obtain grace by doing what is in him adds sin to sin so that he becomes doubly guilty," Luther pointed out in Thesis 16 at Heidelberg.[14] He added:

> On the basis of what has been said, the following is clear: While a person is doing what is in him, he sins and seeks himself in everything. But if he should suppose through sin he would become worthy of or prepared for grace, he would add haughty arrogance to his sin and not believe that sin is sin and evil is evil, which is an exceedingly great sin.[15]

Luther then quoted Jeremiah 2:13—"For My people have committed two evils: they have forsaken Me, the fountain of living waters, and hewed out cisterns for themselves, broken cisterns that can hold no water"—before commenting that "through sin they are far from [God] and yet they presume to do good by their own ability."[16]

The paradoxical and contradictory element in this theological worldview is that the pursuit of pious works of all sorts is actually self-seeking, self-serving love. In such a system, human beings seek what they can get from God rather than seeing and embracing what God has done for them by His grace alone. According to Luther, this is a subtle form of idolatry because human efforts to keep God's Law always fail. Luther had his own bitter, agonizing experience with such theology from his years in Augustinian monasticism. As an Augustinian, he had undergone the rigors of severe discipline only to become aware of its inadequacies. Even under the

kindly hand of Johann von Staupitz, his mentor and confessor, Luther could find no lasting comfort, a fact illustrated by Staupitz's comment that Luther was enjoying making himself more sinful so he could confess more.

Luther failed miserably at finding peace with God through the rigors of monasticism. He was punished by a theology of glory that contradicted the Gospel itself. Staupitz, however, pointed Luther in the right direction: the bloody wounds of Jesus. In Christ, and not in himself and in his own efforts, Luther found peace for his troubled heart. Thus at Heidelberg, Luther propounded the theology of the cross: "For without grace and faith it is impossible to have a pure heart. Acts 15[:9]: 'He cleansed their hearts by faith.'"[17]

In Theses 16–18, Luther demonstrated that it is Christ's righteousness alone, which is altogether alien or outside of humans, that avails before God. Christ's righteousness is imputed to believers by faith and not by works, thus believers have forgiveness and acceptance before the holy Lord. Therefore, the theology of the cross is the complete opposite of a theology of glory. But humans are forever prone toward the latter, and the church itself also is inclined toward the same error. In the history of the church in this sinful world, Luther's voice was a clarion call back to the Gospel, one the apostle Paul also had clearly articulated: "For by grace you hve been saved through faith. And this is not your own doing; it is the gift of God, not a result of works, so that no one may boast" (Ephesians 2:8–9).

When Luther smashed the icon of good works as the source of the sinner's justification before God, he did so not because he stood against good works in the believer's life. Instead, Luther wanted to cut down the self-constructed ladder by which the good works of pious pilgrims were believed to be the key element in one's ascent to God. But Luther first had to

rebuild theology in the church on a truly biblical base; he had to knock down, destroy, and clear away the rubble, getting down to the bedrock on which Christian theology must rest: God's grace alone, through Christ alone, by faith alone. Luther upheld the apostle Paul's proclamation: "For we are [God's] workmanship, created in Christ Jesus for good works, which God prepared beforehand that we should walk in them" (Ephesians 2:10). Luther articulated this plainly in Theses 7–9, as well as in other writings in which he emphasized that "the righteousness of God is not acquired by means of acts [pious works] frequently repeated . . . but . . . by faith, for 'he who through faith is righteous shall live' (Rom. 1[:17])."[18] Luther pointed out that the Scriptures teach "that [man's] works do not make him righteous, rather that his righteousness creates works."[19] Luther correctly understood the apostle's explanation that good works flow out of faith in Christ and not the other way around. Thus the formula Augustine had proclaimed— faith formed by good works—needed to be reversed: Good works always flow from faith in Christ. In his comment on Heidelberg Thesis 26, Luther stated: "Wherefore we also fulfill everything through [Christ] since he was made ours through faith."[20]

Luther was not happy with the term or appellation "*ascent* theology" to describe humanity's quest to climb the ladder to heaven. He was willing, however, to continue to use the concept because it allowed the opposite emphasis: The situation for humans in their sin must be understood as necessitating God's *descent* to us in and through Christ, for sinners' sakes. Luther sensed that much confusion concerning the ground and base for salvation had entered the church's teaching beginning with Augustine, to whom Luther was indebted on so many other positive counts. But Augustine's formula of faith informed by love had expanded into a rationale to sup-

port works-righteousness and a pursuit of piety within the church's religious system and practice. Unnoticed and unchallenged was the radical difference and clash between "ascent theology" and its works-righteousness and the biblical teaching of the theology of the cross, or righteousness by faith in Christ. Garbed in its dress of what is right and proper, theology of glory had subtly insinuated itself into the Christian faith as the more perfect way to salvation. But Luther found that it was lethal and left the believer without the comfort and peace of God's forgiveness in Christ. Rightly distinguishing between God's Law—which judges and convicts—and God's precious Gospel that proclaims redemption through Christ is humanity's sure and eternal hope.

In the theology of the cross, God is close at hand, not distant, as He is in a theology of glory. Luther demonstrated that God comes to human beings with His grace, through His Word; they do not have to climb up to Him. God is close in every need, in suffering, despair, and the multiple burdens of life. God is near with tender care, though believers may find His purposes hard to reconcile. In Heidelberg Thesis 20, Luther affirmed and emphasized this when he stated that a man "deserves to be called a theologian . . . who comprehends the visible and manifest things of God seen through suffering and the cross."[21] Luther explained: "It is not sufficient for anyone, and it does him no good to recognize God in his glory and majesty, unless he recognizes him in the humility and shame of the cross."[22] Luther reminded his audience that Christ rebuked Philip when, in tune with a theology of glory, the disciple blurted out, "Show us the Father." But Jesus returned his disciples' thoughts to earth, stating: "Philip, he who has seen Me has seen the Father" (see John 14:6–14). Instead of trying to take "the hind parts of God" like some contemporary Moses—so human beings can construct God in conformity with their

pious notions of what they think He must be—Luther urged believers to look in Bethlehem's barn, on the cross of Calvary, and in God's abiding word and His promises of help in every trial. Then Christians could bow in humble, trusting faith before Jesus, confessing their sin and unworthiness before Christ, the Son of God, just as Peter did (Luke 5:8).

Luther also emphasized the "passive mood" of the theology of the cross. The righteousness sinners receive for salvation is worked for them by Christ, not in them or through them and their pious efforts. Luther wrote: "Actually, one should call the work of Christ an acting work and our work an accomplished work, and thus an accomplished work pleasing to God by the grace of the acting work."[23] Thesis 26 explained: "The law says, 'do this,' and it is never done [while] grace says, 'believe in this,' and everything is already done."[24] Luther believed that Christian preaching should focus on the truth that Christ, by His atoning, vicarious sacrifice, has suffered and completely paid for each sinner's salvation. The proclamation of Christ's redemptory work on sinners' behalf should not be a morbid rehearsal that dwells on the rigors of Christ's suffering but a declarative, objective, wondrous truth that by His suffering and death Christ has paid completely for sin. That great truth is "passive righteousness" because it has been done for believers by Christ, not through anything believers have done. Luther taught that faith does not even contribute to that righteousness; it simply clings to what has already and fully been accomplished by our Savior.

Luther stated that the theology of the cross and the gracious working of the Holy Spirit combine in leading the sinner to repentance and saving faith. The Word—Law and Gospel—constitutes the Spirit's instrument in dealing with the individual. God's Law is good not evil, but a theology of glory tends to confound things by elevating a sinner's capacity for keeping

the Law. People fail to see that God's Law pronounces them guilty; it condemns, judges, and kills sinners who seek to stand before God in their own holiness. No one can flee the Law and its demands before God. Without the wisdom of the cross, people misuse that which is good in an evil way. Luther clearly articulated this at Heidelberg in Theses 21–28. The Gospel cannot be preached as Gospel unless it is preached in the context of the Law. Otherwise a person succumbs to "dropsy of the soul," as Luther labeled the puffed-up smugness of a proud, unrepentant sinner before God.[25] Moreover, in Baptism the Old Adam in each individual is drowned by daily contrition and repentance. In his commentary on Galatians, Luther noted how the Old Man in all people needs to be shown who's boss on a continual basis.

Hence the paradox in the lives of believers: On the one hand the closer believers come to Christ in faith, the farther they feel from Him because God's Law presses the truth and fact of sin on them. On the other hand, the Gospel comforts gloriously as it declares forgiveness to every repentant believer. "The law says, 'do this,' and it is never done [while] grace says, 'believe in this' and everything is already done."[26] This was Luther's ringing emphasis at Heidelberg.

At the Heidelberg conference, the theology of the cross gained a new and necessary hearing in the life of the church. According to Luther, under the cross, the church finds its life and hope. With this foundation, the church goes forward with lightened step, joyfully and willingly bearing its crosses and burdens in the knowledge of salvation through faith in Christ's vicarious suffering and death for sinners' sakes. For Luther, there was no substitute for the Gospel-centered theology of the cross.

In an off-the-cuff comment, Luther once shared the importance of the theology of the cross in his life. If someone

were to come to the door of his heart, asking, "Who lives here?" Luther said that he would answer, "Christ lives here now." In the same way, when Christ comes to live in a believer's heart, the house becomes crowded. Christ's holiness haunts the believer, bothering him, because as a human being, he is inclined to seek his own holiness, not Christ's. But for Christians, Christ lives in them, and they are at peace. A biblical example—the story of the rich young man—demonstrates the point. The man's answer to Jesus, in effect, amounted to, "Why did You have to make my life uncomfortable and turn my riches into ashes?" Peter went through a similar struggle in the boat after his great catch of fish. Awed by what he had seen, Peter fell on his knees before Jesus, confessed unworthiness, and pleaded, "Depart from me, for I am a sinful man, O Lord" (Luke 5:8). Peter clung to Jesus' pronouncement that he was not to be afraid and would now be a "catcher of men" (Luke 5:10). The theology of the cross would become the theme of Peter's preaching and of his life.

4

THE HEART AND SOUL
OF THE REFORMATION

SINNERS' JUSTIFICATION

The formative years in Luther's life and ministry included the period leading up to the posting of the "Ninety-five Theses," the meeting at Heidelberg in 1518, and the 1519 debate with Johann Eck at Leipzig. In 1521, Luther stood trial for his life before the Imperial Diet at Worms. All these events pressed Luther to sharpen and solidify the platform on which he would take his stand. At the risk of death, Luther stood firmly on Scripture as the highest and last court of appeal. He preached and taught what the Bible revealed. With his whole heart, Luther believed Scripture to be God's inspired Word, given through His chosen prophets and apostles.

Few in world history could match Luther in knowledge and understanding of the Bible's content, including the original Hebrew and Greek texts. In the classroom—as professor at Wittenberg from 1512 until his death in 1546—and in the pulpit (from 1514 until his death), Luther considered it his highest duty to proclaim and expound the Word of God clearly and faithfully, humbly and forthrightly. The text of Holy Scripture was the measure and standard by which Luther

evaluated all doctrine and practice in the church. It was the litmus test by which he judged the indulgence trafficking and found it wanting. Luther employed Scripture to open the eyes of those attending the Heidelberg conference to the persistent tendency in the church to allow a theology of glory to encroach on and neutralize the theology of the cross, thus obfuscating the Gospel. And at Leipzig, Luther used Scripture to expose the charade of papal authority as supreme and God-given within the church, a myth that was hindering the saving Gospel itself.

During these initial years, Luther became increasingly convinced that deviations from sound doctrine within the church were deep and serious, so serious that a break was imminent and inevitable. The papacy had been working to call Luther to account, to quiet things if possible. In October 1518, while the Imperial Diet met at Augsburg, papal orders summoned Luther to meet with Cardinal Cajetan. In turn, Cajetan was under orders to get Luther to recant or to send him to Rome to face heresy charges. Elector Frederick at Saxony secured an imperial safe-conduct visa so his famous monk could attend the meeting. Of course, Luther refused to acknowledge that his stance on the Gospel was heretical.

THE LEIPZIG DEBATE

In 1519, Luther devoted himself to preparation for a debate at Leipzig with Johann Eck, an able protagonist for Roman Catholicism and a professor at the University of Ingolstadt. The debate was actually a response to theses drawn up by Luther's colleague Andreas Bodenstein von Karlstadt, but Luther was participating in the debate because Eck intentionally had added a thesis directed against Luther and his stance on papal authority. Karlstadt's performance at Leipzig was

inconsequential; he was no match for Eck.

On July 4, 1519, Luther entered the fray at Leipzig. He had prepared carefully for his encounter with Eck. Luther's approach was twofold: solid scriptural testimony coupled with sound attention to church history to support his positions. An official ruling concerning the winner of the debate was never given, though Luther apparently carried the day for the Reformation cause. Eck, of course, claimed victory for the Roman Catholic side over the so-called "Husite heretic," whom he obviously despised. When the Universities of Paris and Erfurt were asked for an evaluation and judgment on the debate's summaries, they cautiously declined to pronounce a decision on the proceedings, except to say that Luther's books were to be burned. Thus Luther and his writings were dismissed as heretical. He was deemed an enemy of the faith and the church. This forced the papacy and the church hierarchy to determine that the sooner Luther was brought to Rome to recant or to face punishment, the better.

The machinery was set in motion within the papal office to bring Luther to heel. He was gaining supporters, particularly in Electoral Saxony, which threatened the imposition of the Interdict, curtailing services and ministry to church members. By July 1520, news reached Germany of the papal bull *Exsurge Domine*, which threatened Luther with excommunication within 60 days unless he recanted. The bull was delivered to Luther through Eck and papal legate Girolamo Aleander, but it did not arrive in Wittenberg until October 10. Philipp Melanchthon, one of Luther's supporters, staged a protest on December 10 that included a bonfire in which the bull and papal canon law were burned. The die was cast; there was no turning back. Luther was determined to preach and uphold Scripture's core message, the Gospel that a sinner was justified in the sight of God by faith in Christ alone.

LUTHER'S COMMENTARY ON GALATIANS

There is little doubt that a key element in Luther's firm theological stance was Paul's letter to the Galatians. Like nothing else, this epistle reveals that only by faith in Christ's atoning work and sacrifice are sinners forgiven before God so they can stand righteous in His eyes. In Paul's inspired words, every agonizing sinner finds everlasting comfort in the bloody wounds of Christ, the world's Savior. Luther's love affair with the Epistle to the Galatians was lifelong, a fact demonstrated by the frequency of his lectures on the subject and the amount of his writings dedicated to the letter.[1]

Luther began his study of Galatians by carefully distinguishing the righteousness of which the apostle Paul speaks—the "righteousness of faith" or "Christian righteousness," which is taught and proclaimed by the Gospel—from other kinds of righteousness, including political or civil righteousness (abiding by statute law), ceremonial righteousness (conforming to given rules of religious practice and ceremony), and devout obedience to God's Law and statutes given through Moses. Concerning the latter "righteousness," Luther noted that Christians also teach obedience to the Ten Commandments, but only "*after* the doctrine of faith."[2] Such attention to the commandments was embraced within the believer's sanctified life, which Luther perceived to be the third use or function of God's Law in the believer's life. But the "righteousness of faith" proclaimed by the Gospel is the highest righteousness—and it is "altogether contrary" to the realm of human works.[3] For Luther, the righteousness of faith is a "passive righteousness" that transcends human comprehension because it is hidden in the mystery of God's unspeakable love and mercy toward His sinful human creatures. But the Gospel proclaims Christ, and Luther noted that "there is no comfort of conscience so solid

and certain."[4] Objective justification is the vital postulate on which faith rests. By faith it becomes the believer's possession for his or her personal or subjective justification before God, "the righteousness of faith, or Christian righteousness."[5]

Human beings, however, tend to "look at nothing except our own works, our worthiness, and the Law," Luther commented.[6] This fact causes sinful human flesh to return to some form of theology of glory, injecting one's own pious works and efforts into the realm of righteousness before God. Moreover, Luther noted that Satan stands forever ready to capitalize on the natural tendency of human beings to increase and encourage these thoughts.[7] According to Luther, the only recourse or remedy for a troubled, afflicted conscience that is struggling within sinfulness is for faith "to take hold of the promise of grace offered in Christ."[8] The troubled heart will only be at peace when it is fully persuaded that the Law cannot condemn it because of God's grace and mercy shown to it for Christ's sake. Luther wrote:

> Therefore when I see that a man is sufficiently contrite, oppressed by the Law, terrified by sin, and thirsting for comfort, then it is time for me to take the Law and active righteousness from his sight and to set forth before him, through the Gospel, the passive righteousness which excludes Moses and the Law and shows the promise of Christ, who came for the afflicted and for sinners.[9]

God's imputed (passive) righteousness belongs to the person of faith. Such righteousness before God is the priceless treasure to which faith clings. But Luther believed the Law is still necessary until believers are home in heaven at God's right hand. It continually presses down and drives sinners to daily contrition for sin. But repentant sinners cling firmly to the Gospel promise for forgiveness of sins. Luther added, however, that

no one should believe that he rejected good works; rather, these works were done through faith.

Is the righteousness that a Christian believer achieves by keeping God's Law ever good and meritorious? Luther addressed this question at Heidelberg, clarifying that a human being was unable to contribute anything to his or her salvation through works. In his lectures on Galatians, Luther pointed out how the apostle Paul, writing by inspiration, ruled out all human contribution toward a righteousness that avails before God. To the question of what human beings contribute to righteousness, Luther answered:

> For this righteousness means to do nothing, to hear nothing, to know nothing about the Law or about works but to know and believe only this: that Christ has gone to the Father and . . . He is our High Priest, interceding for us and reigning over us and in us through grace. Here one notices no sin and feels no terror or remorse of conscience. Sin cannot happen in this Christian righteousness; for where there is no Law, there cannot be any transgression [Rom. 4:15].[10]

Luther averred that this fact is a great treasure for every believer, and "if the doctrine of justification is lost, the whole of Christian doctrine is lost."[11] This righteousness is complete and perfect before God because Christ nailed all transgressions to Calvary's cross and triumphed over them for believers (Colossians 2:14–15). For Luther, no compromise between active and passive righteousness is possible. But confusion persists, penetrating Christian theology on this point. Satan's favorite tactic, Luther pointed out, is "to set against us those passages in the Gospel in which Christ Himself requires works from us."[12] Thus Christians must distinguish between the passive righteousness imputed through faith in Christ and the active righteousness that the believer pursues because of love for God. To

counteract Satan's prompting to elevate the latter, the Christian response is:

> Law, you want to ascend into the realm of conscience.
> . . . You are exceeding your jurisdiction. Stay within
> your limits, and exercise your dominion over the flesh.
> You shall not touch my conscience. For I am baptized;
> and through the Gospel I have been called to a fellow-
> ship of righteousness and everlasting life, to the king-
> dom of Christ.[13]

According to Luther, when Christ's righteousness reigns in the believer's heart, every faithful Christian "gladly works in his calling," knowing "that God wants this and that this obedience pleases Him."[14] Meanwhile, the believer continues to hold firmly to the Savior in faith, by whom the believer stands righteous and forgiven before God in heaven.[15]

Luther found the focal point or guiding principle of Christianity summed up by the apostle Paul in Galatians 2:16: "Yet we know that a person is not justified by works of the law but through faith in Jesus Christ, so we also have believed in Christ Jesus, in order to be justified by faith in Christ and not by works of the law, because by works of the law no one will be justified." According to Luther, God's Law teaches human beings that they are sinners. It zeroes in on the neuralgic point, humanity's sinfulness before God. It humbles humans and leaves no mistaken notions about self-righteousness or self-worthiness. Luther wrote: "A man must be taught by the law to know himself, so that he may learn to sing: 'All have sinned and fall short of the glory of God.' "[16]

For Luther, Paul's words demolished the formulas of merit in the Roman Catholic system. No person could possess a created grace whereby with free will he or she could earn God's favor and gain congruent merit. Nor could an individual advance spiritually, once endowed with the Spirit's graces, earn-

ing merit of worthiness and producing works pleasing to God and contributing toward salvation. Luther admitted that much of this theology of glory could be traced to the reasoned formulas of the Scholastics, but "the doctrine of the sophists about the merit of congruity and of condignity is mere ματαιολογια (1 Tim. 1:6) and that the entire papacy is undermined."[17]

In Luther's view, this gross obliteration of the distinction between Law and Gospel distorted and denied the truth of God's work on behalf of sinful humanity. For that reason, Luther considered the papacy to be the Antichrist. It had lost legitimate sanction for continued presence and esteem in the church because the papacy subverted and compromised the Gospel in which Christ's holy bride was garbed and made His beloved.[18]

Luther contended that Holy Scripture plainly taught that three things belong together: "faith, Christ, and acceptation or imputation."[19] These are the essence of Christian faith. The reformer wrote: "For through my works preceding grace I cannot merit grace by congruity, nor can I deserve eternal life by condignity through my merits following grace; but sin is forgiven and righteousness is imputed to him who believes in Christ."[20] For Luther, the very thought of grace ruled out all notions of merits of congruity and condignity, of earning God's favor. Good works do belong to each Christian's life, but they are the fruit of faith, inevitably present "because you have taken hold of Christ by faith" and "you should now go and love God and your neighbor. Call upon God, give thanks to Him, preach Him, praise Him, confess Him. Do good to your neighbor, and serve him; do your duty."[21] But when Luther saw works, piety, and religious practices elevated as contributing factors toward salvation, he saw the theology of the cross, the Gospel itself, exchanged for a theology of glory, which made one guilty of idolatry.[22]

With Galatians 2:16 in mind, Luther emphasized that a sinner's justification before God comes only through faith in Christ. But did Luther believe that charity, or love, played no role at all? Did Luther see any connection between charity and faith and justification? After all, Augustine taught that love forms faith. Without faulting the esteemed church father, Luther pointed out that correct wording is essential. Thus in a rare occurrence, Luther criticized Augustine, stating that Christian theology formulates the relation between faith and godliness in reverse order. Luther averred that faith forms love because it is from faith that good works flow, though they contribute nothing to the sinner's justification. Luther stated that human reason inevitably turns the formula around: If people are alive to God, they must do and perform God's Law. Luther, however, contended that Paul could have uttered nothing more effectual against the justification of the Law than to say, "I have died to the law."[23] Luther commented that Paul's words meant the Law no longer has a claim on believers or their consciences regarding salvation because they are saved by Christ alone. Of course, the Old Man is still with believers, daily causing them to sin, so the Law continues to accuse. But Christians are comforted and hold on to the assurance of forgiveness in Christ, thus they deflect the Law's valid incriminations with confidence. Luther wrote that Christians can say to the Law that they are dead to it because they live in Christ, who has redeemed them from sin and the Law's accusations. Christians may be overwhelmed by feelings of unworthiness because of sin, but they can look to the Savior, even as God's Old Testament people looked at the bronze serpent Moses placed in their midst (Numbers 21:9).

Luther summarized Christ's work for sinners beautifully:

These things be not done by the law or works, but by Christ crucified; upon whose shoulders lie all the evils

and miseries of mankind, the law, sin, death, the devil
and hell: and all these do die in him, for by his death
he hath killed them. But we must receive this benefit of
Christ with a sure faith. For like as neither the law nor
any work thereof is offered unto us, but Christ alone,
so nothing is required of us but faith alone, whereby
we apprehend Christ, and believe that our sins and our
death are condemned and abolished in the sin and
death of Christ.[24]

Never was the doctrine of the sinner's justification more clearly
and beautifully stated. The apostle Paul first pronounced it in
Galatians 3:13: "Christ redeemed us from the curse of the law
by becoming a curse for us." Luther stated that this means for
"all the sins of all men."[25] Christ was no mere icon to be
esteemed and looked up to; instead, He was wrapped in the
sins of the world. Christ shed His blood and gave His life on
Calvary to make atonement for all humanity. He became the
archsinner of all time, though He was holy and without sin.
Luther emphasized that Christ receives no honor when Chris-
tians lose sight of this fact. Luther urged believers to remember
that "if [Christ] is innocent and does not carry our sins, then
we carry them and shall die and be damned in them." That is
why "we must magnify the doctrine of Christian righteousness
in opposition to the righteousness of the Law and works."[26] For
Luther, if a sinner's justification before God rested on even the
slightest iota of personal works and religious practices—no
matter how piously conceived and defined or even authorized
by the pope himself—sinful creatures placed their eternal sal-
vation in jeopardy.

For Luther, God's Law performs a double function in this
world. On one hand, it is a curb that affects civil righteousness
among people and nations, restraining outbursts of evil. With-
out its impact and influence, humanity would be completely

self-destructive. "It is indeed very necessary," Luther stated, "but it does not justify."[27] Luther averred that the world continues to be "wicked and insane and . . . it is driven by its prince, the devil"[28] and is greatly in need of God's help. But humanity has not been left without help: "The other use of the Law is the theological or spiritual one, which serves to increase transgressions, [that is to say] . . . to reveal to man his sin, blindness, misery, wickedness, hate and contempt of God, death, hell, judgment, and the well-deserved wrath of God."[29] Luther asserted that this "use of the Law is extremely beneficial and very necessary" because it mirrors sin and presses home humanity's spiritual need for help.[30] More fitting even than "mirror," Luther denominated God's Law as "the hammer of death, the thunder of hell, and the lightening of divine wrath."[31] Accordingly, nothing else prevails in every sinner to "attack the presumption of righteousness, which is a rebellious, stubborn, and stiff-necked beast."[32]

Luther believed that human spiritual nature is inclined to be puffed up by self-esteem, like the Israelites at Mt. Sinai, who were "drunk with the presumption of their own righteousness."[33] Luther dubbed this spiritual inebriation "dropsy of the soul." Then the hammer of God's Law smashed to pieces all the vain boasts of self-righteousness and caused the people to cry out for God's mercy and help. The Israelites were proud of their compliance with God's statutes and with their privilege as His chosen people when in reality they were desperately in need of the precious Gospel that alone affords an answer and relief for their desperate dilemma under the Law's judgments and condemnations. Luther knew that sinners needed to understand the proper function of the Law—to reveal sin, engender wrath, accuse and terrify—so it would bring them to the brink of despair. But there it had to end.[34] At this point, all humanity needed the Gospel that "illumines hearts and makes

them alive. It discloses what grace and the mercy of God are" and works salvation as it draws sinners' hearts to faith in the Savior from sin: Christ Jesus, the Lord.[35] The treasure is given by God's grace alone, through faith, for Christ's sake (*sola gratia per fidem propter Christum*).

Luther pointed out that not even the fathers of the early church, such as Jerome, got this straight, though "Augustine taught and expressed it to some extent. . . . For unless the Gospel is clearly distinguished from the Law, Christian doctrine cannot be kept sound."[36] This was the dilemma in the church as the Reformation dawned, and it remains a problem whenever the Law intrudes into the arena that only the Gospel can occupy as the source for sinners' justification before God.

Luther had experienced what the apostle Paul described in Galatians 5:17: "For the desires of the flesh are against the Spirit, and the desires of the Spirit are against the flesh, for these are opposed to each other, to keep you from doing the things you want to do." Luther recalled how Johann von Staupitz lamented about his own efforts and pious resolve. Luther noted from his own experience the inverse proportion that invariably exists between the godliness of a Christian and the rigors of the spiritual battle in which he is engaged throughout his life: "This battle of the flesh against the spirit, all the saints have had and felt, if he is not a hypocrite."[37] This struggle continues as surely as sinful flesh continues to dwell in the believer's life. Thus the apostle Paul exhorted the believers at Galatia to be "led by the Spirit" (Galatians 5:18) and to pursue godly living as the Spirit empowers one to do so (Galatians 5:16–26).

Paul admonished that to be tempted and to commit sin are two different things. Do both happen in the Christian's life? Do saints ever fall? Are they ever without temptation or without sin? In what do they place their hope? Luther pointed out

that Holy Scripture teaches that even the saints do not live without concupiscence, without temptation. He described how Mary, Paul, and David were swallowed up with grief, sorrow, self-pity, and even more heinous sins. But how do Christians differ from unbelieving sinners? Luther affirmed that the Scriptures teach that believers, though they continue to succumb to sin, do not willfully continue in their sins. Instead, they repent and cling to the passive righteousness and redemption God has provided in and through Christ's life and sacrifice on their behalf. According to Luther, Christians should rise up daily and strive onward, each one seeking to fulfill faithfully his or her calling according to God's Word.[38] Thus Luther taught that the Law has three uses or functions: For the believer, it defines clearly the will of God. Second, it serves as a mirror or norm to drive home the reality of sin in believers lives. Third, the Law also serves as the norm or rule according to which the believer is guided in pursuit of God's standards. But Luther taught that hope does not lie in achieving these standards because the believer's performance is always deficient. Rather, hope is in the objective, passive righteousness won for all believers by Jesus Christ. In Him alone is hope, the source of forgiveness and peace, given by faith as "God spreads over them an infinite heaven of grace, and does not impute unto them their sins for Christ's sake."[39]

"But we teach," Luther stated, "that the church has no spot or wrinkle (Eph. 5:27) but is holy, though only through faith in Jesus Christ."[40] In this life, the church contends against the lusts of the flesh, evil desires, sinful opinions, and errors. As soldiers of the cross, Christians strive to avoid the works and lusts of the flesh and stay clear of sinful trust in personal righteousness. "For the church always confesses its sin," humbly and contritely clinging to Christ because in Him alone is hope and salvation.[41]

Luther's encounter with Eck at Leipzig exemplified that it was this doctrine on the justification of sinners before God that motivated the reformer. This was the pure Gospel that God had given to the church to proclaim. Luther was the voice within the church that cried out against the intrusion of a theology of glory hidden under the cloak of the Gospel. For Luther, the church's message was to be the theology of the cross and no other. It alone distinguished the Christian church from all natural theologies in the world. Luther said:

> The most important article of the entire body of Christian doctrine is how we are saved. If this article of our soul's salvation is grasped and held with a sure and firm faith, the other articles, such as that of the Trinity, will easily follow. Nor has God so patently and clearly explained any other article as he has this one: that we are saved solely through Christ. Although he has also said much of the Trinity, yet he has always lingered over this article of the soul's salvation. The others are, of course, also important; but this is the most important one ... Workmongers are deceived; there is no salvation outside Christ; he can be grasped and apprehended only in the Word by faith. If this article remains pure, the church also remains pure, but if it is falsified or falls, the church has become a harlot, and is gone, as we have seen and experienced in the papacy.[42]

5

Upon This Rock

Prelude to the Diet at Worms

Beginning in Leipzig, Martin Luther carried the brand "heretic" in official circles of the church. He was slurred as a "Bohemian" and as an outcast. Yet without Leipzig, there would have been no Worms. Luther's preparation for his confrontation with Eck fine-tuned him for his heroic stand at the Imperial Diet in Worms in 1521.

Much would take place, however, before Luther's dramatic refusal to recant. Emperor Maximilian died in January 1519, unleashing political unrest in the Holy Roman Empire. After five months of political maneuvering, the seven electors of the realm elected Maximilian's grandson Charles of Spain—who was barely 19 years old—to succeed him. The charter Charles signed to ascend the throne required that he safeguard Germany against all threats to its borders, including the pope's machinations. He also had to ensure that if any German citizen was brought to trial, the trial would be held on German soil, a pledge that would be of strategic importance to Luther.

Luther's prince, Elector Frederick the Wise—who had been a prime candidate to be emperor until he declined the post—resolved that his Wittenberg professor would not be

sent to Rome for trial on charges of heresy. Thus Luther was temporarily protected from surreptitious seizure by papal agents. Whenever he traveled from Wittenberg, Luther always had an imperial safe-conduct visa and was accompanied by an officer of the realm. But Luther spent a rather quiet 1520 waiting in Wittenberg as the papacy mustered evidence and muscle against him, building the heresy charge and preparing the formal bull of excommunication.

By the 1520s, the power and authority of the pope had diminished considerably in German territory. Before this time, the threat of the Interdict—curtailing all priestly ministry in a given region—afforded the papal office extraordinary power and control not only in ecclesial matters but also in the political realm. With this threat, outcomes could be conformed to the will of the reigning pope. But Pope Leo X could not count on such compliance in the territories governed by the seven German electors of the Holy Roman Empire. Moreover, public sentiment in general had swung in Luther's favor and against autocratic intrusion into German life and society from the outside, even in the realm of the church. A restless mood had come over society in general, from the peasants to the burghers, or city-dwellers, to the upper classes and the nobility.

But Luther was no rebel. In fact, he always stood for law and order. So while early public sentiment built in his favor, he did not exploit it. With the threat of excommunication hovering, the year 1520 became one of the most productive of Luther's life. While faithfully tending to his duties at the university and fulfilling his pastoral calling at St. Mary's, Luther churned out no less than thirty significant treatises on issues pertinent to individual life and society as a whole. Although Luther's literary work and correspondence during those early years fills volumes, the focus here is on four treatises from 1520

that had significant impact on society and specifically on Christians, whatever their station in life.

"Treatise on Good Works"

One of the first treatises to appear in 1520 was "Treatise on Good Works,"[1] which Luther dedicated to Prince John, brother of Frederick the Wise. Luther wrote with the average Christian layperson in mind, addressing the lawlessness and even immorality of which he had been accused because of his emphasis on faith alone in salvation. Luther wanted to set matters straight. Different from many modern crusaders who harp on current issues and neglect the essentials that undergird society, Luther explicated on the basis of the Ten Commandments the necessary fruit that flows from faith in Christ and how Christians seek to conform their lives according to God's will. Luther's treatment of the subject became the first evangelical text on the godly life of a Christian. Luther wrote that while still a sinner, a child of God lives before the Lord in humble faith, clinging to Christ for forgiveness. Different from Aristotelian ethics, Luther showed how the Christian believer's source of strength is God, not the self. Luther believed such godly living by believers was a fundamental underpinning of Christian society.

Luther wrote that a believer's life was characterized by three stages. First, all the works in a believer's life flow freely and joyfully out of love for God, without thought of merit. A person who doubts and frets whether enough has been done is not at one, or at peace, with God, fully trusting Him and His mercy in Christ above all things. The second stage of faith is exemplified by the fact that a believer loves God even when He permits suffering, confident that the Lord has not forsaken him. The child of God also refrains from blaming those

around him or the devils in hell. The third stage of faith, and the highest, according to Luther, is that which persists and prevails when torments of conscience seek to overwhelm and destroy the child of God. Luther personally had gone through these stages. He believed they also portrayed each believer's life. Luther had come to realize that there was no help other than the sweet Gospel that God proclaims in His Word. Faith and trust in that Gospel, worked in hearts by the Holy Spirit, was the firm foundation on which every Christian's life must be based. Out of this faith flowed every good work in the believer's life.

"Treatise on Good Works" was a positive and serene production amid the turbulent years. It demonstrated the sincerity of Luther's ministry to and for people. The years 1518 and 1519 had been marked by Luther's sharp encounters with papal emissaries, notably the papal court theologian and Dominican monk Sylvester Prierias, as well as Cardinal Cajetan. These emissaries pressed Luther to recant, to acknowledge his error in questioning papal authority in the indulgence squabble. At a prearranged meeting in Augsburg in 1518, Cardinal Cajetan confronted Luther with the charge that he was violating the pope's God-ordained authority, the authority of the church. The cardinal told Luther he needed to recant or he would be charged with and stand trial for heresy.

While the call for official ecclesiastical action increased, public sentiment, especially support from leaders in various sectors of Germany, offered increasing support for Luther. He had demonstrated that the church—the pope and the Curia—had seriously compromised and trodden on the lives and rights of the citizenry. It had acted contrary to the Word of God yet demanded compliance on threat of discipline, including excommunication from the church and its sacraments. Through his research in preparation for the debate with

Johann Eck in Leipzig, Luther had become convinced that the papacy and Curia had become a scourge on the world because they abused their power and authority in the name of God and His Word. It was at considerable risk that Luther took this stance, but his encounters with the papal henchmen Prierias, Cajetan, and the Franciscan Alveld served to sharpen and crystallize Luther's position. In response to Alveld, Luther penned "On the Papacy in Rome," which in turn led to the writing of "To the Christian Nobility of the German Nation."

"On the Papacy in Rome"[2]

This tract was published when Luther's support from the ruling class had reached its zenith and is perhaps one of his most important works. It is packed with facts that clearly state the abuses—moral, religious, economic, political, and social—that had come to plague the world. Luther perceived that these ills in various ways stemmed from corrupt papal authority. The treatise provides a valuable description of all areas of sixteenth-century life.

Luther believed there were three walls behind which Rome or the papacy hid and dominated people of every station. First, Rome brashly claimed and operated under the rubric that the church—pope, bishops, and priests—constituted its own jurisdiction above the state and temporal rulers. Second, in the interpretation of Scripture and matters of religion, supreme authority was vested in Christ's vicar on earth, the pope. Third, only the pope had the right and power to call a general church council. Under such an autocratic ordering of things, the papacy had become a scourge on the commonwealth of the realm, whether of low or high estate. Thus Luther's proclamation that all Christians constitute the "spiritual estate," not only the vested clergy of the church, sounded

a welcome note in the world. Luther stated there was no essential difference between clergy and laity except for the office conferred on the priests so they could minister to the people. This office did not exempt the clergy from temporal jurisdiction nor was the pope excluded. Equally flimsy and worthless in Luther's opinion was the claim that the pope alone possessed infallible authority in interpreting Scripture.

Point by point, Luther listed the many abuses that existed in the church and in society. The list illustrated the vastness of the problem. First, the worldliness of the papacy, the cardinals, and the Curia; their inadequate administration of the church; and their extravagant living had made the church a laughing-stock in many circles. Closely connected with these critiques was the buying and selling of church offices, especially those related to the governance of the dioceses of the realm. By controlling these offices, bishops became feudal lords, owing their allegiance in turn to the pope. Luther identified a dozen or more glaring ills afflicting the papacy's administrative dealings, confidently asserting, "Let no one accuse me of exaggeration. It is all so open . . . I really think it has just reached the limit."[3] Luther followed his catalogue of the ills with proposals for reform.

It is evident from this treatise that the public must have been aware of—and offended by—the questionable practices and dealings of the church and some of its clergy. Because he spoke so clearly of the sore spots troubling church and society, Luther's treatise brought many evils into the open. Luther realized that by publicizing the wrongs and calling for reform, he had in effect cut himself off from the church as it was presently constituted. Therefore, in the preface to a reprint of "On the Papacy in Rome," Luther declared: "And now farewell, unhappy, hopeless, blasphemous Rome! The wrath of God has come upon you in the end, as you deserved."[4]

Centuries later, the blunt, plainspoken manner in which Luther wrote this treatise is a main feature. He obviously knew the die had been cast as far as his own position was concerned; the rumblings about his impending papal excommunication would clearly become fact. But Luther was not a rabble-rousing rebel, though he was a champion for the fundamental rights of Christians, rulers or peasants. Luther zeroed in on the problems society faced and the possible solutions. Because the church played a prominent role in all affairs, including political, Luther targeted Rome and the papacy. His boldness in listing the wrongs and offering correctives indicates the public was aware of the papacy's involvement in society's ills.

Luther's concluding thoughts in "On the Papacy in Rome" were significant. He referred to the travesty connected with the burning of John Hus and Jerome of Prague despite the "papal, Christian, imperial oath and promise of safe-conduct."[5] Luther stated that Roman Catholic practice at the time underscored that it was wrong to compel "the Bohemians to abolish both kinds in the sacrament since that practice is neither un-Christian nor heretical."[6] The universities of the day also received a boost in Luther's treatise as he contended for high academic standards and a godly way of life. He also made a pitch for sound biblical theology with a stress on biblical languages. Luther believed that education in general required attention and support, and he specifically mentioned the education of girls.[7] The reformer pointedly accused the papacy of insinuating its will on the people of Germany, asserting, "There is now a second Roman Empire, built by the pope upon the Germans."[8] Luther did not ignore economic and social reforms either, specifying the need for people to refrain from overindulging in food, drink, or their appetite for luxuries. Luther's closing admonition reminded the reader, "I would rather have the wrath of the world upon me than the wrath of

God."[9] Luther added one final salvo, as it were, informing his readers that another treatise addressing the errors of the church was on its way.[10]

The 4,000 copies of "On the Papacy in Rome," which was addressed to the German nobility, were quickly exhausted, and its impact was considerable. Luther was heralded as a spokesman either of the Holy Spirit or of the devil, depending on the reader's position. "On the Papacy in Rome" represents the embryonic form of the principle of separation of church and state, a separation that would provide critical interaction between the realms without trespassing on either realm's responsibilities. As Luther presented it in this treatise, the scriptural doctrine of the priesthood of all believers also was an influential restoration of a fundamental truth in the life and structure of the church and of society.

"THE BABYLONIAN CAPTIVITY OF THE CHURCH"[11]

This treatise focused on theological issues. It evidenced Luther's conviction that Rome's chief fault was theological, not merely its heavy-handed administrative practices. This treatise was written in Latin, which indicates it was intended primarily for clergy and academics. Although it reveals Luther at the culmination of his theological attack against Rome, he probably never considered this treatise to be a final statement of his position. It is evident, however, that Luther was now convinced there was no turning back in his opposition to papal theologizing and authority. Moreover, word of the papal bull against him and the Reformation had reached Wittenberg.

Luther's intention in "Babylonian Captivity of the Church" clearly was to present the theological grounds for his position. Supposedly when Erasmus read this treatise, he sagely commented, "The breach is irreparable."[12] Through con-

scientious study of God's Word, Luther had become convinced that the wall behind which Roman Catholic theology hid and exercised its autocratic rule over the faithful was its unfounded claim of infallible divine authority over the biblical word and its meaning.

Luther launched this treatise by stating: "Some two years ago I wrote on indulgences, but in such a way I now deeply regret having published that little book. At that time I still clung with a mighty superstition to the tyranny of Rome. . . . I now know for certain that the papacy is the kingdom of Babylon."[13] His exploration of the Scriptures, following the furor caused by the "Ninety-five Theses," had convinced Luther that the papacy had fashioned a tyranny over souls to rival the bondage inflicted on the Israelites by the Babylonians. Sacramentalism (the belief that the sacraments are necessary for salvation) and sacerdotalism (the belief in the necessity of a priest as mediator between human beings and God), so vital in Roman Catholic theology, gave the papacy a stranglehold over people's lives from cradle to grave, from Baptism to Extreme Unction. But Luther averred that the Scriptures revealed that however pious the original intent may have been to enhance church practices, God had ordained only Baptism and the Lord's Supper as means of grace in support of the precious, saving Word of the Gospel. Luther was willing to include a third sacrament—confession and absolution— because it delivered the pronouncement of forgiveness to the penitent. In effect, this third sacrament actualized the preaching and application of the Gospel to penitent believers for their forgiveness.

In Luther's review of the sevenfold roster of Catholic sacraments, Baptism and the Supper received first and primary attention. He began by addressing the Eucharist, showing from Scripture that the cup was meant for every believing, contrite

sinner, not only for the clergy. He also pointed out that the bread and wine were not transubstantiated but were in communion with Christ's body and blood in the Sacrament. Moreover, Luther stated that the metamorphosis of the Supper into a sacrificial Mass that was offered to God by the priest for the people was without warrant and diminished the perfection of Christ's once-for-all sacrifice for sin. In the same way, Luther said that the elevation of the host in the Mass was unnecessary.

Second, Luther treated the God-given sacrament of Baptism, rejoicing that it most often stood at life's beginning so it had escaped significant exploitation within the church. However, Luther deplored the church's use and teaching of Baptism that had caused it to be viewed as inferior to the sacrament of penance, a view Luther said was contrary to Scripture's teaching. Instead, Baptism's promise was a sturdy plank that never sinks. Through daily contrition and faith in the Savior, Baptism's blessings endure to the end of life. Luther stated that neither works of satisfaction nor pilgrimages nor religious vows adduced any power or benefit beyond what Baptism bestows on all believers, namely, that in Baptism believers partake of the benefits of Christ's death and resurrection. The apostle Paul affirmed this when he addressed the believers in Rome: "All of us who have been baptized into Christ Jesus were baptized into His death . . . so that we would no longer be enslaved to sin" (Romans 6:3, 6). For Luther, Baptism lost its power only if one lost faith in God, doubting His promised forgiveness that is sealed by Baptism's washing.

Luther boldly stated that to rank the rest of the sacraments in Roman Catholic theology with Absolution, Baptism, and the Supper was without foundation or scriptural warrant. As with indulgences, Rome had made a tyranny out of the ministry of the saving Word, literally locking up the faithful under a regimen of saving acts from cradle to the grave,

including the sevenfold sacraments. Luther deplored that the church had added works of satisfaction determined by the priest as a necessary component to confession and absolution. On Scripture's clear testimony, Luther affirmed that "a contrite heart is a precious thing, but it is found only where there is a lively faith in the promises and the threats of God."[14] Thus Luther set straight the proper roles of Law and Gospel in the spiritual conditioning of the sinner, or as Jesus explained to Nicodemus, "You must be born again" (John 3:1–21). Luther believed that when the church added its own rules to what God had ordained, sinners were directed away from the comfort of the Gospel and left confused. "There is no doubt that confession of sins is necessary and commanded of God," Luther averred,[15] but Roman Catholicism's creation of the "sacrament" of penance distorted what God had mercifully done for sinners and turned it into a grueling and forever uncertain dilemma concerning one's efforts at satisfaction. Luther saw that penance undercut and even negated what the Gospel so gloriously proclaimed, as Paul told the Corinthians: "In Christ God was reconciling the world to Himself, not counting their trespasses against them" (2 Corinthians 5:19). Christ Himself had commissioned the church to proclaim this comforting Gospel to all the world: "Whoever believes and is baptized will be saved, but whoever does not believe will be condemned" (Mark 16:16).

Luther never doubted the importance of religious education for the young. His 1529 Small Catechism—and the Large Catechism published later in the same year—testifies to this focus. Throughout his life, Luther saw the need for sound education of young and old in the things of God, the truths taught in the Scriptures. But he demurred that the rite of confirmation was a sacrament that was necessary to salvation. He pointed out that at best it was a useful church rite, one to be

valued and retained in the church's ministry for orderly preparation of the young in the things of God.

Luther was more outspoken in his judgment of marriage as a sacrament. The Bible plainly spoke of the union of a man and woman in marriage as established by God from the beginning. Moreover, Scripture clearly delineated the relation of each partner in this bond of wedlock. Luther upheld and urged these scriptural roles, but he believed it was a farce to make of this relationship a sacrament under the church's governance and control. Luther stated that the marriage of unbelievers was as valid as that of Christians. A marriage did not confer grace or forgiveness before the throne of God in heaven. The marriage of Christians would, of course, be enriched and blessed by the faith they shared in their gracious God.

The rite of ordination, likewise, had been transformed into a sacrament within the church's theology and practice. It bestowed higher station, grace, and power on the priest, a position to be esteemed by the one ordained and those over whom he presided as spiritual master. "Here, indeed, are the roots of that detestable tyranny of the clergy over the laity," Luther stated.[16] He pointed out that on the basis of 1 Peter 2:9 "we all are priests, as many of us as are Christians. But the priests, as we call them, are ministers chosen from among us."[17] The calling (ordaining) of a qualified man into the office of pastor followed apostolic practice or example, Luther granted, but to embellish it with sacramental meaning and status was entirely without scriptural warrant. He contended, "Christ knows nothing of it."[18]

The seventh sacrament of the Catholic church—Extreme Unction—likewise did not qualify as a means of grace like Baptism and the Lord's Supper for Luther. The reformer did not minimize the importance of a pastor's ministering to and praying with the sick and dying because the Bible taught in

James 5:14–15 that it should be done. Luther cautioned, however, that

> even if the apostle James did write it, I still would say, that no apostle has the right on his own authority to institute a sacrament, that is, to give a divine promise with a sign attached. For this belongs to Christ alone. ... Nowhere do we read in the gospel of the sacrament of extreme unction.[19]

Although Luther remained sensitive to each person's final moment of life and how they handled death, he could find nothing in Holy Scripture that justified making Extreme Unction a sacrament.

Luther concluded "Babylonian Captivity of the Church" with a summarizing statement: "There are, strictly speaking, but two sacraments in the church of God—baptism and the bread. For only in these two do we find both the divinely instituted sign and the promise of forgiveness of sins."[20] He recognized the God-given benefit and value of confession and absolution in a believer's life. Thus he added in explanation, "The sacrament of penance, which I added to these two, lacks the divinely instituted visible sign, and is, as I have said, nothing but a way and a return to baptism."[21] Luther urged sinners to cling to and to return throughout life to the gracious promise of forgiveness that is theirs under the canopy of grace given in Baptism, which was instituted by Christ for salvation's sake, as well as to the sacred pledge of His body and blood in the Supper that Christ promised as a seal of the mercy and forgiveness of God.

Luther's "Treatise on Good Works," which had been addressed to the nobility and rulers of Germany, had focused on abuses that affected society in general. "Babylonian Captivity of the Church," though less popular, was no less important because it struck a blow to the solar plexus of Roman Catholic

theology: the sevenfold sacramental system. Through this system, the church had placed people into virtual slavery to the ceremonies and rites controlled and administered by the clergy. The effect was crass infringement on the individual conscience. In opposition to the wrongful elevation of the priestly class, Luther emphasized the priesthood of all believers. He had touched on this scriptural truth in "On the Papacy in Rome" and would do so again in "The Freedom of a Christian." Baptism and the Lord's Supper were given their rightful place not as tasks to be done by the faithful, but for the benefits received by faith in each believer, including infants. Confession and absolution was strongly supported not as a sacrament, but as a key aspect of the Christian life. Luther also upheld the bond of marriage as a civil contract between a man and woman while also acknowledging that it was a sacred relationship established by God. Thus "The Babylonian Captivity of the Church" had a profound and lasting impact, though Luther did not consider it to be a consummate piece of theological writing.

"THE FREEDOM OF A CHRISTIAN"[22]

A fourth significant writing of 1520 appeared in late fall. Luther had promised it in the conclusion to "Babylonian Captivity of the Church." Different from the preceding works, "Freedom of a Christian" was conciliatory and included a letter to Pope Leo X. It was a beautiful portrayal of the life of a Christian, a free man before God by virtue of his justification by grace alone through faith in Christ yet a servant of all in sanctification, in good works flowing out of faith.

Luther explained that he had been urged to write this treatise to affirm that he was not a radical iconoclast of the Christian faith but that he firmly supported it and Christ's

church. Earnest prompting on the part of associates and by the papal chamberlain or nuncio Karl von Miltitz, a member of the lesser Saxon nobility, helped to actuate the treatise. Miltitz had sympathized with Luther because of vituperative opponents such as Johann Tetzel and Johann Eck, particularly the latter in the Leipzig Debate of 1519. In several meetings, Miltitz urged Luther to "silence," but in mid-1520, when word of the papal bull *Exsurge Domine* was in the air, Miltitz suggested a conciliatory treatise to Pope Leo X that would assure the pontiff that Luther's critique of events and dogma within Roman Catholicism was not meant as a personal attack. Thus Luther decided to include as a "gift" to the pope this treatise on the freedom, or liberty, of a Christian believer, accompanied by a prefatory letter that expressed Luther's assurances concerning his motivation for his critiques. The treatise was meant to illustrate the kind of work Luther would like to do, if his enemies would leave him alone. By mid-November 1520, "Freedom of a Christian" was already in circulation. There is no record whether Luther's letter and copy of the treatise were received at the Vatican or, for that matter, whether they were read by the pope.

Luther pulled no punches when it came to criticizing the Curia, which "neither you nor anyone else can deny is more corrupt than any Babylon or Sodom ever was" and a threat to the papal office itself.[23] Luther firmly stated that he could not recant his position because to do so would deny the authority of God's Word. Nor would Luther accept man-made rules for interpreting the Word of God, even when issued from the papal office. By sending the pope "Freedom of a Christian," Luther sought to demonstrate the clarity and authority of the biblical text.

Luther stated in prefatory remarks that the treatise offered a brief statement of everything related to the Christian life. Then the reformer offered two propositions around which

he would proceed, namely: "A Christian is a perfectly free lord of all, subject to none. [And a] Christian is a perfectly dutiful servant of all, subject to all."[24] Luther continued that "these two theses seem to contradict each other. If, however, they should be found to fit together they would serve our purpose beautifully."[25] Luther followed with many apt citations from Scripture, especially from the Psalms and Paul's Epistle to the Romans.

Luther skillfully articulated and portrayed how the freedom the believer has received through faith in Christ ties him, not unwillingly but happily, in a "bondage" to God and man because of his freedom in Christ. Aside from the Bible itself, a more perfect depiction of a sinner's justification before God and the life of sanctification would be difficult to denominate within the Christian realm of theological writing.[26]

Luther affirmed and demonstrated that a Christian lives in Christ and for his neighbor. This freedom or liberty is not an occasion for license nor for slavish observance of rituals. For Luther, faith in Christ did not free the believer from works but from false opinions about justification by works. Ceremonies and rituals serve their purpose, like a builder's plans and models, because they help to train people in worship, especially the young. But when ceremonies and rituals are taught as necessary elements of the Christian faith and are demanded of worshipers, then the freedom of the believer in Christ has been compromised. Luther noted that the pieties practiced by believers and the rules they followed had usurped the place meant for Christ alone. The theology of the cross has been replaced by a theology of glory. "When laws and works are prescribed, that righteousness must be obtained through laws and works . . . it is impossible that they should of themselves escape . . . and come to a knowledge of the freedom of faith . . . as [God] has promised."[27]

On December 10, exactly 60 days after receiving the papal bull in Wittenberg, Luther solemnly cast it, along with books of canon law and other papal decretals, into a bonfire set by university students (at the prompting of Philipp Melanchthon) outside the Elster Gate. As a doctor of Holy Scripture, Luther took his office as theological professor of biblical studies at the university and conscientious pastor at the City Church seriously. Luther's response to the papal bull demonstrated his repudiation of the false teaching and dangerous confusion that had entered into the church's doctrine. His action was not committed in rash anger; instead, it was offered out of deep concern for the church of Christ and the travesty that had encroached on people's lives in God's name. As Luther saw it, the antichrist had come to roost within the church, Christ's precious bride.

Charles V, who had occupied the emperor's throne for little more than a year, was actually in favor of a reformation of sorts. He favored, however, a reform more in line with the Renaissance, one in the style of Erasmus. Charles probably had little idea of or appreciation for the doctrinal issues Luther had pinpointed in his theses and treatises, though the emperor did believe that the church should refrain from interfering in the political realm. In fact, Charles's coronation oath said that he would defend the German territories against the arrogance of Rome and not allow any German citizen to be taken to Rome for a trial without first receiving a hearing and opportunity for defense on German soil. But Charles had no sympathy for any rebel who disturbed the peace, whether for spiritual or temporal causes. Regardless of his views, Charles wanted to remain a loyal member of the church, and his oath of office also included his pledge to defend the faith and the church, as well as to render due subjection and compliance to papal authority.

On January 3, 1521, Pope Leo X issued the bull *Decet*

Early in 1520, Luther preached a series of sermons that presaged the matters addressed in these treatises. With the Ten Commandments as the focal point, Luther's messages had been foreshadowed in published form in the "Treatise on Good Works." Luther was aware that his emphasis on salvation by grace alone through faith and not by works had been criticized as promoting lawlessness. His purpose, therefore, in preaching on the commandments was to inspire his listeners—gladly, because they are God's children—to conform their whole lives to the rubrics of God's holy will.

In a manner of speaking, therefore, Luther believed the Christian had no need for a teacher of good works because they flow naturally, spontaneously, out of faith. But Luther knew all people were sinners and in desperate need of guidance, as well as prompting and power for holy living. Therefore, faith leans on God's guidance and prompting as taught in His commandments. Beautifully, scripturally, Luther laid out the meaning of the commandments, following the order in which they were first spoken by God. For each commandment, Luther explicated how faith received forgiveness and thereby purified the content and worth of these works so they would be pleasing to God.

Thus "Treatise on Good Works" became the first evangelical treatment of Christian ethics and morality. A view of ethics based on Law and Gospel and their appropriate application, the "Treatise on Good Works" formed the backdrop for Luther's three more conspicuous works of 1520: "To the Christian Nobility of the German Nation," "Babylonian Captivity of the Church," and "Freedom of a Christian." The awesome production of booklets and treatises by Luther in 1520 set the stage for a confrontation, pitting the papacy against the priesthood of believers, the latter having gained a voice through the efforts of the Wittenberg monk. A new day was dawning for

the church and for the Gospel, which had long been held in bondage. God had prepared His chosen spokesman for a crucial midstream course correction for the church and the world.

6

The Diet at Worms

The Continental Divide of Modern World History

The papal bull threatening Martin Luther with ⸻cation was on the way from Rome to Witten⸻ summer 1520. Johann Eck, Luther's opponent in ⸻ Leipzig in 1519, and papal emissary Girolamo ⸻ given the task of publishing the bull in the S⸻ Titled *Exsurge Domine*—"Arise, O Lord, in thine⸻ 7:6)—the bull spelled out more than 40 suppose⸻ doctrine committed by Luther. Unless he reca⸻ days of reception of the bull, Luther would be e⸻ from Christ's church as a manifest and unrepe⸻ would deserve to burned at the stake along wi⸻ writings. Charles V, emperor of the Holy Rc⸻ loyal servant of the church, as well as the te⸻ Germany, were expected to support this ju⸻ October, Luther had received a copy of the b⸻ was concerned, the charges were false and u⸻ they illustrated and reinforced the faulty the⸻ tice of Rome against which he had taken h⸻ ings that had issued so rapidly from his ha⸻

Romanum, which effected Luther's excommunication from the church as an unrepentant heretic. It appeared Luther's case was sealed and his cause lost. The emperor directed Elector Frederick the Wise of Saxony to invite Luther to a hearing at the Diet of Worms, which was convening January 27, 1521. Cardinal Aleander, the papal legate, protested that to invite an excommunicated monk to the hearing was an insult to the pope. Thereupon, Charles V recalled his "invitation" and ordered that Luther be brought to the diet so the assembled territorial princes might act on his case. Frederick, seeing through the devious scheme that would place his esteemed professor within Rome's clutches, protested. He was joined by the rest of the German princes and electors. They maintained that as a German citizen Luther must have a fair trial and a guarantee of safe conduct before the diet could adjudicate his case. Cardinal Aleander argued for almost three hours that it would be unprecedented for a condemned heretic to be given such consideration, but his arguments were to no avail. The electors supported Frederick, much to the cardinal's dismay.

In early March, the imperial summons ordering Luther to Worms was drawn up and delivered to the Wittenberg reformer personally by the emperor's herald, Caspar Sturm, on March 29, along with a voucher guaranteeing safe conduct. Luther left Wittenberg for the diet on April 2. He was accompanied by Sturm and a considerable number of supporters, among them his associate and close friend Nikolaus von Amsdorf, who was also a member of the Wittenberg University faculty. Duties at the university prevented Melanchthon from accompanying Luther. As the party passed through Erfurt, they were joined by the jurist Justus Jonas, who was a devoted supporter throughout Luther's life.

Public sentiment on behalf of Luther's cause had increased, a fact that Emperor Charles V knew. As the travelers

proceeded toward Worms, Luther was prevailed on to preach at the various overnight stops. He always consented, offering evangelical messages that were not inflammatory. Several somewhat devious attempts to divert Luther from the designated route seem to have been made, but he and his associates recognized when such "invitations" were really subtle efforts to maneuver the reformer into the hands of his opponents. In addition, Elector Frederick had arranged for two sturdy Saxons to act as Luther's bodyguards. The whole entourage, with a few delays, reached Worms by April 16, 1521.

Luther's case was scheduled to be heard on April 17 at 4 o'clock in the afternoon. And it was truly to be a hearing, not a presentation of an issue already decided, because the German princes had insisted on a hearing. Jerome Schurf, Elector Frederick's jurist and legal adviser, informed Luther that when the emperor's moderator asked whether he was prepared to recant, he should ask for time to evaluate his position. After all, this was to be a hearing, not a condemnation. Accordingly, Luther asked that the titles of the books before him on the table be read to verify that they were indeed from his hand. After confirming they were authentic, Luther then requested additional time for consideration and his response.

On April 18, Luther was again asked whether these were his writings and whether he was prepared to give an answer and recant what he had written. Despite the fact that it was late in the day, Luther offered his answer in the form of a long speech. He had prepared carefully and spoke loudly, firmly, and with confidence. Instead of recanting what he had written, Luther elaborated briefly on the nature and content of the writings. The hall was crowded with listeners, and many more gathered outside under the windows to listen. It was a warm day, and Luther perspired as he proceeded at length to explain and defend what he had written. His books and treatises were

of three kinds, he stated. First, he had provided writings in support of practical Christian living and morals. Second, some writings targeted the gravamina sparked by the papacy and Curia, serious grievances that concerned believers in the church agonized over and about which they complained. Third, there were the responses he felt constrained to make against the vitriolic attacks leveled at him by those defending the papacy and conditions in the church. Luther admitted to speaking in a harsh and straightforward manner, but he had been defending the religion of Christ. And in no way did he feel that the things he had said were contrary to the faith, nor was he ready to withdraw them or recant them.

Supposedly after Luther finished speaking, the emperor rose in anger, as did his Spanish courtiers. Amid the enraged listeners, Luther was led safely from the hall by ranking members of the diet. Before leaving, he had been asked once more, in a final confrontation, despite all he had explained, whether he was prepared to recant the stance he had taken and the books he had written. Luther declared in a loud voice:

> Unless I am convinced by the testimony of the Scriptures or by clear reason (for I do not trust either the pope or in councils alone, since it is well known that they have often erred and contradicted themselves), I am bound by the Scriptures I have quoted and my conscience is captive to the Word of God. I cannot and I will not retract anything, since it is neither safe nor right to go against conscience. May God help me. Amen.[1]

In the confusion that ensued, it is not certain that these were Luther's exact words because the court reporters were unable to record the words amid the commotion. Luther never verified whether these were his words, but he also never denied them.

Despite the furor Luther's case had ignited—and probably because of it—the emperor brought the diet to an end.

Charles V wanted to deal harshly with the heretic because he could not understand how one man could be right when the church had believed and taught differently for a thousand years. The electors, meanwhile, were in a quandary. A week-long discussion ensued as they debated what to do with Luther. The result was a split vote: five supported the emperor in his condemnation of Luther as an unreconcilable heretic while two electors—those of Saxony and the Palatinate—supported Luther against the papal and Curial gravamina that lay at the bottom of his protest. To complicate matters, placards began to appear in Worms linked to the *Bundschuh*, which was a radical secret peasant society of which the princes were all wary. (The *Bundschuh* was not connected with Luther's cause.) One of the electors, the Archbishop of Trier, asked Luther if he would agree to submit to a general church council's decision. Luther replied that he would, if it was held quickly and if he would be allowed to defend himself against the grievances he had addressed in his writings.

All such negotiations came to a dead end, however, and the emperor, grown impatient with the delay, sent notice to Luther that the guarantee of safe conduct would end the next day, April 26. Elector Frederick quickly worked out a strategy for his esteemed monk's safety on the journey home. Luther and his party, including the imperial marshal and bodyguards, left Worms for Wittenberg, but the elector had arranged for his younger brother, John, to "kidnap" Luther. The plan worked well, and the imperial guard was driven off along with the rest of Luther's party as his abductors came suddenly out of the Thuringian forest on horseback. The "kidnappers" took Luther to the safety of the Wartburg Castle near Eisenach, which was the elector's stronghold in that part of Saxony. Luther would remain at the castle for almost an entire year.

Meanwhile, back at Worms, the emperor, unaware of the

"abduction," tried to proceed with Luther's case on April 30, but he was stymied by the failure to get the electors' compliance. Charles needed their continued support for military reasons, however, thus he could not press for a vote without the approval of each leader. The Diet at Worms ended on May 25 without a consensus vote by the seven electors on the matter of Luther's condemnation. But through the effort of Cardinal Aleander and the three ecclesiastical electors (the bishops of Trier, Mainz, and Cologne), the Edict of Worms was prepared. It gave Luther 21 days to recant before he would become *Vogelfrei*—"free as a bird"—and open to being hunted down as an enemy of the realm. The imperial edict adjudged the reformer to be cut off from the church of God because of heresy. If he did not recant, Luther could be killed on sight. The edict also applied to any and all supporters of the Wittenberg monk, and the edict was never revoked. When news of the "kidnapping" reached Worms, the diet was still in session. The townsfolk were so enraged at the papal legate Cardinal Aleander, they were ready to lynch him. Each representative almost immediately left Worms for his home territory.

THE WARTBURG

After his abduction, Luther was brought safely within the ramparts of the Wartburg. His presence there and his identity remained hidden to everyone except his immediate guards and the warden of the castle. He took the identity of Junker Georg, and the castle attendants believed Luther was a member of the lesser nobility who was temporarily residing at the castle. Luther was not too happy with the confinement, wondering if it would be perceived as cowardice or desertion. He brooded, too, on whether he had the right to oppose the whole church.

As he obtained library resources and other materials,

Luther occupied his time with study and writing, sharpening his skill at Greek and Hebrew and exploring the Bible. He also crafted a commentary on Gospel and Epistle lessons used in the worship services. One of Luther's first productions from his solitary mountaintop hideaway was the treatise "The Judgment of Martin Luther on Monastic Vows," which he dedicated to his father.[2] Luther now acknowledged that he had sinned against Hans because he had entered the monastery against his father's will and judgment. But Luther believed that God had led him in that direction so he might know personally the faults and evils of monasticism: its infringement on Christian liberty, its encouragement of false pride in practiced piety, and its communication of a false sense of security in each individual member.

Luther's isolation in the elector's custody at the Wartburg did not mean, however, that all contact with the outside world had ended. He was kept informed about world events, especially the goings-on in Wittenberg. Correspondence with Philipp Melanchthon kept Luther posted on the university's affairs, which were in the good hands of his trusted and valued co-worker. But another colleague, Andreas Bodenstein von Karlstadt, was causing a commotion. A somewhat naïve fanatic, Karlstadt seemed to take advantage of Luther's absence, introducing changes in the worship life and practice at the City Church somewhat precipitously. For example, Karlstadt was preaching that the rules of celibacy for priests, monks, and nuns were not only wrong, but marriage should be urged instead and monastic institutions closed. He stated that Communion in both kinds should begin immediately in all the churches and the celebration of the Mass should be discontinued at once. Karlstadt proceeded in such pell-mell manner that even Frederick the Wise warned him not to press for these things because it would furnish grounds for the papists

to shoot down all reform measures, even those in harmony with God's Word.

During Luther's sojourn at the Wartburg, he translated the New Testament into German, using the Greek original made available early in the sixteenth century by Erasmus. Luther had been using this Greek text rather than the often unreliable Vulgate version of the New Testament since 1512. He set himself to the task in November 1521 and, in about 11 weeks, completed the translation, which still serves to the present day. It remains one of history's most amazing feats and is indisputable proof of Luther's astounding capacity for literary production. While at the Wartburg, Luther worked on this project alone, but after his return to Wittenberg and before publication, he reviewed the translation with Melanchthon and Georg Spalatin, a trusted counselor and the confessor of Elector Frederick. The men made few changes, and Luther's original manuscript is still extant.

In December 1521, Luther made an unauthorized secret trip from the Wartburg to Wittenberg to quell the growing unrest among the people because of Karlstadt's reform measures. He also wanted to strengthen Melanchthon's leadership among faculty and students at the university. As quietly as he arrived, Luther returned to the Wartburg.

"A Sincere Admonition"[3]

During his brief excursion, Luther took note of the revolutionary mood prevailing among the people. There were calls for emancipation from the church and the despotic government. Luther sensed that the common folk were looking to him for leadership in their cause, but he disagreed with this uprising because he believed it to be contrary to the rules of law and the teachings of God's Word.

Upon his return to the Wartburg, Luther dashed off an

important treatise—"A Sincere Admonition." He admonished the people not to commit any form of violence or civil disobedience. Luther advised meaningful consultation and adjudication between the downtrodden and those in authority in the political realm against whom disobedience and revolt were being perpetrated. Lawless rebellion solved nothing, Luther stated. And as far as reform in the church was concerned, he urged that God's Word was arbiter between the people and the clerics who served them. He also rejected any move by the people to name their cause after him.

THE INVOCAVIT SERMONS[4]

Luther observed the roiling unrest while enroute between the Wartburg and Wittenberg. His journey by foot had required 10 days. It was evident that a spirit of radical fanaticism had spread over the land and the people, much of which could be traced to the unbridled zealotry of Karlstadt. Melanchthon was unable to provide the same strong leadership Luther had offered to the town, the people, and the university. When Luther returned to the city to stay on March 6, 1521, things had worsened, despite Melanchthon's yeoman effort. The city's schools had closed, working conditions had been disrupted, and the university was near collapse. Luther was determined to quell the dangerous emotions among the townsfolk, the crumbling civic order, and the chaotic conditions at the university. After hasty discussions with Melanchthon, Nikolaus von Amsdorf, Justus Jonas, and Jerome Schurf, Luther launched a series of sermons for eight consecutive days in a valiant effort to heal the community's disquiet and return the people, their leaders, and the university community to normalcy. The first sermon was delivered on March 9, 1522, which was Invocavit Sunday. Faithfully, the people gathered to hear Luther's messages, which were

straightforward, pertinent masterpieces designed to restore order to the city and its inhabitants.

Calmly, pointedly, yet firmly, Luther set forth in his initial message that people need to "know and be armed with the chief things which concern a Christian," applying both Law and Gospel with pertinent scriptural references.[5] Luther reminded his listeners "in the first place we must know that we are the children of wrath," sinful human beings as St. Paul wrote to the Ephesians (2:3). Second, Luther reminded the people "that God has sent us his only-begotten Son that we may believe in him and that whoever trusts in him shall be free from sin and a child of God," as the apostle John writes (1:12). Third, Luther stated that "we must also have love, and through love we must do to one another as God has done to us through faith. For without love faith is nothing at all," as St. Paul wrote in his first epistle to the Corinthians (chapters 2 and 13). "For a faith without love . . . is not faith at all, but a counterfeit of faith." Finally, Luther stated that patience also was needed because suffering and persecution always are part of life. In dealing with the trials and vicissitudes of life and in interactions with fellow human beings, one needs to show patience and forbearance. Luther continued: "If you have suckled long enough, do not at once cut off the breast, but let your brother be suckled as you were suckled. I would not have gone so far as you have done, if I had been here. The cause is good, but there has been too much haste."[6] Although the people of Wittenberg knew the Scriptures, Luther pointed out that they had not taken note "of these two things, 'must' and 'free.' . . . Now do not make a 'must' out of what is 'free,' as you have done."[7] Then he zeroed in on the excesses that Karlstadt had triggered with his harangues.

In his second sermon, Luther focused on the Mass. He demonstrated how church doctrine over the centuries had

twisted a blessed means of grace into "an evil thing," treating it "as if it were a sacrifice and work of merit."[8] Luther agreed that Karlstadt and those who supported him were right to call for the abolition of the Mass, especially the private Mass. But Luther counseled, "Yet Christian love should not employ harshness here nor force the matter."[9] People needed to understand that these things ought to be abolished in the church so "we should give free course to the Word and not add our works to it."[10] Luther pointed out that when Paul arrived in Athens "he found in the temple many ancient altars, . . . but he did not kick down a single one of them . . . [but] begged the people to forsake them."[11] This was the central point of Luther's contention at the Diet at Worms: God's Word must do it; Christians must let it be heard but without force. In a lighter vein, Luther added:

> I simply taught, preached, and wrote God's Word; otherwise I did nothing. And while I slept [cf. Mark 4:26–29], or drank Wittenberg beer with my friends Philip and Amsdorf, the Word so greatly weakened the papacy that no prince or emperor ever inflicted such losses upon it. I did nothing; the Word did everything.[12]

The remaining sermons that memorable week highlighted theological points or practices that required reform in the church. Thus on Tuesday, Luther—though a devout Augustinian—targeted the supposedly holier lifestyle of the cloisters and the rules of celibacy for all the clergy. Luther said monks should be free to marry, but such liberty should not be a law.[13] In the same sermon, he dealt with images in the church, referencing how the apostle Paul handled the problem in Athens: "He preached against their idols, but he overthrew none by force. . . . Let the Word alone do the work. . . . The Word must first capture the hearts of men and enlighten them."[14]

On Wednesday, Luther dealt with rules of fasting. He noted that trust in abstinence wrongfully impacted the Gospel. Care needed to be exercised concerning such rules so "Christian liberty may suffer no injury, and no offense be given to our weak brothers and sisters who are still without the knowledge of this liberty."[15] Thursday's sermon addressed the abuses initiated by Karlstadt when he changed Communion practices. These abuses included handling of the elements, reception of both kinds, the washing and care of altar linens, and more. "You are bad Christians as far as I am concerned," Luther admonished, urging his listeners to proceed slowly and reverently before the Lord at the altar.[16] Luther agreed that reform was in order, but it needed to be accomplished slowly. "It must not be made compulsory nor a general law," he stated, because this could make the Sacrament an outward work and hypocrisy, "which is just what the devil wants."[17]

In the sixth sermon, Luther continued on this theme, reminding people what a treasure the Sacrament is, a blessed means of grace for sinners, pure Gospel to which faith clings. Thus reception of these sacred tokens or seals of Christ's forgiveness must remain a precious gift of the Lord. Such a gift, Luther noted, prompts believers to come to the table freely and regularly rather than because rules of attendance require it. The seventh sermon also addressed the Sacrament, pressing home the "fruit of this sacrament, which is love; that is, that we should treat our neighbor as God has treated us."[18] Luther pointed out, however, that the people's recent behavior and civic disturbances offered evidence to the contrary, forcing him to say, "But this I do not yet perceive among you here in Wittenberg."[19]

Closely connected with Holy Communion in Luther's mind was confession, which prepared the believer for worthy reception of Christ's body and blood in the Sacrament. Luther

devoted the eighth and final sermon of the series to this topic. For Luther, confession was the necessary component of true contrition. To confess sins is required by our patient and gracious heavenly Father, Luther averred, which means it is something to be treasured. Every believing sinner is sorely in need of confession for spiritual well-being before God. "Therefore, as I have said, I will not let this private confession be taken from me," Luther stated, to which he immediately added, "But I will not have anybody forced to it, but (it must be) left to each one's free will."[20] He continued: "Thus you see that confession must not be despised, but that it is a comforting thing" because it belongs to "the whole armor and equipment which God has given us to use against our enemies, . . . the devil."[21]

In these sermons, Luther summed up his approach and appeal for reform in the church, and his listeners would not soon forget his messages. They also illustrated Luther's mastery of the preaching art. He unfolded God's Word with the common person in mind, offering down-to-earth terms and idiom—even with light, humorous twists—but always faithful to Scripture. Although the match of any intellectual, Luther's sermons were clear and uncomplicated so everyone might understand his messages, including children.

Undoubtedly Luther rejoiced to be back in the pulpit after almost a year's absence. For his safety, Frederick had sequestered him because of his dramatic stand at the Diet of Worms. But Luther knew the integrity of God's Word was at stake. Courageously and persuasively he had contended for the right of believers to receive, know, and believe God's Word in the freedom of their own conscience. He proclaimed that sinners are saved by grace alone through faith in Christ. Luther knew that if Christian believers had to surrender this knowledge, what would remain of the faith would be miniscule.

7

REFORMATION AND SOCIAL REFORM

THE PEASANTS' UPRISING

Most histories of the Reformation tie Luther's efforts in the ecclesiastical realm with the Peasants' War. In fact that history is rare that does not credit or blame—at least to some extent—the revolt on Luther's Reformation. Usually such histories also state that Luther switched sides when the peasants began to lose.

In reality, Luther stood for civil obedience and support of government.[1] In his 1520 "Treatise on Good Works,"[2] Luther had articulated under the Fourth Commandment the duties and responsibilities of those who rule and of those who are ruled, of prince and peasant, of constituted authority and those under the rule of law. Luther defined the relationship between those who are ruled and those who rule as one of obedience and considerateness. He wrote: "Obedience is the duty of subjects, considerateness, of masters, that they be diligent to rule their subjects well, deal kindly with them, and do everything to benefit and help them."[3] According to Luther, this was God's formula for peaceful living for both sides.

In Luther's attention to issues assaulting the faith, he never became insensitive to the needs of the common people.

He was not a detached scholar; instead, he was completely attached to and involved in life in Wittenberg, Saxony, and the European scene. After all, Luther had been born into the peasant class and was not inclined to revel in the detached luxury of scholarly life for its own sake.

From the beginning of the Reformation, Luther was a man of the people, and he remained so throughout his life. Luther recognized that both the government and the church had faults. Early on he became aware of the potential to use his eloquence and appeal to gather popular support in his efforts to address grievances within the church and society. He might easily have threatened prince and prelate, but Luther was not a fanatic, demagogue, or rabble-rouser with a vain and self-seeking ego. Whatever the issue, he was too big a person, too balanced a churchman, and, above all, too scriptural and evangelical a Christian theologian to resort to petty debate and rash measures. His overriding concern was for people's souls. He dismissed whatever did not affect salvation. Even when he addressed social reform, Luther's guiding principle was total commitment to his deep-seated pastoral instinct.

Unrest and discontent in the fabric of European society had been brewing for more than a century. With the rise of towns and commerce and the establishment of a money economy in place of barter, societal conditions had forever been altered. Peasant status had been bettered, while that of the princes worsened to a degree. Meanwhile, the knights as a class practically ceased to exist. Rulers slapped additional restrictions and taxes on the peasants, making the gap between the wealth of the nobility and the common person's lack of wealth more offensive. The knights and lesser nobility saw themselves squeezed out with little promise for survival. But the title *Peasants' War* is inadequate because those involved in the uprisings were more often from the towns than they were rural farm

folk. The cause for the unrest and discontent was widespread worsening of the economic conditions coupled with crop failures, high prices, and a general scarcity of money.

These adverse factors coincided with the storm that broke on the religious shore by virtue of Luther's heroic stand at Worms. Because the sixteenth-century church was a major landowner, it played a significant role in the economic community. This made it difficult for the common person to distinguish the church from the civil land barons. Coupled with the economic upheaval and Luther's reforming cry was the *Schwarmerei* phenomenon occurring in some sections of the German realm. This was a form of mysticism that elevated the inner, personal ideas and beliefs of worshipers over the text and meaning of God's Word. Among the purveyors of this mystical theology were individuals such as Thomas Müntzer. He was originally a Lutheran pastor, but he began to use his preaching to agitate the people. His message was encouraged by the radical movement known as the *Bundschuh*. Those involved with this movement rioted against overlords, whether prince or prelate.

The people's turmoil broke into open conflict in various places as a result of incidents both minor and major. Luther's position throughout remained constant, stating that the Gospel must not be tied to political movements. He stated that the peasants had rights and duties that should be respected, but the princes, likewise, had rights and duties required by their office as rulers over territories. For Luther, the Gospel, God's Word, remained free and unfettered, requiring no defense, especially defense that involved violence and bloodshed. Luther was not especially concerned with events in Wittenberg, but the reports coming in from other regions in Germany were alarming.

Luther was concerned about the revolutionary spirit evi-

denced throughout the territories he had traversed on his quick trip to Wittenberg in late 1521. This situation prompted him to write "A Sincere Admonition by Martin Luther to All Christians to Guard against Insurrection and Rebellion" in January 1522. In it, Luther laid out the basic principles that governed the relation of people to government. He also included guidelines that ought to apply to redress wrongs or to adjudicate grievances fairly. Little revolutionary upheaval occurred in those territories that supported Luther and where the Reformation and Gospel preaching had made inroads. The regions dominated by Roman Catholic theology seemed to experience more rebellion and bloodshed. Luther's treatise ended with the prayerful petition: "God grant us all that we may practice what we preach, putting our words into deeds . . . (And) guard against insurrection and giving offense, so that we ourselves may not be the agents for the desecration of God's holy word."[4]

"TEMPORAL AUTHORITY: TO WHAT EXTENT IT SHOULD BE OBEYED"

After successfully restoring calm to Wittenberg, Luther traveled in 1522 to the territory of Thuringia. Along with Swabia and Franconia, this was a troubled region in the German nation. Luther preached a series of six sermons while he spent a week at the church in Weimar. He eloquently laid out in detail the matter of civil government and the people under God, clearly explicating the abiding principles appertaining to all citizens, rulers and subjects alike. Among the listeners was Duke John, younger brother of Elector Frederick the Wise. Among other leaders, John urged Luther to publish his sermons. By March 1523, "Temporal Authority"[5] was in print. It was based on the outline he had used when offering his extemporaneous sermons.

At Weimar, Luther had posited that two kingdoms exist side by side. The kingdom of the left hand of God deals with the worldly realm, that is, with marriage, family, and morality; life, property, and external matters. The kingdom of the right hand of God deals with spiritual things, matters of the heart and soul, sin and grace. According to Luther, the state or government should not intrude in sacred matters nor should the church enter the arena properly belonging to civil government and the rule of law. Luther believed things had turned topsy-turvy. The government presumed to have authority in judging matters of heresy, and the church exercised power and authority in human relations. Luther stated that the Gospel is preeminent for the kingdom of the right, the church; for the kingdom of the left, the law predominates.

In this sinful world, Luther believed these two kingdoms existed side by side by the will of the Creator, but neither side should intrude into territory belonging to the other. Yet the two kingdoms depend on each other. Although each fulfills God-given responsibilities, Luther noted that both kingdoms are to be for the people. The kingdom of the left governs with statutes of law; the kingdom of the right proceeds with proclaiming sin and grace and love toward one's neighbor. Civil law is always subject under God to sound reason and the neighbor's well-being so order and peace might prevail. Where either side, especially the conscience, is infringed on, there Christians appeal directly to God and endure patiently. In this treatise, Luther came close to expressing the principle of the separation of church and state.

"ADMONITION TO PEACE"[6]

At about the same time that Luther published "Temporal Authority," a significant document produced by the peasant

camp appeared in Swabia. It was titled "The Twelve Articles." Its authorship is uncertain, but the articles, or demands, and their formulation are generally traced to radical leaders such as Thomas Müntzer and Balthasar Hubmaier. Both men encouraged the peasants in their fight for their rights by linking their agitation to the cause of the Reformation and to Luther's name.

Disturbed by the actions sparked by these articles and the manner of their promotion, Luther was prompted to respond to what he saw as "a great and dangerous matter. (For) it concerns both the kingdom of God and the kingdom of the world."[7] Luther acknowledged that on the whole the articles were fair and just when they faulted the lords and princes for their indifference to the people's needs and rights, especially when they denied peasants "the right to hear the gospel and choose their pastors, (and) . . . protest economic injustices."[8] But Luther pointed out that though the peasants may rightly claim "the rulers are wicked and intolerable," that "does not excuse disorder and rebellion."[9] Luther reminded his readers "that we do not have the right to use the sword simply because someone has done us an injustice and because the law and justice are on our side."[10] Article by article, Luther reviewed the peasants' plea to right the wrongs, urging that they "arbitrate and settle this dispute amicably."[11]

Luther addressed the lords in the same vein. He agonized over and deplored the violence and bloodshed sweeping the land, especially that it was happening under the banner of the cross. His concluding plea to both sides, peasants and lords, included the admonition: "Both parties are acting against God and are under his wrath . . . For God's sake, then, take my advice! Take a hold of these matters properly, with justice and not with force or violence and do not start endless bloodshed in Germany."[12]

"Against the Robbing and Murdering Hordes of Peasants"

Luther's plea for peace and resolution of the disagreements and injustices through sound, sensible adjudication was too late. The peasant mobs—encouraged by Müntzer, Hubmaier, and others—became violent, causing a bloodbath in several regions of Germany. As a result, Luther published "Against the Robbing and Murdering Hordes of Peasants"[13] amid the terrible carnage. The peasants felt that this treatise added insult to injury. In the words of historian Ernest Schwiebert, "Its theme, which would have been welcomed by a terrorized and apprehensive countryside a few weeks earlier, now seemed like striking a man who had already fallen."[14]

Admitting that the timing of this and "Admonition to Peace" left something to be desired, Luther felt the facts were incontrovertible: Anarchy was never right. The young and weak, especially women and children, fell victim to such bloodshed. While not excusing the godless rulers, Luther called on them for the sake of law and order to be firm and resolute in putting down the rebellion. Hearkening back to "Temporal Authority," Luther reminded the rulers that theirs was the God-given duty to bear the sword and restore order, albeit with mercy, so peace might prevail. He closed by saying: "If anyone thinks this too harsh, let him remember that rebellion is intolerable."[15]

"An Open Letter on the Harsh Book against the Peasants"

Within a matter of days, Luther found himself writing another tract. This time he called on rulers to ease the severity with which they were subduing the peasants. "An Open Letter on the Harsh Book against the Peasants" was published in July

1525.[16] In response to the uprising, Luther knew some rulers had acted with undue severity. He now begged them to show grace and mercy where the troublemakers had surrendered and the mayhem had died down. The peasants had learned to their grief that rebellion was not the answer. The lords, too, must now see that grievances and injustices were addressed so the living conditions and economy of the peasants might be improved. While acknowledging their right to keep order, even with the sword, Luther called on the rulers to show mercy and forgive rather than act as "raving, senseless tyrants, who even after the battle cannot get their fill of blood, and in all their lives ask scarcely a question about Christ—these I did not undertake to instruct."[17]

Luther's intent in this treatise was twofold: "Quiet the peasants, and instruct the pious lords."[18] But Luther was not above a little wordplay concerning the rulers' supposed "piety." He said that those peasants who were literally slaughtered would "have their reward," but as for the proud lords, "hell-fire, trembling, and gnashing of teeth [Matt. 22:13] in hell will be their reward eternally, unless they repent."[19] Plainly, Luther believed both sides to have been at fault. Hence Luther's earnest admonition to both parties.[20]

LUTHER'S MARRIAGE

It may seem hard to reconcile, but amid these troubled days, Luther took an important step in his personal life that would forever influence his work. On June 13, 1525, Luther was joined in marriage with Katharina von Bora. His wife was a former nun who had escaped the Cistercian convent at Nimbschen with several of her sisters, eventually arriving in the relatively safe haven of Wittenberg.

Luther had affirmed and emphasized the sanctity of mar-

riage, even by those in the church's service. He demonstrated that the rules and laws for celibacy were without warrant in God's Word and fundamentally contrary to the natural order. Luther's readiness to marry was encouraged by friends and family, especially by his father, who was anxious for an heir. As for Luther's wife, Katie's family apparently came from the lesser nobility, but she had turned down perhaps more appropriate suitors in favor of the leader of the Reformation himself.

So it was that on June 13, at the local church, with a limited number of friends in attendance—the Lucas Cranachs, the jurist John Apel, and colleague Justus Jonas—Luther's pastor, Johannes Bugenhagen, performed the marriage and exchange of vows. The wedding celebration took place on June 27 at the Augustinian monastery. The numerous guests included Luther's parents. From that day forward, the stately structure became known as the Luther House (*Lutherhaus*). Not only would it to continue to be a place where Luther delivered his university lectures, but by Prince John Frederick's decree, the former monastery became the Luthers' home.

Luther's Family Life

Katie was an efficient manager of the large domicile, especially of the section set aside for family life. Katie and Martin would become parents of six children, three boys and three girls. Unfortunately, one of the girls succumbed early, a victim of the plague in 1528. A second daughter, Magdalene, Martin's beloved "Lenchen," died after a brief illness in 1542 at the age of 13. She left this world in the arms of her devoted father, who was deeply affected by her loss.

Lutherhaus came to be known for its hospitality as Katie provided for countless guests over the years. She and her husband even provided temporary quarters for students and visit-

ing clerics. The evening meals became the source of some of the most popular of Luther's sayings, which are now included in his Table Talk.

"THE BONDAGE OF THE WILL"[21]

During this busy time in his duties as family man, professor, pastor, and spokesperson for the Reformation, Luther produced the significant theological treatise "Bondage of the Will." It was a careful and profound response to and critique of "Concerning Free Choice," which had been published in 1520 by Erasmus. Soon "Bondage of the Will" was recognized as one of Luther's foremost theological writings.

Erasmus (b. 1466), who was also an Augustinian monk by training, was Luther's senior by a few years. He was a universally recognized Greek scholar whose expertise with the ancient manuscripts had given the world a reliable New Testament. In fact, while at the Wartburg in his temporary exile, Luther used Erasmus's Greek New Testament for his German translation.

Undoubtedly, Luther appreciated Erasmus's scholarship. Little wonder, therefore, that the reformer was disturbed when in 1524 he learned that at the prodding of Duke George of Albertine Saxony, Henry VIII of England, and Pope Adrian VI, Erasmus was writing a critical work against him and his theological stance. This news prompted Luther to pen a letter of concern to Erasmus. After all, Erasmus's wide influence could damage the cause of the Gospel. No response came from Erasmus, but by September 1524 his treatise "Concerning Free Choice" was in print. With Erasmus's famous skill and expertise, the work articulated a finely crafted and reasoned position supportive of works-righteous theology.

Luther was dismayed that Erasmus had paid no heed to

his plea. He agonized throughout 1525 over the damage the treatise had done to evangelical theology and to Christians. Friends urged him to respond, but Luther's multiple duties kept him occupied even as the peasants' uprising erupted in several regions. When Luther and Katie were married, she encouraged her husband to respond to Erasmus's damaging publication against the evangelical faith. Therefore, amid routine duties at the university and the City Church, Luther spent September through November writing "Bondage of the Will," which was published in December 1525. He wrote in Latin, the language of scholars, as had Erasmus, but Justus Jonas immediately translated the work into German.

For the scribe of Rotterdam, "Concerning Free Choice" had been a rhetorical exercise to establish a polemic that supported humanity's boast as lord and king over all creation by virtue of his free will. But Luther considered it a crucial assignment to show from Holy Scripture that it was precisely this view that had plagued sinful humanity since Adam and Eve. He wanted to show that since Adam and Eve's fall in the Garden of Eden, sinful people had futilely struggled and groped to deal with the quagmire of evil surrounding them. Meanwhile, though humans are intellectual giants when viewed against the backdrop of the rest of creation, they strive—sometimes in almost heroic fashion—to rise above the evil in the world and in themselves. Luther recognized that Erasmus was simply repeating an age-old human error: He was elevating the human ego, making an icon out of human reason and will, setting humans on a lofty pedestal as lords over all they survey.

Luther explained that his delay in writing came from "sheer disgust, anger, and contempt" because he saw "the case for free choice put forward with all the energy of so distinguished and powerful a mind, but with no other effect than to make things worse than before . . . like the woman in the

Gospel [Mark 5:25f.], the more it is treated by doctors, the worse it gets."[22] In blunt terms, Luther deplored the older man's skepticism about doctrinal teachings clearly asserted in Holy Scripture, emphasizing the need to know God and His sovereignty and power, as the Lord had revealed in His Word. In his treatise, Erasmus had contended he would abide by Scripture's authority alone, then he promptly proceeded to ground his arguments for free will on the authority and theological commentary of the church fathers rather than on Scripture's clear teaching concerning the plight and predicament of fallen, sinful humanity. To speak of "free will," Luther said, is to touch on an attribute that belongs only to the almighty and sovereign Lord God, by whom all things were made and are governed still. But Luther agreed that humans do have free will in things beneath them—their possessions, goods, relationships, existence in the created realm, etc. In matters pertaining to salvation, however, human beings have no such power. Without the saving grace of God, human beings are lost, Luther averred. They are not free but are immutably servants and bond-slaves of Satan and evil. They have no hope in the world.

The bottom line in the debate between Luther and Erasmus was the matter of human capacity in regard to spiritual matters, matters pertaining to salvation. Luther pointed out that with his arguments for human free will, Erasmus stood in line with the Pelagians and philosophers in general, not with God's Word. To say that people, by their free will, can apply themselves to achieving and working out their salvation Luther called tantamount to asserting that a stone or log lying on a hillside can move itself up or down through its own initiative and by its own power. Luther continued: "Is it not the case that the more distinguished they have been, the more absurd the idea of a future life and resurrection has seemed to them to be?"[23] In reality, " 'free-will' is an empty term," Luther con-

tended, because the human will is "bound in the service of sin." He added that "a lost freedom, to my way of speaking, is no freedom at all."[24] The imperatives of Scripture that declare God's commandments for fallen, sinful humankind tell

> not what men do, or do do, but what they should do!
> ... The commandments are not given inappropriately or pointlessly; but in order that through them proud, blind man may learn the plague of his own impotence, should he try to do what is commanded. Scripture, however, represents man as one who is not only bound, wretched, captive, sick, and dead, but in addition to his other miseries is afflicted, through the agency of Satan his prince, so that he believes himself to be free, happy, unfettered, able, well, and alive.[25]

With appropriate references to figures in Holy Scripture—Judas, Jacob, Pharaoh, the potter and the pot—and many pertinent citations from the gospels and epistles, Luther finally affirmed: "Man without grace can will nothing but evil," but human beings are saved by God's free gift of grace alone "if we believe that Christ has redeemed men by his blood."[23]

The conclusion to Luther's treatise was a solemn entreaty to Erasmus to see the error of his way. Luther thanked the older man, stating,

> I praise and commend you highly for this also, that unlike all the rest you alone have attacked the real issue, the essence of the matter in dispute, and have not wearied me with irrelevancies about the papacy, purgatory, indulgences, and such like trifles (for trifles they are rather than basic issues), with which almost everyone hitherto has gone hunting for me without success. You and you alone have seen the question on which everything hinges, and have aimed at the vital spot; for which I sincerely thank you.[27]

Then Luther immediately added:

> I could very much wish that you would remain content with your own special gift, and would study, adorn, and promote languages and literature as you have hitherto done with great profit and distinction. I must confess that in this direction you have done no small service to me too, so that I am considerably indebted to you . . . and admire you most sincerely.[28]

Luther believed that Erasmus's treatise had added to the confusion that had plagued humanity concerning its boasting of the capacity of the human will and its powers to approach God. Luther urged Erasmus not to take issue with him and not to be offended by his critique. He reminded the older scholar that "there is no novelty in it, if God instructs Moses through Jethro and teaches Paul through Ananias."[29]

In a final assertion, Luther humbly charged Erasmus that "since you are human, [you] may not have rightly understood or observed with due care the Scriptures or the sayings of the Fathers under whose guidance you think you are attaining your goal."[30] The issue was this: God's Word, Holy Scripture, affirmed a sinner's salvation to be by God's grace alone, through faith, for Christ's sake. For Luther, the salvation of all humanity did not rest on any power or inclination of the human heart, mind, or will. Instead, it was by God's grace and through His work alone, through the Gospel, by which the Holy Spirit draws forth faith from human hearts to receive what Christ the Savior has won. Luther ended "Bondage of the Will" with an earnest plea and prayer: "I am unwilling to submit the matter to anyone's judgment, but advise everyone to yield assent. But may the Lord, whose cause this is, enlighten you and make you a vessel for honor and glory. Amen."[31]

Thus Luther showed his pastoral heart and his constant concern that the Gospel would be heard and known by each

person. Luther believed souls to be precious, and he taught that human beings cannot find hope in themselves but only in the Savior God sent into the world for their sake. The church could not set up the rubrics or ladders of pious ascent by which people could climb to heaven and merit God's favor. According to Luther, the proclamation of the Gospel was not only the story of what God has done for sinners but also the power by which the Spirit of God works, draws forth, and ignites faith in human hearts.

To the end of his life, Luther was tied to Christ's affirmation: "No one can come to Me unless the Father who sent Me draws him. And I will raise him up on the last day" (John 6:44). He also held firmly to the apostle Paul's words: "For by grace you have been saved through faith. And this is not your own doing; it is the gift of God, a result not of works, so that no one can boast. For we are His workmanship, created in Christ Jesus for good works, which God prepared beforehand that we should walk in them" (Ephesians 2:8–10; see also Romans 3:1–31; Philemon 2). Luther believed that in Jesus, human beings find peace for their souls before God, and from Him they gain strength for the daily walk in firm faith in God and love toward neighbor.

THE DIETS OF SPEYER

The edict adopted at Worms that condemned Luther and called on the princes to act to detain him lay dormant. Charles V was busy with other threats to his realm, not the least of which was the menace of war with the Turks. There was little opportunity or time to address the so-called "religious problem" and deal with Luther and his growing number of supporters. Thus each prince handled the religious issue as he saw fit—always with the proviso that his actions were valid until a

general council occurred. This left many matters in limbo concerning the Reformation. At the Diet of Speyer in 1526, the territorial rulers were given the right to decide religious matters in their own territories in return for their aid against the Turks. This resulted in the practice of "whose the rule, his the religion" (*cuius regio, eius religio*), a sort of religious liberty.

In 1529 at the second Diet of Speyer, the position was reversed, causing supporters of the Reformation to protest. The name "Protestant" was given to those who opposed the reversal. At the Colloquy of Marburg in the same year, the five Protestant electors and dukes, as well as the 14 Protestant imperial cities and their representatives, contended that the diet had no right to rescind by mere majority what had been unanimously adopted at the first Diet of Speyer. These events divided the German nation on the religion question and led to the call for the Diet of Augsburg in 1530.

THE SMALL AND LARGE CATECHISMS

The decade following Luther's initial protest against the sale of indulgences was unruly at best. Not only was there the Peasants' War, but along with the Reformation emphasis on evangelical theology came the fanaticism and radical measures of men such as Karlstadt and Müntzer. Luther was fully cognizant of and pained by the ignorance of basic Christian teaching and life demonstrated by the people in the pew. He also saw the lack of competence and fitness on the part of many of the clergy to do anything about it.[32]

Even before posting the "Ninety-five Theses," Luther had been using the pulpit to preach on fundamentals of the Christian faith: the Ten Commandments, the three articles of the Creed, the Lord's Prayer, Baptism, the Lord's Supper, confession. At one point, Luther attempted to enlist others to set

these chief articles of biblical doctrine into a helpful manual or workbook for the common people and for parish pastors. But the book was never completed, and the church and the people were left without the resource that Luther envisioned and deemed essential.

Then in 1528, Luther, Melanchthon, Hans von Planitz, Jerome Schurf, and Asmus of Haubitz were appointed by Duke John Frederick to visit the Saxon churches. This task exposed the urgent need for catechetical tools. Luther saw firsthand the "wretched deprivation" of the common people who "supposedly . . . bear the name Christian, are baptized, and receive the holy sacrament, even though they do not know the Lord's Prayer, the Creed, or the Ten Commandments."[33] Most disturbing, Luther realized that the restoration of the Gospel had unfortunately led people to abuse the gift of God's grace and forgiveness in Christ. Coupled with this was Luther's realization that many pastors were not fit to teach the people about the Christian life. Upon his return from the parish visitations, Luther immediately began writing the manuals on doctrine he had long considered.

The writing and rewriting of the catechisms occupied the reformer throughout the remainder of 1528 and the early portion of 1529. The Large Catechism was published by April 1529, with the Small Catechism released the following month. Both books were masterpieces whose use and value have continued to the present day. The Small Catechism was designed for young and old to provide uniform instruction in the basic elements of the Christian faith. Luther addressed the same articles in the Large Catechism but used a discursive format that included pertinent polemic to address and rebut aberrations and assaults that confronted believers.

When the Lutheran confessors drew up *The Book of Concord* in 1580, they included Luther's two catechisms among the

symbols or confessions on which they declared their stand. Both Luther's Small and Large Catechisms merit their place as standards alongside the three ecumenical creeds, the Augsburg Confession and its Apology, Luther's Schmalkald Articles, and the Formula of Concord. All these documents provide the solid platform on which scriptural faith and doctrine is built. In them, the church finds strength and the necessary armor to fend off the hostile attacks of the world, as well as to defend itself against the troubling divisions from within its own ranks that are prompted by Satan and his cohorts.

8

THE AUGSBURG CONFESSION

THE *MAGNA CARTA* OF EVANGELICAL THEOLOGY

Why could Martin Luther claim that he had written the Augsburg Confession? It was, after all, Philipp Melanchthon's scholarly and literary hand that gave final shape and form to this document, one of history's most influential writings. Although Melanchthon's role in the preparation of the confession is beyond dispute, Luther's work and writings in the preceding twelve years laid the foundation for and shaped the content of each article in the Augsburg Confession, which became the finest distillation of the religious faith and doctrinal stance of the evangelical position in the Reformation. This document expressed what the Lutheran confessors wanted Charles V and the world to understand about their faith and their concern for the purity of the Gospel. The precedent for this stance had been established throughout Luther's life and work, beginning with the posting of the "Ninety-five Theses" in 1517 and encompassing his heroic stance at Worms in 1521 and his numerous treatises, sermons, classroom lectures, and vast correspondence. But the subject is more complicated than merely citing the documents that predated the writing of the Augsburg Confession.

The Marburg Colloquy

One of the essential precursors to the Augsburg Confession is the Marburg Articles, which Luther helped to craft, along with Melanchthon, Justus Jonas, Johannes Brenz, Johann Agricola, and Andreas Osiander, in preparation for discussion at Marburg with the Swiss and South German reformers. The opposing side was led by Swiss reformer Huldrych Zwingli and included Heinrich Bullinger, Johannes Oecolampadius, Martin Bucer, and Caspar Hedio.

The Reformed and Lutheran teams of theologians met October 2–4, 1529, at Marburg at the prompting of Philipp of Hesse, who urged agreement between the divided Protestant parties. The effort fared well until the conferees came to the fifteenth article, which dealt with the Lord's Supper. Then it became evident that the Swiss reformers disagreed with Luther's emphasis on the real presence of Christ's body and blood in the Sacrament. Other differences soon surfaced because of the Zwinglian tendency to find figures of speech in the declarative truths that Scripture presented as matters of fact.

"Confession Concerning Christ's Supper"

As Melanchthon prepared the Augsburg Confession, he also undoubtedly consulted the Schwabach Articles that Luther had prepared for presentation at Schmalkald, a meeting that was held in fall 1529. This document was a summary of evangelical, biblical articles of faith as taught by Luther and his followers. More significant was the *magnum opus* that lay behind these doctrinal statements: Luther's "Confession Concerning Christ's Supper," which had been written in 1528.[1] Luther's "Confession" was a masterpiece of Christology and confronted head-on the Swiss (Zwinglian and Reformed) tendency of

introducing figurative interpretations of Bible texts to accommodate human reasoning, even when the Bible clearly stated a fact, as, for example, Christ's promise of His body and blood in the Sacrament of the Altar. After examining with careful exegesis the four texts of the Bible that treat the Lord's Supper, Luther added a summary confession of faith. This beautiful, lucid statement of the Christian faith is given as an article-for-article position, in a manner similar to the ecumenical creeds.

PREPARATION FOR AUGSBURG

The Marburg and Schwabach Articles provided ample resources to the Lutheran party as it prepared to plead its case before the Diet of Augsburg. On January 21, 1530, Emperor Charles V proclaimed an empire-wide conclave of the governing authorities, including the seven electors of the realm, their legal advisers, and their retinues. Those called to participate were to convene in Augsburg by April 8. The contingent from Wittenberg, including Elector John's team of theologians, which was led by Melanchthon, did not arrive until May 2, but the emperor did not show up until June 16.

The agenda of the diet would address two focal points: (1) the Turkish threat on the southern perimeter of the empire—though it was somewhat subdued at that particular time; and (2) the religious question of what might be done about the division and separation in the holy faith. The latter concern prompted Elector John to charge Luther, Melanchthon, Jonas, and Johannes Bugenhagen with the preparation of a defense of the articles of faith and practice among Luther and his followers. A preliminary meeting of Luther and the other theologians occurred over several days at the electoral residence in Torgau. The original plan called for an apology, or defense of the faith, on two points: (1) to

counter the abuses present in Roman Catholic theology and practice; and (2) to prepare a defense of Luther's cause, demonstrating that Luther's papal opponents had begun the strife, not the reformer.

The strategy changed, however, when the theologians became aware of the redoubtable Johann Eck's more than four hundred propositions that accused the Protestants and Luther of heretical teaching. This Catholic position called for a change in tactics by Luther and his associates and led to the decision to include all the articles of the Christian faith that Luther and his followers upheld and taught. Such a statement would show the injustice of Eck's charges. Drawing on already available statements of faith from Marburg and Schwabach, as well as Luther's "Confession Concerning Christ's Supper," the response took form as a summary declaration of the Christian faith that was clearly grounded on God's Word and in harmony with the teachings of the ancient church.

After completing preparations and strategy for Augsburg, Elector John and his theologians traveled to his castle at Coburg—the southernmost fortress in Electoral Saxony—to rest and fine-tune the apology. Luther remained behind when the other theologians left for Augsburg. Although he was not happy about it, Coburg became Luther's haven for the next several months because he was still under the imperial ban and the threat of burning at the stake for his supposed heresy.

During the diet, theological leadership for the Lutheran party fell to Luther's trusted friend and colleague Melanchthon, though a steady stream of correspondence flowed between Luther at Coburg and the Saxon party at the diet. More than seventy letters were sent from Luther to Melanchthon, and Melanchthon sent another thirty to Luther. Elector John engineered the courier system, which in addi-

tion to suggestions concerning the confession also included missives from Luther designed to buoy Melanchthon's spirits. Via courier, Luther received updated versions of the confession to be presented.[2] Each time Luther poured over the document and sent his suggestions for revision, if he had any, by return courier.

Melanchthon's work pleased the reformer. Luther recognized the content as completely consonant with his own stance, commenting in admiration of Melanchthon's literary hand: "I cannot step so softly and quietly."[3] Luther, however, was aware of his colleague's tendency to "fiddle" with the text, always looking for a better turn of phrase because of his worry about how the document would be received by the emperor. Justus Jonas urged Luther to keep the letters to Melanchthon coming to shore up his friend's courage and spirit.

Luther did not sit idle in his sanctuary at Coburg. Instead, he experienced a productive period as he devoted time and energy to various writing projects. At his side to help was Veit Dietrich, a former student at Wittenberg who had taken the role of private secretary to the reformer.

On February 16, 1530, Luther had learned of the serious illness of his father, who still lived in Mansfeld. He penned a caring, consoling letter, commending to his father's attention the "precious promises of Psalm 91, so suited for the sick."[4] Both men had grown to respect and love the other, especially as Hans saw how the Lord had used his son's talents for service in His kingdom. "May the dear Savior be with you, and we shall shortly meet again with Christ," Luther said in closing, signing the letter, "Your dear son, Martin Luther."[5] When Martin learned by letter on June 5 that his father had died a week earlier, he was so overcome with grief that even his scholarly efforts had to be laid aside for a time.

"Exhortation to All Clergy Assembled at Augsburg"

Despite his grief, Luther had not forgotten the task his loyal friends faced in Augsburg. The first thing to which he set his mind and pen was the treatise "Exhortation to All Clergy Assembled at Augsburg."[6] Alongside the positive declaration of the Protestant faith that Luther and his supporters had prepared at Torgau and refined at Coburg, there was need for a straightforward polemic and frontal attack on the abuses and false teaching that had taken over in the church and reached all the way to the papal office. This manifesto spelled out the grounds for the great upheaval that had engulfed the church and, for that matter, the entire empire. Lest any supporters be inclined to compromise or make light of the existing situation, Luther sought to make clear the real source of the problem: the Roman Catholic camp and its theology. Luther reminded his readers that the Lutheran party had prepared its formal statement of the faith, attesting full compliance of faith and support of Christian doctrine. They were not heretics.

The treatise was published hurriedly in Wittenberg and was offered for sale by mid-May, even before the start of the diet. Almost immediately the supply was exhausted as the public became aware of its publication and eagerly devoured what Luther had to say. Widely disseminated, the copies reached the Augsburg assembly.

As Luther explained in the introduction, he could not appear personally at the diet because of the imperial ban, but he wished for God's grace and blessing on the emperor's efforts "to do and accomplish much and great good through this diet."[7] He added: "Therefore I, too, am now doing what I do for your own good and for the sake of peace and unity."[8] Luther continued that "you know, too, how faithfully and firmly we

have held out against all factious spirits. . . . [And] for this rea-
son they are more hostile to us than to you and accuse us of
knuckling under and recanting."[9] Luther reminded his readers
that he had always stood for law and order, "teaching the peo-
ple nicely to maintain the peace and to obey the authority."[10]

Of course, Luther pointed out that the papal party would
clamor that the unrest in the church was all Luther's fault,
referring to the posting of the "Ninety-five Theses." There-
upon, Luther's "Exhortation" listed and briefly treated the
many abuses that had invaded Roman Catholic theology and
practice to the detriment of the Gospel. Luther stated: "I must
drag out the old skeletons . . . [and] begin precisely at the point
where my teaching began, that is, with indulgences."[11] Luther
stated that "if our gospel had accomplished nothing else than
to redeem consciences from the shameful outrage and idolatry
of indulgences, one would still have to acknowledge that it was
God's Word and power."[12] In Luther's view, the tragedy cer-
tainly was that "the gospel, which is, after all, the only true
indulgence, had to keep silence in the churches in deference to
the indulgence."[13] Then, with an aside that referenced the other
major concern facing the emperor and those assembled at the
diet, Luther illustrated his points on the evils of indulgence
promotion, adding, "It was a real Turkish army against the true
Christian faith."[14]

Luther continued his list of multiple abuses and false reli-
gious notions in "Exhortation" with a discussion of confession
as a work required in the sacrament of penance. He stated that
this work had "caused so many souls to despair, and have
weakened and quenched all men's faith in Christ" because the
papists had "made a work out of it" and people despaired of
true peace before God.[15] Luther continued:

> From this abomination have come all the other out-
> rages . . . the self-righteousness of so many of the

monasteries and chapters . . . the sacrificial masses, purgatory, vigils, brotherhoods, pilgrimages, indulgences, fasts, veneration of saints, relics, poltergeists, and the whole parade of hellish procession of the cross.[16]

The reformer pointed out that because of these "shameful doctrines all the legitimate good works instituted and ordered by God were despised and even reduced to nothing."[17]

Luther's concern throughout "Exhortation" is how the papists "despised the Holy Scriptures and let them lie under the bench."[18] Although Luther did not address each false notion, practice, or abuse at length, by the end of the treatise, little about the Roman Catholic faith and practice of the time remained untouched. Luther even mentioned how Pope Adrian—the last non-Italian to occupy the throne of St. Peter (r. 1522–1523)—tried for reform and "confessed through his legate at Nürnberg that the Roman See was the cause of much misery and offered himself to improve it."[19] Despite the more than one hundred topics Luther addressed in "Exhortation," the reformer merely alluded to the "topics with which it is necessary to deal in the true Christian church and about which we are concerned."[20] These would be addressed in the first part of the Augsburg Confession.

When Emperor Charles V and his retinue finally arrived in Augsburg on June 15, 1530, the dignitaries respectfully gathered to greet the emperor. Cardinal Lorenzo Campeggio, the papal legate, pronounced a blessing, during which all knelt except Elector John of Saxony and Landgrave Philipp of Hesse. The next day a solemn Corpus Christi procession to the cathedral took place. Again all the onlookers except the evangelical contingent knelt as the sacred icon passed by the gathering.

One of the first pieces of business for Charles V was a meeting with the Lutheran princes to demand that they

require their preachers to refrain from preaching while in Augsburg. He hoped to use this means to prevent negative outbursts and political unrest and trouble between the opposing parties. For the sake of peace, the evangelical side complied with the emperor's orders. Luther also had offered this counsel in a May 15, 1530, letter to Elector John. Luther reasoned that it was not a crucial issue, and, moreover, the city was under the emperor's control.

On June 25, 1530, the Augsburg Confession was read publicly before the assembled diet and the emperor. Charles had asked for the document to be written in Latin, but at the urging of Elector John, he granted permission for the German version to be read because the diet was meeting on German soil.[21] Christian Beyer, chancellor of Electoral Saxony, read the document before an attentive audience of some 200 delegates who were crowded into the assembly room. An eager crowd also had gathered beneath the opened windows, and they strained to hear Beyer's voice as he clearly and loudly intoned each article of the confession. After the German version had been read, it was given to Archbishop Albrecht (Albert), the elector of Mainz. The Latin version was given to the emperor and his advisers. In addition to these originals, which were lost, the Lutheran party retained carefully prepared copies of both versions.

Shortly after the hearing, Justus Jonas reported to Luther that the emperor appeared gracious, impressed, and friendly. He had listened attentively, and several members of the Catholic party had nodded their approval of what had been read. In general, the *Apologia*—the title given to the document by the Lutheran party—enjoyed a favorable reaction from most who had heard it, including many Roman Catholics. Melanchthon, on the other hand, greeted the morning of June 26 with a gloomy outlook, writing to Luther, "We are in deep-

est trouble here and are forced to many tears."²² He advocated further concessions to the Roman Catholics, causing Luther to reply sternly on June 29:

> I have received your *Apologia*, and I wonder what it is you want when you ask what and how much is to be conceded to the papists. . . . For me personally more than enough has been conceded. . . . Day and night I am occupied with this matter, considering it, turning it around, debating it, and searching the whole Scripture [because of it]; certainty grows continuously in me about this, our teaching, and I am more and more sure that now (God willing) I shall not permit anything further to be taken away from me, come what may.²³

In the same letter, Luther expressed his pleasure at the courage demonstrated by the princes and laymen. He summoned Melanchthon to equal fortitude, to get out from behind Luther's mantle, and to make the cause his personal battle. Luther stated: "If this is not simultaneously and in the same way your cause, then I don't want it to be called mine and imposed upon you [because] . . . then I will handle it by myself."²⁴ As Luther saw it, the doubts in Melanchthon's mind stemmed from his uncertainty on the doctrine of the church in this struggle against the monolithic papal ecclesial regime. "If Christ is not with us," Luther fired off, "where, I earnestly wish to know, is He then in the whole world?"²⁵ More to the point, the reformer wrote: "If we are not the church, or a part of the church, where is the church? Are the dukes of Bavaria [Eck's lords], Ferdinand [King of Bavaria and brother of Charles V], the Pope, the Turk, and those like them, the church?"²⁶ Luther pointed Melanchthon to Scripture, saying, "If we don't have God's Word, who are the people who have it?"²⁷ He closed the letter with the wish—almost a threat—that he might come to Augsburg despite the imperial ban because Melanchthon had

let Satan's taunts make him "so distressed and weak."[28]

Perhaps Melanchthon had forgotten Luther's eloquent message to the congregation that had gathered at Coburg shortly before departing for the diet. In his sermon, Luther had appealed to the contingent to be ready for whatever cross of suffering God purposed to send their way. The reformer urged them to place themselves in God's hands and Word because "He will nevertheless defend his Word simply because it is his Word."[29] He reminded them that God would uphold and sustain them.

Although one might conclude from Luther's June 29 letter that he was unfeeling toward Melanchthon and the pressures he faced as leader of the Lutheran party, Luther admitted in a letter written the next day to their mutual colleague George Spalatin, court chaplain to the Saxon elector, that he had been "angry and full of fear" because of "Philipp's worries."[30] Luther admitted that anxieties and afflictions are quite human. He then went on to express nothing but praise for the Augsburg Confession and for those who had bravely presented and defended it. In a July 3 letter to Melanchthon, Luther reiterated, "Yesterday I carefully reread your whole *Apologia*, and I am tremendously pleased with it."[31] The reformer then reminded Melanchthon that it is sin to doubt God's support.

The haggling at the diet went on and on, especially over the division of power between the secular and ecclesiastical realms, a point which the Confession had addressed.[32] In a July 16 letter to several colleagues at the diet, Luther counseled, "Our case has been made, and beyond this you will not accomplish anything better or more advantageous."[33]

Meanwhile, on orders from Charles V, the papal theologians (Eck and company) scrambled to complete their *Confutation*, which was the official answer to the "heretics." It was poorly written and poorly supported from Scripture. In an

August 26, 1530, letter to Elector John, Luther advised: "Your Electoral Grace certainly knows that one of our principal tenets is that nothing is to be taught or done unless it is firmly based on God's Word."[34] Thus no concession could be made, for example, in regards to "one kind" in the Sacrament because, as Luther reminded the contingent, that was "purely human invention, and is in no way confirmed by God's Word."[35]

In evident weariness, Luther penned a note to his wife, Katie, on September 8. He was waiting patiently for his return to Wittenberg: "If only there will [finally] be an end to the diet! We have done and offered enough; the papists do not want to give a hair's breadth."[36] On September 22, 1530, the emperor finally proclaimed the diet in recess, declaring the Lutheran party had been given a fair hearing and that by April 15, 1531, they were to show cause why they should not be condemned under the so-called proof of the *Confutation*.

Elector John of Saxony left with his party the next day without receiving a copy of the *Confutation*. Melanchthon, however, and others had made ample notes; moreover, they obtained a copy through friendly sources in Nürnberg. Melanchthon's efforts to respond to this papal document led to the writing of the Apology of the Augsburg Confession.[37]

Philip Schaff is undoubtedly correct in his assessment of the respective roles of Luther and Melanchthon in the production of the Augsburg Confession:

> Luther thus produced the doctrinal matter of the Confession, while Melanchthon's scholarly and methodical mind freely reproduced and elaborated it into its final shape and form, and his gentle, peaceful, compromising spirit breathed into it a moderate, conservative tone. In other words, Luther was the primary, Melanchthon was the secondary author, of the con-

tents, and the sole author of the style and temper of the Confession.[38]

It could be debated whether such a clean division between these two great spirits looming behind the final product of Augsburg should be made. Close attention to Luther's literary productions—without reference to the Marburg and Schwabach articles or his "Confession Concerning Christ's Supper"—demonstrates that much of the wording of the confession, if not always the style, was as much Luther's as Melanchthon's.

However, the fact remains that every item and article treated in the Augsburg Confession, including the many abuses that had crept into the church's teaching and practice, had been previously pinpointed and cited for correction in Luther's sermons and/or treatises. For example, nothing is said in the Augsburg Confession about ecclesiastical power and authority in relation to the secular realm that had not first been addressed by Luther in his several treatises on the Christian, or the church, in society.[39] To such a list, one would have added Luther's equally significant works on marriage, the economy, education, and other matters relevant to the Christian citizen's daily life in the sixteenth century.

The Augsburg Confession is known as the *Magna Carta* of the Lutheran Church because it forms part of the constitution of every Lutheran congregation. Moreover, all of Protestantism has benefited from and is to some extent modeled after its straightforward presentation of the Christian faith. When Charles V and the papists accepted the *Confutation* as a sufficient response and refutation of the Augsburg Confession, the real break between Rome and the "Protestants" took place. As Roland Bainton has observed, with the June 25, 1530, reading of the Augsburg Confession, world history had arrived at the

dissolution of the Holy Roman Empire. Europe was split between the Protestants and the Roman Catholics thereafter and was destined for bloody conflict between the rival parties of the Christian church.

Luther's stay at Coburg Castle yielded voluminous correspondence and writing, despite several bouts of illness. He completed pertinent treatises that spoke to current issues, and he pursued his Old Testament translation project, working on Jeremiah, Ezekiel, and the Minor Prophets. After assistance from Melanchthon, Bugenhagen, Rörer, and others, Luther had the translation on the market by the end of 1534. In 1535, Luther's Lectures on Galatians were published. This was one of Luther's favorite epistles because of the forceful clarity with which the apostle Paul treated sinners' justification before God.

After the failure of the Diet of Augsburg to achieve a resolution of the religious issue dividing the realm, the Protestant leaders saw the need for an alliance to safeguard their rights and territories. Charles V, his legal counselors, and the papal legate Cardinal Campeggio had set April 15, 1531, as the deadline for the Lutherans to accede to the *Confutation* and recant their confession. The April 15, 1531, deadline for the Lutherans to recant their position came and went, and the emperor let it pass. The Turkish threat kept him so preoccupied for the next 15 years that he could do nothing about the religious problem in his realm, not even call a general church council as he had promised. On the theological side, however, Melanchthon produced the Apology of the Augsburg Confession, which articulated at greater length the Lutheran position.

On the political side, the evangelical princes formed the Schmalkald League for mutual protection against arbitrary and high-handed imperial action in their territories. This alliance included five princes (Saxony, Hesse, Anhalt, Mans-

feld, and Lueneburg) and 11 municipalities or "free cities." The legal advisers of the Schmalkald League pointed out that the emperor had gone beyond the imperial statutes by requiring compliance from the territories on matters of religion. Moreover, fundamental differences remained that had not been addressed or resolved, for which the emperor had promised a free general council. Therefore, the legal advisers determined it had become a matter of prudent wisdom on the part of these concerned civic leaders that they band together to defend their borders, as well as the consciences of their citizens, against all oppression, especially any prompted by distant Rome and the papal office.

From the beginning, Luther had favored a free general council of the church so serious attention might be given to the evils that had encroached on theology and life. Emperor Charles V also believed such a council would be beneficial, but papal attitude was understandably negative, deeming such a gathering a threat. Thus delaying tactics by the reigning pontiffs ensued, first by Clement VII in 1532, then by Paul III in 1537. Then, shortly before Luther's death, the Council of Trent convened in 1545. It continued, with several interruptions, until 1563. It was hardly a *free* council, however, and instead focused on a counter-Reformation agenda.

In the years following Luther's death in 1546, the Augsburg Confession continued to be the cornerstone of Lutheran teaching while troubling divisions and doctrinal controversies tore at the innards of those claiming kinship and discipleship in Luther's Reformation. Melanchthon's leadership was not sufficient to the task of providing course correction and clear direction to the various factions within the church after Luther's death.

Martin Chemnitz and Jakob Andreae, with the resources of leading laymen such as Elector August of Saxony, succeeded

in healing the controversies and calling the splintered parties back to confidence in and a theological stance on the foundation of their confessions, chiefly the Augsburg Confession.[40] When *The Book of Concord* was adopted by the various Lutheran factions in 1580, its subscribers stated in the words of the Preface their total and unqualified agreement with the 1530 Augsburg Confession:

> Once again we wholeheartedly confess our adherence to this same Christian Augsburg Confession, solidly based as it is in God's Word, and we remain faithful to its simple, clear, unequivocal meaning, which its words intend. We regard this confession as a pure, Christian creed, which (after the Word of God) should guide true Christians in this time By the grace of the Almighty we, too, are resolved to abide faithfully until our end in this oft-cited Christian confession, as it was delivered to Emperor Charles in 1530. We do not intend to deviate in the least from this Confession either in this document or in any other, nor do we intend to submit any other, new confession.[41]

THE SCHMALKALD ARTICLES

When it did appear as though Pope Paul III would call a council in Mantua in 1537, Elector John Frederick of Saxony[42] expressed strong misgivings about a council called by the pope rather than by the emperor. The elector was of the opinion that such a council would not be free and open but would follow a course predetermined by the pope. So the Lutheran side might be prepared for a council, the elector asked Luther to write a confessional statement for use at the council. Although increasingly bothered by illness, Luther complied, preparing the Schmalkald Articles. This appellation was taken from the location at which the Schmalkald League members and their

theologians, including Luther, convened in early February 1537.

Almost immediately upon arrival in Schmalkalden, Luther developed a severe kidney stone. When all medical treatment failed and his life seemed in jeopardy, the elector arranged for transportation to return Luther to the care of his wife. Then the elector pressed for the assembly at Schmalkalden to read and adopt the articles Luther had prepared, but Melanchthon jockeyed the program into a rereading and reaffirmation of the Augsburg Confession and its Apology. Although the motivation for this tactic is not entirely clear, Melanchthon was always inclined toward appeasement and compromise. He may have felt the Schmalkald Articles was too forceful in its positions.

Despite the change in agenda, Luther's text was still read by the conferees, and there was unanimous agreement and voluntary subscription by all, except those few who inclined toward Crypto-Calvinism. These men were mainly South Germans. The Schmalkald Articles was recognized as being fully in tune with the Scriptures and with the intent and meaning of the Augsburg Confession. The tract Melanchthon had prepared at the behest of the conference delegates, "Treatise on the Power and Primacy of the Pope," was also read at Schmalkalden. In this treatise, Melanchthon conformed to the mind and urging of all the members present. It was written in tune with the stance and position Luther had taken when identifying the papal office as a clear and obvious human invention. Melanchthon's treatise was also adopted at Schmalkalden and became an official appendix to Luther's articles.

The Schmalkald Articles was a relatively short document that stated the cause Luther and the protesting party were bringing before the proposed church council. In part I, Luther briefly cited the areas in which, as Christians, there was general

agreement. He acknowledged that both parties upheld "the sublime articles of the divine majesty" as confessed in the ecumenical creeds, including the Trinity, the distinct persons and activities of the Godhead, and the incarnation. He stated that "these articles are not matters of dispute or conflict, for both sides confess them. Therefore it is not necessary to deal with them at greater length now."[43]

In part II of the Schmalkald Articles, Luther singled out four areas of sharp disagreement. Each area impinged directly on the gracious and wondrous saving work and office of the Lord Jesus Christ for sinners' redemption, thus jeopardizing the Gospel. With clear scriptural citation, Luther began: "Here is the first and chief article: That Jesus Christ, our God and Lord, 'was handed over to death for our trespasses and was raised for our justification' (Rom. 4[:25])."[44] Luther stated that "this must be believed and may not be obtained or grasped otherwise with any work, law, or merit, it is clear and certain that this faith alone justifies us."[45] He added that "nothing in this article can be conceded or given up" because "on this article stands all that we teach and practice against the pope, the devil, and the world."[46] This was the ultimate, foundational platform on which Luther took his stand, as did his fellow confessors at Augsburg. Their concern was for the Gospel itself, the central, fundamental heart of the Christian faith. In this statement, Luther set the course for the rest of the document.

Luther's second focus in the Schmalkald Articles was the Mass. Luther wrote that "the Mass under the papacy has to be the greatest and most terrible abomination, as it directly and violently opposes this chief article."[47] In Luther's opinion, if the Mass were a sacrifice, what did that say about Christ's sacrifice on the cross? His answer was that the Mass "is a mere human invention, not commanded by God. And we may discard all human inventions."[48] Moreover, "if the Mass falls, the papacy

falls."[49] Luther added the admonition that "the invocation of saints is also one of the abuses of the Antichrist that is in conflict with the first, chief article and that destroys the knowledge of Christ."[50] Although the saints and angels may indeed be concerned for the salvation of human beings, this did not prove for Luther that Christians should serve, invoke, and adore them. For Luther, hope and faith had to cling to Christ alone.

Third among the grave abuses Luther listed in the Schmalkald Articles were the religious chapters and cloisters that had been established as more excellent ways to achieve piety and live the Christian life. Luther spoke from experience on this point; he had tried this route as an Augustinian monk, only to find it empty. He believed that to view life in a religious order or chapter as "something better than everyday Christian walks of life" was contrary to the first chief article, the Gospel, which pointed people to Christ alone for salvation.[51] Religious orders and cloisters pointed to one's own practiced pieties and disciplines. Luther desired to reposition chapters and cloisters as institutions that would provide solid training for teachers and clergy, as well as for magistrates and public servants.

The institution of the papacy was the fourth and last in the list of abuses Luther singled out in the Schmalkald Articles as damaging to the faith. He considered the papacy especially troubling when coupled with the pretentious claim that there was no salvation without acceding to the pope's rule as ordained by God. Luther asserted that "the pope is not the head of all Christendom 'by divine right' or on the basis of God's Word, because that belongs only to the one who is called Jesus Christ."[52] He also pointed out that the early church had existed without the papacy for more than 500 years. Moreover, Luther pointed out that papal primacy was no guarantee for unity in the church because that goal is accomplished when Christians "live under one head, Christ, and [when] all the

bishops . . . keep diligently together in unity of teaching, faith, sacraments, prayers, and works of love."[53] Luther added: "Therefore, as little as we can worship the devil himself as our lord or god, so we cannot allow his apostle, the pope or Antichrist, to govern as our head or lord."[54]

In his concluding summary of the Schmalkald Articles, Luther stated that these four topics would provide enough for the council to condemn, if and when it should ever take place. He also expressed serious doubts that the papists would yield or correct their course because they "neither can nor will concede to us the tiniest fraction of these articles."[55] As things turned out, Luther would not live to see such a general council. However, the story of the Council of Trent fully corresponds to the reformer's assessment and predictions.

In part III of the Schmalkald Articles, Luther presented the articles of faith that were of particular concern to the Reformation cause: the way of salvation, the means of grace, the church, and church organization. The first three points treated sin, the law, and repentance, devoting special attention to the true nature of penitence and the confusion Roman Catholic theology had introduced into the church with the buying and selling of indulgences. In Luther's view, such confusion of the roles of Law and Gospel in the sinner's life left devout Christians dangling, uncertain of their forgiveness before God. Thus, Luther pointed out, "no one knew how great the contrition should be in order for it to suffice before God."[56]

In articles 4 to 8 of part III, Luther set forth Holy Scripture's teaching on God's manifold goodness and mercy whereby His saving grace and forgiveness are made available to sinners.

> Because God is extravagantly rich in his grace: first, through the spoken word, in which the forgiveness of sins is preached to the whole world (which is the

proper function of the gospel); second, through baptism; third, through the holy Sacrament of the Altar; fourth, through the power of the keys and also through the mutual conversation and consolation of brothers and sisters. Matthew 18[:20]: "Where two or three are gathered . . ."[57]

Luther also expressed the desire to include confession (particularly private) and absolution with the Gospel's proclamation. In his summary on the means of grace, Luther stated: "Therefore we should and must insist that God does not want to deal with us human beings, except by means of his external Word and sacrament. Everything that boasts of being from the Spirit apart from such a Word and sacrament is of the devil."[58] Luther averred that God had chosen not to deal with human beings without "his external Word."[59]

In articles 9 through 15 of part III of the Schmalkald Articles, Luther drew together Scripture's teaching on the nature of the church and matters related to the church's life in this world. He briefly yet clearly addressed fundamentals such as the exercise or practice of evangelical discipline within the church; the calling and ordaining of pastors; the God-given right of the clergy to marry; the role of human traditions in the church; the evil of monastic vows; and the blessing of godly living as a fruit of faith. Especially memorable is Luther's short paragraph on the nature of the church:

> We do not concede to [the papists] that they are the church God be praised, a seven-year-old child knows what the church is: holy believers and "the little sheep who hear the voice of their shepherd." This is why children pray in this way, "I believe in one holy Christian church." This holiness does not consist of surplices, tonsures, long albs, or other ceremonies of theirs that they have invented over and above the Holy

Scriptures. Its holiness exists in the Word of God and true faith.[60]

Concluding the Schmalkald Articles, Luther stated: "These are the articles on which I must stand and on which I intend to stand, God willing, until my death. I can neither change nor concede anything in them. If anyone desires to do so, it is on that person's conscience."[61] Luther's signature was then followed by a long list of signatures by the pastors and theological leaders of the various territories and municipalities belonging to the Schmalkald League.[62]

9

THE SUNSET YEARS

THE REFORMER'S FINAL MESSAGES
TO THE CHURCH

The conferees at Schmalkalden undoubtedly wondered whether they would see Martin Luther again as he was gently loaded into a carriage provided by Elector John Frederick for the return trip to Wittenberg. He was, after all, grievously ill with a kidney obstruction. The patient made a miraculous recovery, however, on the first day of the journey. After approximately 10 miles of jostling and bumping along the road, the stone apparently was jarred loose, returning Luther to health. In due time, he was safely home in the loving care of Katie and his family. The reformer knew it had been a close call, as did his friends. After about a month of convalescence, Luther turned his full attention to his multiple tasks: teaching, preaching, counseling, carrying on his vast correspondence, and preparing treatises that addressed pertinent issues.

Luther was a veritable dynamo, but many scholars believe he would have been unable to carry on without Katie and his family. He meant it sincerely when he testified, "I wouldn't give up my Katy for France or for Venice."[1] Despite all obstacles, Martin and Katie had established a home and raised a family of

six children together.[2] Indeed, theirs became the model parsonage.

Luther continued to fulfill the responsibilities of his calling at the university and at the Wittenberg parish. During these final years of his life, Luther accomplished a truly monumental piece of work: the delivery of and publication of his lectures on the Book of Genesis. In December 1545, shortly before his death, the reformer finally concluded his lectures on the first book of the Bible, some 10 years after launching the project. Along with his translation of the Bible into German, the commentary on Genesis easily ranks among the greatest feats of human achievement in the field of literary production.[3]

As agitation continued concerning the need for a general council to address and resolve the religious dispute dividing the church and disturbing the empire, Luther felt compelled to address a treatise to the resolution of the impasse. Even before the Diet of Worms, he had urged in his 1520 treatise "To the Christian Nobility of the German Nation" that a general, free council should be called.[4]

But the papacy had bad memories of the conciliar movement that in preceding centuries had chipped away at papal supremacy. Thus when the imperial diet in 1524 urged that a free, general council be scheduled to address those issues ignited by Luther's "Ninety-five Theses"—and that such a meeting should take place on German soil—the papacy did everything in its power to delay things. Primarily, calling a council would give undue recognition to the Protestant party, legitimizing its cause and acceding that the Protestants had reason to call for reform in the church.

By 1537, members of the Schmalkald League had prepared for a council in Mantua proposed by Pope Paul III. They had stipulated four conditions or rubrics under which they were willing to participate: (1) The council must be free and

open (they could not already be condemned as heretics). (2) They must attend as full and equal participants. (3) The Holy Scriptures would be the supreme authority. (4) The meeting site had to be on German soil. The Mantua council never convened; however, a council did take place in Trent from 1545 until 1563. It cemented papal supremacy, as well as the judgment of heresy against Luther, his doctrines, and his followers.

"ON THE COUNCILS AND THE CHURCH"

Luther's treatise "On the Councils and the Church," published in 1539, had been written in response to the unsettled situation in the church.[5] Although he was not entirely happy with the end product, Luther had done careful work in its preparation. In the first part, he asserted and demonstrated with historical references that the church was never, nor could it ever be, reformed by councils. Nor could the church fathers set the guidelines as supreme authority or norm. Citing historical evidence at length, Luther concluded, "No, there must be another way than proving things by means of councils and fathers, or there could have been no church since the days of the apostles."[6] Luther averred that the Holy Scriptures alone must rule in the church and guide it in the ways of God's truth. Only then would the church continue to abide and prosper in this world.

The second part of "On the Councils and the Church" reviewed the most significant councils in the post-apostolic history of the church. Among Luther's sources were Eusebius of Caesarea (A.D. 280–339); Cassiodorus, who founded a monastery to perpetuate early Greek culture (A.D. 490–580); Peter Crabbe, whose summary of the early councils remains a primary source (1470–1553); and Platinas, who from 1470 to 1481 compiled *Lives of the Popes*. On the basis of these sources, Luther set forth a brilliant argument for the centrality of the

Christological content of theology in the life and teaching of the church through the centuries. He demonstrated that the main purpose and function of the early councils—Nicaea (A.D. 325), Constantinople (A.D. 381), Ephesus (A.D. 431), and Chalcedon (A.D. 451)—was achieved in their defense of the faith, upholding the saving work of Jesus Christ, true God and true man, who was graciously sent into the world by a loving heavenly Father for the salvation of humanity. This was Holy Scripture's clear teaching. Luther showed that the other matters that often occupied the attention of the early church councils were, for the most part, little more than peripheral.

The reformer was ready to grant that a general council could be of help for the church in a time of crisis, stating, "At this point we ask and cry for a council, requesting advice and help from all of Christendom."[7] Such a council would have to "occupy itself only with matters of faith, and then only when faith is in jeopardy."[8] Its participants would have to be willing to bow before Scripture's authoritative teaching, "that we must be saved by the grace of God alone (as St. Peter testifies [Acts 15:11]), as all of Christendom since the beginning of the world was saved."[9]

The third part of the treatise has forever established its significance as a theological work of highest value because it explores what, who, and where the church is. According to Luther, Rome likes "very much to be regarded as the church," but the children's creed explains simply "what the church is, namely, a communion of saints, that is, a crowd or assembly of people who are Christians and holy."[10] Luther pointed out that this is the meaning of the Greek word *ekklesia*—"an assembly of people"—as indicated in Acts 19:39–41. But Christians are a people with a special call. Therefore, they are not only *ekklesia* but *sancta catholica Christiana*, that is, a holy, catholic, and Christian assembly. Luther emphasized that a person is holy

and a child of God by faith in God's Word, the Gospel, not by throwing a surplice over one's head or practicing prescribed rules of piety.

> The holy Christian people are recognized by their possession of the holy Word of God, . . . for God's word is holy and sanctifies everything it touches A Christian, holy people must exist there, for God's Word cannot be without God's people, and conversely, God's people cannot be without God's word.[11]

The external Word—"preached, believed, professed, and lived"—is the foundational mark by which the *una sancta* can be spotted in this world.[12] The people "themselves confess that it is God's word and Holy Scripture."[13]

There were additional marks of the true church, Luther added. He noted: "God's people . . . are recognized by the holy sacrament of baptism, wherever it is taught, believed, and administered correctly according to Christ's ordinance."[14] According to the reformer, Baptism's validity is not dependent on who baptizes, but on God. Luther wrote: "[Baptism] was ordained for [the baptized] by God, and given to him by God, just as the word is not the preacher's . . . but belongs to the disciple who hears and believes it."[15]

While Baptism is administered once, when faith in Christ's promised forgiveness is first confessed, the Sacrament of the Altar is repeated often for repentant sinners who earnestly seek God's calming, comforting, continuing assurance of love and forbearance. Luther stated that the church also was recognized "by the holy sacrament of the altar, wherever it is rightly administered, believed, and received, according to Christ's institution."[16] He did not want people to "be led astray by the question of whether the man who administers the sacrament is holy" or other such pious notions or external stipulations.[17] Instead, Luther counseled that "it is enough that you

are consecrated and anointed with the sublime and holy chrism of God, with the word of God, with baptism, and also this sacrament."[18]

Word, Baptism, and the Lord's Supper may be God's chosen means of grace by which He builds and keeps the church, but according to Luther there also are other marks by which "you may be assured of the presence of God's people."[19] He listed four additional tokens of the church's presence in the world. First, the office of the keys—confession and absolution—embraces the ministering of the means of grace, Word and Sacrament. "The keys belong not to the pope (as he lies)," Luther stated, "but to the church, that is, to God's people, . . . wherever there are Christians."[20] Luther taught that Christians have the God-given authority to administer the keys publicly, but not every individual believer is a minister in the sense that he assumes the authority and responsibility of the pastoral office. Thus for Luther, a fifth mark of the church is that

> the church is recognized externally by the fact that it consecrates or calls ministers . . . who publicly and privately give, administer, and use the aforementioned four things or holy possessions in behalf of and in the name of the church, or rather by reason of their institution by Christ The people as a whole cannot do these things, but must entrust or have them entrusted to one person.[21]

Thus the office and the person of a called pastor is also a mark of a Christian assembly or church. Here Luther pointed out, on the basis of Scripture (1 Corinthians 14:34; 1 Peter 3:7; Genesis 3:16), that only qualified men are chosen for the office. Therefore, women, children, immature individuals, and those who are incompetent are excluded from the pastoral office. Luther stated that the officiant does not "make God's word and sacraments . . . worse or better," but he is to be equipped and

ready to adhere "to correct doctrine and practice."[22] In this regard, Luther considered Rome's qualifications for the pastoral office to be less than satisfactory. It "regarded bishops and popes as bridegrooms of the church," allowed incompetents to minister in the church, and winked at sinful lifestyles while forcing celibacy on its workers. Finally, in the list of marks by which the Christian church is to be recognized in the world, Luther designated "prayer, praise and thanksgiving to God" in the worship life of Christians, as well as cross-bearing or suffering "misfortune and persecution, all kinds of trials and evil." This mark of the church is inevitable, Luther added, because "the only reason they must suffer is that they steadfastly adhere to Christ and God's Word."[23]

There were, in addition, other signs and uses associated with Christians in the forms of worship and the houses of worship they build in the name of God, but, as Luther stated, "these signs cannot be regarded as reliable as those noted before since the heathen too practice these works and indeed at times appear holier than Christians."[24] Luther also pointed out that Christians should not grow weary of or indifferent to what God had placed in their hands and lives—His precious Word and Sacraments. He reminded his readers that the radical charismatic spirits, such as Thomas Müntzer, would always be around to turn people inward for a supposedly superior spirituality. Luther noted that these radicals cried: "Spirit! Spirit! The Spirit must do it! The letter kills!"[25] But Luther stated that the church must remember that its externals—Word and Sacraments—are not merely that, but they are "commanded, instituted, and ordained by God, so that he himself and not any angel will work through them with the Holy Spirit."[26] Luther counsels that "if God were to bid you to pick up a straw or to pluck out a feather" and thereby to know that sins are forgiven, it should be done gladly and thankfully

because "it is God's will that we obey his word, use his sacraments, and honor his church."[27] Other externals, such as special holy days, hours, sacred places or buildings, pulpits, fonts, candles, bells, vestments, and so on may also appertain, Luther wrote, but "Christians could be and remain sanctified even without these items . . . But for the sake of children and simple folk, it is a fine thing and conducive to good order to have a definite time, place, and hour . . . where they may assemble. . . . Nevertheless, there should be freedom here."[28]

In the same vein, Luther argued that "schools must be second in importance only to the church. . . . Next, then, to the school comes the burgher's house, for it supplies the pupils; then the city hall and the castle, which must protect the schools."[29] However, "God must be over all and nearest to all to preserve this ring or circle against the devil."[30] Luther discerned that there "are three hierarchies ordained by God."[31] Two are temporal—the home and the city or government. Luther stated: "The home must produce, whereas the city must guard, protect, and defend. Then follows the third, God's own home and city, that is, the church, which must obtain people from the home and protection and defense from the city."[32] Obviously Luther conceived of the church as a visible entity, according to the marks he had cited, yet this was in perfect accord with the "holy Christian church, the communion of saints" confessed in the Apostles' Creed. Luther concluded this tract by stating that the papal claim of rule "over and above these three high divine governments, these three divine, natural, and temporal laws of God" was "bogus" and "blasphemous."[33]

"THAT JESUS CHRIST WAS BORN A JEW"

At the dawn of the Reformation—after the Diet of Worms and the Diet of Nürnberg—the question of what to do with Luther

had persisted, both for the empire and for the Roman Catholic Church. All manner of false rumors circulated about the reformer and his teachings, including the farfetched notion that he denied the virgin birth of Christ. Committed as he was to Holy Scripture's teachings, in 1523 Luther fired off the treatise "That Jesus Christ Was Born a Jew."[34] Luther explained in the preface to the treatise that though he had become accustomed to the lies perpetrated against him, he had to answer the charge that he denied the virgin birth.

With appropriate scriptural citations from the Old and New Testaments, Luther underscored that Christ indeed was born of a virgin. Moreover, the young lady in question was Jewish, a descendant of Abraham. With long excursus, Luther emphasized that Isaiah had foretold how a young maiden of David's line, a virgin, would give birth to the promised Messiah (Isaiah 7:14). Luther then pointed out that it was not the Virgin Mary but the Son who was conceived and born of her whom the world must recognize, worship, and serve.

"Against the Roman Papacy"[35]

Luther also addressed the standoff between the papacy and the German Protestant princes, who, because of fealty to Charles V, were involved in a conflict with Francis I, as well as the Turks. The papal office, now occupied by Pope Paul III, had played a devious role in fomenting trouble between Charles V and Francis I. At the Diet of Speyer in 1544, the Protestant princes had pressed concessions from Charles in exchange for their military support against the Turks, including the right to ecclesial revenues in their territories, cancellation of pending lawsuits against the Protestant cause, and abolition of the various decrees invoked against the Protestants by previous diets of the realm.

These concessions, in turn, caused Pope Paul III to offer strenuous objections to the emperor, asserting that only the pope had the power to call a council to adjudicate temporal affairs. Paul III also reminded the emperor that he was the sole authority to judge in religious matters and to establish doctrine in the realm. Although Charles V and Francis I reached an accord and agreed that the pan-European council would be held at Trent in 1545, the papal *monitum*, or warning, against the emperor had already been issued. This warning prompted Luther to prepare his treatise against the papacy. His concerns were threefold and constituted the body of the treatise: (1) Is the pope supreme in secular as well as ecclesiastical matters? (2) Could the pope be recalled or deposed? (3) Were the (so-called) Holy Roman Empire and the German territories bestowed by the pope on the emperor? Luther addressed the first audacious claim at length, while the last two he treated more briefly.

That popes alone had supreme authority to rule in matters of state or church, or call a general council, "would be nothing but a farce," Luther pointed out. It would be like conjuring "horse dirt into our mouths."[36] A council could not be called *free* if everything were already decided ahead of time. Luther stated that *free* ought to mean "above all that God's Word, or Holy Scripture should—free and without strings (as it must be)—have its way and rights, according to which one decides and judges everything."[37] Luther then referenced the Diet of Worms where he had contended for that same point at the risk of his life, only to be condemned as a heretic and placed under the imperial ban. Luther explained in blunt terms that his purpose for writing this treatise was simply "that those who now live and those who will come after us should know what I have thought of the pope, the damned Antichrist, and so that whoever wishes to be a Christian may be warned

against such an abomination."[38] He realized, of course, that his language was coarse, but he wanted it to be known and said that Pope Paul was a warmonger who had set France against Charles V to thwart his efforts for a general, free council. Thus Paul III manipulated men and nations for his own purpose as supreme authority in world affairs, political as well as ecclesiastical. Luther ended his lengthy preface, stating:

> But I must stop here . . . and yet I still have not gotten to the points I had intended to make in this book . . . three things: first, whether it is true that the pope in Rome is the head of Christendom—above councils, emperor, angels, etc.—as he boasts; second, whether it is true that no one may sentence, judge, or depose him, as he bellows; and third, whether it is true that he has transferred the Roman Empire from the Greeks to us Germans.[39]

Luther delved into the first question with a brilliant survey of history and biblical references. He demonstrated "that the bishop of Rome was nothing more than a bishop and should still be that."[40] Luther pointed out that the keys of the kingdom of Christ were given neither to the pope nor to any single individual—not even to the apostles. Instead, the keys were given to all Christians, to all believers, so they can tell the saving Gospel to everyone. Luther stated that "Christendom has no head and can have none, except the only Son of God, Jesus Christ, . . . who is tied neither to Rome nor any other place."[41] He added that "the dear Lord Christ knows of no more than one church in the whole world, which he builds on himself, the rock, through faith."[42] Thus Luther affirmed what the creeds (the Apostles' and the Nicene) already declared concerning the holy Christian church. Clearly and convincingly, the reformer laid out the meaning and significance of key passages, especially Matthew 16, which concerns the "rock"

(Christ) on which the church is built, and John 21, which provides the mandate for Christ's disciples and His church to "feed My sheep." Luther expressed the ongoing mission Christ left for His church as "the whole world stand[ing] open, if only someone would want to pasture it."[43]

The second question aired in the treatise was that of the primacy of the papacy. Were papal incumbents supreme and above all judgment, or could they be called to account, even deposed? Luther said it is a matter that must be decided on the basis of divine authority as given to the church by the Lord Himself. Luther contended that God's Word, Holy Scripture, must be the only arbiter. Because of God's Word, "every baptized child is not only a judge over the pope, but also over his god, the devil," Luther contended.[44] Luther said that he was prepared to "recognize the pope . . . [as] the true, final horror, the Antichrist [because] the pope would like to sit in judgment over this word and remain unpunished by the Holy Spirit."[45] Luther believed such was "the verdict of the holy Christian church—yes, of the Lord Jesus Christ."[46]

The final point Luther addressed in this treatise concerned a key matter of state. Was it true that papal power and authority had conferred the empire on the German people in the time of Pope Leo III and Charlemagne (A.D. 800)? Luther's evaluation was that this was "pure papal twaddle."[47] He added that Charlemagne "said afterward that if he had foreseen this, he would not have gone to church" that day.[48] Luther pointed out that "Charles had inherited France and Germany from his father Pepin . . . [and] received nothing from the pope, except the mere name 'Roman Emperor' . . . [moreover] electors make an emperor," not popes.[49]

In his concluding words, Luther called on the providence of the Almighty: "If I should die meanwhile, may God grant that someone else make it a thousand times worse, for this dev-

ilish popery is the last misfortune on earth, nearest to that which all the devils can do with all their might. God help us. Amen."[50]

THE DEATH OF THE REFORMER

The year 1545 moved quickly to a close. Luther had completed his lectures on the Book of Genesis in mid-November. Late in December, he traveled with Philipp Melanchthon to Mansfeld to attempt a reconciliation between the feuding princes, the brothers Albrecht and Gerhard. But the mission by the two colleagues from Wittenberg was unsuccessful, and in early January, they returned home.

On January 17, Luther preached for the last time at St. Mary's in Wittenberg. Shortly after, another effort was launched to work out a peaceful solution between the two counts of Mansfeld. This time Luther's three sons accompanied their father to his boyhood town, but the entire party was bogged down at Halle by the River Saale, which was in flood. After several days of waiting, the group was helped across the river by several dozen horsemen sent by the counts. Luther's sons remained in Mansfeld to visit relatives while their father went to nearby Eisleben to arbitrate the feud. This time the efforts were successful and the differences concerning mining operations were resolved.

Because Eisleben was his ancestral home, Luther preached at least four times at St. Andrew's, the cathedral church of Eisleben. At the time of this trip, Luther was 63 years old, and his life had been marked with frequent illness, including several near-death episodes. While at Eisleben, the reformer became ill again. However, when he wrote letters to Katie in Wittenberg, he did not complain about his health but remained upbeat, perhaps because their sons also were absent

from home. On February 14 or 15—the date is disputed—
Luther preached his final sermon and penned his last letter to
Katie. He assured her that the proceedings had been successful,
adding that he hoped to return home that week. He also clari-
fied that their sons were still in Mansfield, visiting with Jacob
Luther.

Despite the cheery notes to Katie that assured her of his
well-being, Luther's physical condition was worsening by the
day. Other notes indicate that Luther knew he was growing
weaker under the burdens of persistent kidney stones and even
heart problems. In words of dedication that he inscribed in a
book for the Eisleben town clerk, Luther confidently penned
thoughts that reveal his readiness to meet his God, quoting
Jesus' words in the Gospel of John (8:51): "If anyone keeps My
word, he will never see death." Luther added that this "is the
truth, for if a person earnestly reflects on God's Word in his
heart, believes it, and sleeps away and dies in this faith, then he
perishes and passes on before he is even aware of death . . .
saved by the Word which he contemplates and believes."[51]

Luther's words were soon actualized. On February 16,
Luther briefly attended the arbitration sessions with the counts
but soon retired, feeling quite ill. The following day he could
not muster the strength to participate further.[52] On February
17, Luther kept to his quarters, and in the early hours of Feb-
ruary 18, after a restless night, he succumbed. Two doctors
attended Luther throughout his stay in Eisleben, as well as Jus-
tus Jonas, Johannes Aurifaber, his private secretary, and
Michael Coelius, who was pastor at the Castle Church of
Mansfeld. Luther's three sons also were present during his final
hours. Although anguished with pain and increasing weakness,
Luther had moments of clarity during which he repeated many
of the treasured passages of Holy Scripture he had committed
to memory. Several times as the end approached, Jonas and

Coelius asked if Luther was ready to confirm the faith he had confessed and commit his soul into the tender care of his heavenly Father. Luther repeated several times, "Father, into Thy hands I commit my spirit," before breathing his last.

Luther's death occasioned much agitation in the Protestant camp. Word was immediately sent by courier to Katie and the various authorities in Wittenberg. At Eisleben, funeral arrangements were delayed until Elector John Frederick ordered that the burial would take place in Wittenberg. A funeral service was conducted in Eisleben on February 19. Jonas preached for this service, but Coelius delivered the message for a second service held on February 20. Then a solemn cortege with a large troop of horsemen leading the procession set out for Wittenberg, making its somber journey through Halle.

Along the way, crowds gathered respectfully. At the Elster Gate of Wittenberg, by arrangement of Elector John Frederick of Saxony, the mourners were joined by Katie and Margaret. The entourage also included family members from Mansfeld, faculty and students of the university, municipal officials, and more. The group proceeded slowly to the Castle Church for the funeral service. Preaching on this occasion was Luther's friend and pastor, Johannes Bugenhagen. Melanchthon, as the university's representative, gave a memorable eulogy for his longtime colleague and friend. Luther's body was then lowered into the grave prepared at the Castle Church. The reformer's resting place was immediately in front of the pulpit from which he had preached so many times.

Martin Luther would be sorely missed not only by a loving family but also throughout the world. He had been a fearless spokesman for the Christian faith. Throughout his life, he had championed the cause of the Bible, God's precious Word. His translation of the Scriptures into the people's idiom testi-

fied to his influence and impact on society at the dawn of the modern world, as did the force and clarity with which he proclaimed the Gospel to sinful people. "By grace alone through faith in Christ" was no mere slogan for Luther. Instead, it was the lifeline to God in heaven for every sinful offspring of Adam and Eve. To the end of his life, Luther was deeply concerned that each person would hear that precious truth, to live and die in it with trusting faith. He took to heart the Lord's admonition to "love your enemies, do good to those who hate you, bless those who curse you, pray for those who abuse you" (Luke 6:27–28). Therefore, even when Luther, wrote strong treatises, especially against the papacy, his motivation and harsh words issued forth because he perceived that the Gospel was being denied. Luther stood for the Gospel, and in this truth he lived and died.

The last thing Luther wrote was a short note, which apparently was preserved by Johannes Aurifaber. It highlighted this position.

> Nobody can understand Vergil in his *Bucolics* and *Georgics* unless he has first been a shepherd or a farmer for five years. Nobody understands Cicero in his letters unless he has been engaged in public affairs of some consequence for twenty years. Let nobody suppose that he has tasted the Holy Scriptures sufficiently unless he has ruled over the churches with the prophets for a hundred years. Therefore there is something wonderful, first, about John the Baptist; second, about Christ; third, about the apostles. "Lay not your hand on this divine Aeneid, but bow before it, adore its every trace." We are beggars. That is true.[53]

The words that Melanchthon shared with the students when he announced Luther's death at the University of Wittenberg ring true to this day. He began with Elisha's words as

he lamented Elijah's passing into heaven (2 Kings 2:12ff.):

> Alas, gone is the horseman and the chariot of Israel! It was he who guided the church in the recent era of the world. It was not human brilliance that discovered the doctrine of the forgiveness of sin and of faith in the Son of God, but God who raised him up before our very eyes, who has revealed these truths through him. Let us hold dear the memory of this man and the doctrine in the very manner in which he delivered it to us. I beseech you, Son of God, O Immanuel, crucified and risen for us, to save, preserve and protect your church.[54]

Luther was a concerned pastor and shepherd of souls throughout his life and remained so until the end. This had prompted the reformer to issue one of his sharpest treatises, appealing to Duke Henry to listen and become obedient to God's Word.

> To give up or change the word of God is not open even to God himself ... [2 Tim. 2:13], and his word remains forever [Isa. 40:8] ... Therefore, the holy church cannot and may not lie or suffer false doctrine, but teach nothing except what is holy and true, that is, God's word alone.... If the word were to be sinful or untrue, after what would or could men guide their lives? Then, no doubt, a blind man would lead a blind man, and both would fall into the pit [Matt. 15:14]. If the plumb line or the T-square were false or crooked, what kind of work would or could the master-builder produce? One crooked thing would make the other crooked, without limit or measure. Life too can be sinful and untrue in the same way—unfortunately life is indeed very untrue—but doctrine must be straight as a plumb line, sure, and without sin. ... When there is disagreement in doctrine, it becomes quite evident

who the true Christians are, namely, those who have God's word in purity. . . . Since there is no judge on earth in this matter . . . we shall . . . in addition to the judgment of God, the highest judge . . . [find it] in his Holy Scripture."[55]

ABBREVIATIONS

K-W Kolb, Robert, and Timothy J. Wengert, eds. *The Book of Concord*. Translated by Charles Arand et al. Minneapolis: Fortress, 2000.

LW Luther, Martin. *Luther's Works*. American Edition. General editors Jaroslav Pelikan and Helmut T. Lehmann. 56 vols. St. Louis: Concordia, and Philadelphia: Muhlenberg and Fortress, 1955–86.

SA Schmalkald Articles

WA Luther, Martin. *D. Martin Luthers Werke. Kritische Gesamtausgabe. Schriften*. 68 vols. Weimar: Hermann Böhlaus Nachfolger, 1883–1999.

WATr Luther, Martin. *D. Martin Luthers Werke. Kritische Gesamtausgabe. Tischreden*. 6 vols. Weimar: Hermann Böhlaus Nachfolger, 1912–21. Reprinted in 2000.

NOTES

PREFACE

1. James M. Kittelson, *Luther the Reformer* (Minneapolis: Augsburg, 1986), 17.

CHAPTER 2

1. LW 48:46.

2. LW 48:46

3. LW 48:46, 47

4. LW 31:25

5. LW 31:84.

6. LW 31:83.

7. LW 31:28.

8. LW 31:180, which is reiterated in a 1530 letter to Philipp Melanchthon regarding the Augsburg Confession (see LW 49:344).

9. LW 31:28.

10. LW 31:189.

11. LW 31:26.

12. LW 31:98.

13. LW 48:66.

14. LW 31:29.

15. LW 31:105.

16. LW 31:31.

17. LW 31:230.

18. LW 31:231.

19. LW 31:231.

20. LW 31:26.

21. LW 31:121.

22. LW 31:77–259 *passim*.

23. LW 31:159.
24. LW 31:187.
25. LW 31:208–9.
26. LW 31:199–204, 209–11.
27. E. Gordon Rupp, "Luther's Ninety-five Theses and the Theology of the Cross," in *Luther for an Ecumenical Age*, ed. Carl S. Meyer (St. Louis: Concordia, 1967), 76.
28. Theses 63–67. See LW 31:232–34.
29. LW 31:32.
30. Thesis 82 (LW 31:32).
31. Thesis 83 (LW 31:32).
32. Thesis 84 (LW 31:32).
33. Thesis 86 (LW 31:33).
34. Thesis 87 (LW 31:33).
35. Thesis 89 (LW 31:33).
36. LW 31:250.
37. Thesis 91 (LW 31:33).
38. A year later, however, Luther modified this position radically when he asserted that the keys had been given by God to the royal priesthood of all believers and through them to the pastoral servants of the church.
39. LW 31:28.
40. LW 31:250.

CHAPTER 3

1. LW 31:52.
2. LW 31:52.
3. LW 31:52–53.
4. LW 31:53.
5. LW 31:53.
6. LW 31:53.
7. LW 31:54.
8. LW 31:54.
9. LW 31:54.
10. LW 1:11. Cf. LW 3:108; 24:143; 111:119; 112:118.

11. LW 1:11.
12. LW 1:13–15.
13. E. Gordon Rupp, "Luther's 95 Theses and the Theology of the Cross," in *Luther for an Ecumenical Age*, ed. Carl S. Meyer (St: Louis: Concordia, 1967), 69.
14. LW 31:50.
15. LW 31:50.
16. LW 31:50.
17. LW 31:43.
18. LW 31:55.
19. LW 31:56.
20. LW 31:56.
21. LW 31:40.
22. LW 31:52–53.
23. LW 31:56.
24. LW 31:56.
25. Thesis 22 (LW 31:54).
26. Thesis 26 (LW 31:56).

CHAPTER 4

1. Luther offered his first lecture on Galatians in 1516 and addressed the book again in 1519, 1523, and from 1531 to 1535.
2. LW 26:4 (*author's emphasis*).
3. LW 26:253.
4. LW 26:5.
5. LW 26:4.
6. LW 26:5.
7. LW 26:5.
8. LW 26:5.
9. LW 26:7.
10. LW 26:8.
11. LW 26:9.
12. LW 26:11.

13. LW 26:11.
14. LW 26:12.
15. LW 26:134.
16. LW 26:131.
17. LW 26:131.
18. LW 26:407.
19. LW 26:132.
20. LW 26:134.
21. LW 26:133.
22. LW 26:133f.
23. LW 26:157.
24. WA 40:273 (*author's translation*).
25. LW 26:276.
26. LW 26:280.
27. LW 26:7f.
28. LW 26:309.
29. LW 26:309.
30. LW 26:310.
31. LW 26:310.
32. Lw 26:310.
33. LW 26:312.
34. LW 26:311–13.
35. LW 26:313.
36. LW 26:313.
37. LW 27:78.
38. LW 27:78.
39. LW 27:78.
40. LW 27:85.
41. LW 27:85.
42. WATr 6, no. 6732. Cf. Ewald Plass, comp, *What Luther Says* (St. Louis: Concordia, 1959), 424.

CHAPTER 5

1. LW 44:17–114.

2. LW 39:51–104
3. LW 44:154–55.
4. LW 44:118.
5. LW 44:195.
6. LW 44:198.
7 "Would to God that every town had a girls' school as well" (LW 44:206).
8. LW 44:208.
9. LW 44:217.
10. Luther was referring to "Babylonian Captivity of the Church."
11. LW 36:5–126.
12. LW 36:9.
13. LW 36:11–12.
14. LW 36:85–86.
15. LW 36:85.
16. LW 36:112.
17. LW 36:112.
18. LW 36:117.
19. LW 36:118.
20. LW 36:124.
21. LW 36:124.
22. LW 31:329–377.
23. LW 31:336.
24. LW 31:344.
25. LW 31:344.
26. As with other classic works of Luther—for example, the Small and Large Catechisms, "Bondage of the Will," etc.—there is no summary or abridgment that will substitute for reading the document itself.
27. LW 31:376.

CHAPTER 6

1. Martin Brecht, *Martin Luther: His Road to Reformation, 1483–1521*, trans. James L. Schaaf (Minneapolis: Fortress, 1985), 460.

2. LW 44:245–400.

3. LW 45:53–74.

4. LW 51:69–100.

5. LW 51:70.

6. LW 51:72.

7. LW 51:74.

8. LW 51:75.

9. LW 51:75.

10. LW 51:76.

11. LW 51:77.

12. LW 51:77.

13. LW 51:79f.

14. LW 51:83.

15. LW 51:88.

16. LW 51:91.

17. LW 51:90.

18. LW 51:95.

19. LW 51:95.

20. LW 51:99.

21. LW 51:99.

CHAPTER 7

1. See LW 44:21–114.

2. LW 44:21–114.

3. LW 44:99.

4. LW 45:74.

5. LW 45:77–129.

6. LW 46:5–43.

7. LW 46:18.

8. LW 46:22.

9. LW 46:25.

10. LW 46:30.

11 LW 46:42.

12. LW 46:40.

13. LW 46:47–55.
14. E. G. Schwiebert, *Luther and His Times* (St. Louis: Concordia, 1950), 567.
15. LW 46:55.
16. LW 46:59–85.
17. LW 46:84.
18. LW 46:84.
19. LW 46:84.
20. LW 46:84.
21. LW 33.
22. LW 33:17.
23. LW 33:106.
24. LW 33:134.
25. LW 33:130.
26. LW 33:293.
27. LW 33:294.
28. LW 33:294.
29. LW 33:295.
30. LW 33:295.
31. LW 33:294.
32. Small Catechism, "Preface," 1–4 (K-W, 347–48).
33. Small Catechism, "Preface," 3 (K-W, 347).

CHAPTER 8

1. LW 37:153–372.
2. Elector John sent a preliminary version of the confession on May 11. Melanchthon sent Luther a second revision on May 22. The final form to be presented before the diet reached Luther sometime between June 8 and 25, shortly before its formal presentation and reading at the assembly on June 25, 1530.
3. LW 49:297–98.
4. Margaret A. Currie, trans., *The Letters of Martin Luther* (London: Macmillan, 1908), 202.
5. Currie, *Letters of Martin Luther*, 202.
6. LW 34:5–61.

7. LW 34:9.

8. LW 34:10.

9. LW 34:13.

10. LW 34:14.

11. LW 34:15.

12. LW 34:16.

13. LW 34:16.

14. LW 34:18.

15. LW 34:19.

16. LW 34:20–21.

17. LW 34:21.

18. LW 34:27.

19. LW 34:60.

20. LW 34:52–53.

21. As a result of this concession, both versions have equal standing.

22. Martin Luther, *Sämmtliche Schriften*, ed. J. G. Walch (St. Louis: Concordia, 1881–1910), 16:882 (*author's translation*).

23. LW 49:328.

24. LW 49:330.

25. LW 49:331.

26. LW 49:331–32.

27. LW 49:332.

28. LW 49:332.

29. LW 51:205.

30. LW 49:336.

31. LW 49:343.

32. Augsburg Confession XXVIII.

33. LW 49:377.

34. LW 49:407.

35. LW 49:407.

36. LW 49:416.

37. The Apology became the companion to the Augsburg Confession. Eventually it was included in *The Book of Concord*, which

was formulated in 1577 by the Lutheran confessors, notably Martin Chemnitz and Jakob Andreae. *The Book of Concord* embraces nine historic doctrinal statements, or summaries, of the Christian faith. For more than four centuries, these nine statements have constituted the platform on which confessional Lutheran teaching is grounded and to which every Lutheran pastor takes an oath of fidelity. The documents included in *The Book of Concord* are the three ecumenical creeds (Apostles', Nicene, Athanasian), the Augsburg Confession, the Apology of the Augsburg Confession, the Schmalkald Articles (and the Treatise on the Power and Primacy of the Pope), Luther's Small Catechism, Luther's Large Catechism, and the Formula of Concord (Epitome and Solid Declaration).

38. Philip Schaff, *The Creeds of Christendom*, 3d ed. (New York: Harper, 1881–82), 1:229.

39. A partial list would include "A Sincere Admonition by Martin Luther to All Christians to Guard against Insurrection and Rebellion" (1522); "Temporal Authority: To What Extent It Should be Obeyed" (1523); "Admonition to Peace" (1525); "Against the Robbing and Murdering Hordes of Peasants" (1525); "An Open Letter on the Harsh Book against the Peasants" (1525); "Whether Soldiers, Too, Can Be Saved" (1526); "On War against the Turk" (1529); and "Commentary on Psalm 82" (1530), which was produced while Luther was at Coburg Castle.

40. Martin Chemnitz has been called the "second Martin" because of the work he and his co-workers accomplished in unifying the Lutheran Church through the writing of the Formula of Concord in 1577. This document addressed the divisions that had occurred among the Lutherans and returned them to the solid platform that Luther—with Melanchthon and others—had articulated for scriptural theology.

41. Formula of Concord, "Solid Declaration," 4–5 (K-W, 524–25).

42. In 1532, John Frederick had succeeded his father, who was known as Elector John the Constant for his heroic stand and support of the Augsburg Confession.

43. SA I (K-W, 300).

44. SA II, 1–2 (K-W, 301). Luther also cited John 1:29; Isaiah 53:6; and Romans 3:23–25.

45. SA II, 4 (K-W, 301). See also Romans 3:28.
46. SA II, 5 (K-W, 301). See also Acts 4:12 and Isaiah 53:5.
47. SA II, 2, 1 (K-W, 301).
48. SA II, 2, 2 (K-W, 302).
49. SA II, 2, 10 (K-W, 303).
50. SA II, 2, 25 (K-W, 305).
51. SA II, 3, 2 (K-W, 306).
52. SA II, 4, 1 (K-W, 307).
53. SA II, 4, 9 (K-W, 308).
54. SA II, 4, 14 (K-W, 309).
55. SA II, 4, 15 (K-W, 310).
56. SA III, 3, 16 (K-W, 314).
57. SA III, 4 (K-W, 319).
58. SA III, 8, 10 (K-W, 323).
59. SA III, 8, 10 (K-W, 323).
60. SA III, 12, 1–3 (K-W, 324–25).
61. SA III, 15, 3 (K-W, 326).
62. Melanchthon qualified his subscription with a mediating statement concerning the papal office, adding: "However, concerning the pope I maintain that if he would allow the gospel, we, too, may (for the sake of peace and general unity among those Christians who are now under him and might be in the future) grant to him his superiority over the bishops which he has 'by human right'" (SA, "Subscriptions" [K-W, 326]). Such a qualification was typical of Melanchthon's nature and appears not to have raised too many eyebrows among Luther's supporters, who were by now accustomed to Melanchthon's compromising spirit.

CHAPTER 9

1. LW 54:7.
2. The Luthers' oldest son, Hans (b. June 7, 1526), pursued the study of law and served in civil government. Martin (b. November 9, 1531) studied theology, like his father, but was not strong physically and never became active in the ministry. Paul (b. January 28, 1533) studied medicine, gaining a wide

reputation as a physician. Margaret (b. December 17, 1534), the only daughter who survived to adulthood, married a wealthy nobleman. Elizabeth (b. December 10, 1527) died in infancy, and Magdalena (b. May 4, 1529) died in her father's arms in September 1542.

3. Luther's lectures and commentary on the Book of Genesis account for the first eight volumes of the 50-volume American Edition of Luther's Works.

4. LW 44:115–217.

5. LW 41:3–178.

6. LW 41:47.

7. LW 41:138.

8. LW 41:136.

9. LW 41:138.

10. LW 41:143.

11. LW 41:149.

12. LW 41:150.

13. LW 41:151.

14. LW 41:151.

15. LW 41:151.

16. LW 41:152.

17. LW 41:152.

18. LW 41:152.

19. LW 41:152.

20. LW 41:154.

21. LW 41:154.

22. LW 41:156.

23. LW 41:165.

24. LW 41:167.

25. LW 41:170.

26. LW 41:171.

27. LW 41:172–73.

28. LW 41:173–74.

29. LW 41:176.

30. LW 41:176.

31. LW 41:177.
32. LW 41:177.
33. LW 41:177.
34. LW 45:197–229.
35. LW 41:259–376.
36. LW 41:264.
37. LW 41:265.
38. LW 41:273–74.
39. LW 41:289.
40. LW 41:290.
41. LW 41:327.
42. LW 41:332.
43. LW 41:355.
44. LW 41:359.
45. LW 41:364.
46. LW 41:365.
47. LW 41:373.
48. LW 41:373.
49. LW 41:374–75.
50. LW 41:376.
51. WA 40:160 (*author's translation*).
52. On the previous Sunday, while preaching his last sermon, Luther had suffered a spell of dizziness and weakness that caused him to end the sermon abruptly.
53. LW 54:476. According to Aurifaber, this note was written February 16, 1546.
54. Oskar Thulin, *A Life of Luther* (Philadelphia: Fortress, 1966), 129.
55. LW 41:212–21.

BIBLIOGRAPHY

Bainton, Roland. *Here I Stand: A Life of Martin Luther*. New York: Mentor, 1957.

Bornkamm, Heinrich. *Luther in Mid-Career, 1521–1530*. Edited by Karin Bornkamm. Translated by E. Theodore Bachmann. Philadelphia: Fortress, 1983.

Brecht, Martin. *Martin Luther: His Road to Reformation, 1483–1521*. Translated by James L. Schaaf. Minneapolis: Fortress, 1985.

———. *Martin Luther: The Preservation of the Church, 1532–1546*. Translated by James L. Schaaf. Minneapolis: Fortress, 1993.

———. *Martin Luther: Shaping and Defining the Reformation, 1521–1532*. Translated by James L. Schaaf. Minneapolis: Fortress, 1990.

Ebeling, Gerhard. *Luther: An Introduction to His Thought*. Translated by R. A. Wilson. Philadelphia: Fortress, 1964.

Edwards, Mark U. Jr. *Luther's Last Battles: Politics and Polemics, 1531–1546*. Ithaca: Cornell University Press, 1983.

Forde, Gerhard O. *Where God Meets Man: Luther's Down-to-Earth Approach to the Gospel*. Minneapolis: Augsburg, 1973.

Hendrix, Scott. *Luther and the Papacy: Stages in a Reformation Conflict.* Philadelphia: Fortress, 1981.

Kittleson, James M. *Luther the Reformer*. Minneapolis: Augsburg, 1986.

Köstlin, Julius. *Life of Luther*. New York: Scribner's, 1911.

———. *The Theology of Luther in Its Historical Development and Inner Harmony*. Vol. 2. Translated by Charles E. Hay. Philadelphia: Lutheran Publication Society, 1897.

Lohse, Bernhard. *Martin Luther: An Introduction to His Life and Work*. Translated by Robert C. Schultz. Fortress, 1986.

BR 333.3 .K58 2003
Eugene F. A. Klug
Lift High This Cross

ematic Devel-
opment. Translated and edited by Roy A. Harrisville. Min-
neapolis: Fortress, 1999.

Oberman, Heiko A. *Luther: Man between God and the Devil.* Translated
by Eileen Walliser-Schwarzbart. New Haven: Yale University
Press, 1989.

Preus, Robert D. *Justification and Rome.* St. Louis: Concordia Academic
Press, 1997.

Rupp, E. Gordon, and Philip S. Watson, eds. and trans. *Luther and
Erasmus: Free Will and Salvation.* Library of Christian Classics
17. Philadelphia: Westminister, 1969.

Schwiebert, E. G. *Luther and His Times.* St. Louis: Concordia, 1950.

Smith, Preserved, and Charles M. Jacobs, eds. and trans. *Luther's Corre-
spondence and Other Contemporary Letters.* 2 vols. Philadelphia:
Lutheran Publication Society, 1913–18.

Thulin, Oskar. *A Life of Luther.* Philadelphia: Fortress, 1966.

Wa *f the Theology of*

DATE DUE

DEC 1 0			